Wedding Photography
Art and Techniques

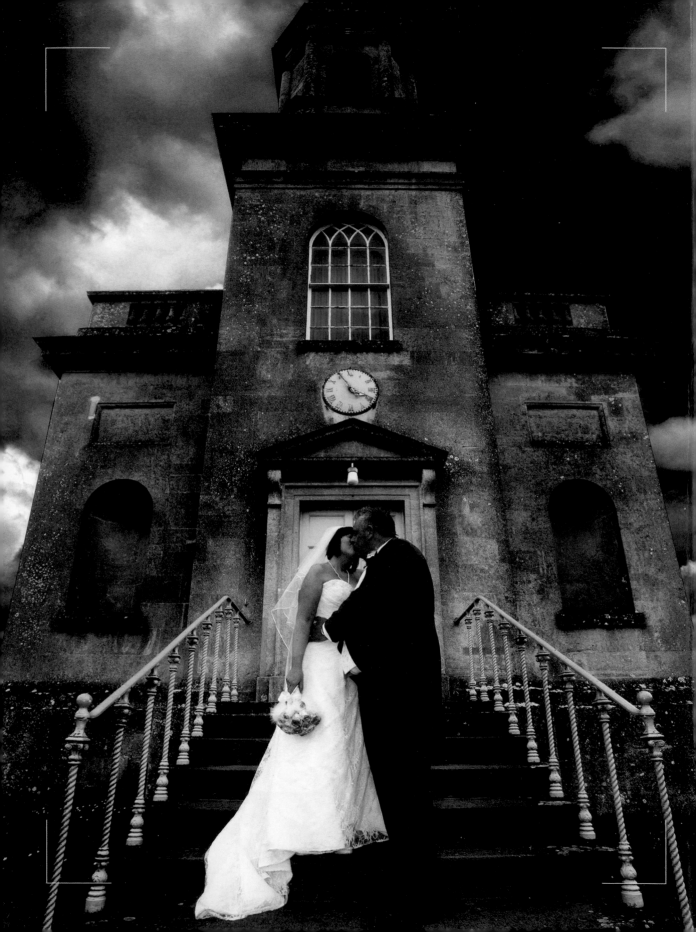

Wedding Photography
Art and Techniques

Terry Hewlett ARPS

CROWOOD

First published in 2012 by
The Crowood Press Ltd
Ramsbury, Marlborough
Wiltshire SN8 2HR

www.crowood.com

British Library Cataloguing-in-Publication Data
A catalogue record for this book is available from the British Library.

ISBN 978 1 84797 429 7
All photographs are by the author, with the exception of page 22 by Andy Cubin

Dedication

To my supportive and caring wife, Vivienne

Graphic design and layout by www.peggyandco.ca
Printed and bound in Singapore by Craft Print International

CONTENTS

Foreword by Andy Cubin MBE, ASIFGP 7

Introduction 9

1 Developing Your Style 11

2 Starting Your Business 25

3 The Bag of Tricks 35

4 Working and Shaping the Light 43

5 Seeing the Picture 63

6 Planning the Day 83

7 Signature Shots 91

8 Group Shots 95

9 Working the Day: The Ceremony 99

10 Working the Day: The Reception 137

11 Digital Workflow 155

12 Albums and End Products 163

Conclusion 169

Appendix: The 'Must-get' Shots 171

Further Information 172

Index 173

Foreword

I have known the author for a healthy number of years. Our relationship is an odd one in that it would be befitting of many descriptions; master/student, business partners, friendly rivals, confidants and mutual critics would all be or would have been apt at some time. Certainly, we have become fast friends and will doubtlessly remain so whilst both of us are still drawing breath.

I first met him at a photographic convention and, on our first encounter, we barely exchanged ten words. Since then we have exchanged hundreds of thousands of words. So it should have been a simple matter to set down a few more in this foreword – it is after all a well-known subject. Only when I started to put finger to keyboard did I begin to realize what a mammoth task writing a book on wedding photography must have been.

Today, wedding photography is saturated with thousands of people (not photographers) who have invested in an SLR and go out without any education or training and offer their services at appealingly low prices to the budget-conscious couple-to-be. And many of these couples fall into the trap only to be disappointed at the final results on what should have been their most important of days – this book is not for them.

Being a competent wedding photographer is much more than just having the ability to take impressive pictures – that in itself should be an essential skill that, sadly, many photographers fail to achieve. In order to command a respectable level of remuneration for photographing the big day, the image-maker must be creative and efficient within the time allotted to him or her – and that takes knowledge and practice.

There is no substitute for practical experience but, in addition, the wedding photographer needs to be a tactician, comedian, diplomat, motivator, suppressor, improviser, sergeant-major, sympathizer, clairvoyant, detective and all round problem-solver. He or she needs not only to possess all these character traits, but also be able to switch from one to another instantly and to keep it up for ten hours or more come (and in) rain or shine.

This book provides a vital part of the aspiring or improving wedding photographer's education. It is well-established that knowledge and experience are skills without which the wedding photographer would surely fail. Knowledge is an essential require-ment that the wedding photographer needs in order to be ahead of the game and/or to cope with the unexpected – and the unexpected always happens.

Within these chapters lie words of wisdom borne from decades of experience of photographing hundreds of weddings and from years of training wedding photographers on how to make a success of this business.

This book is likely to be one of the most com-prehensive tomes written on the subject, by one of the most experienced and qualified photographers in the industry. It is specifically aimed at the seri-ous aspiring wedding photographer who wants to successfully negotiate the hurdles of a wedding day, meet and exceed the expectations of the newly-weds, and command a credible income for their work. Enjoy...

Andy Cubin MBE, ASIFGP

Introduction

Photographing weddings is one of the most rewarding, inspiring and creative assignments that any photographer can have, producing creative images that the couple will cherish and enjoy for many years to come.

Driven by emotion and anticipation, a wedding is about the excitement that starts when the bride begins to prepare for the thrilling day ahead, with the delivery of the flowers and the fitting of the dress, the anticipation and excitement growing with the arrival at the ceremony and everyone's eyes on the bride as she makes her entrance towards the waiting groom. The fairytale builds through the ceremony and on to the reception, with the photographer capturing the couple's experiences in a creative and imaginative style.

A wedding photographer requires a significant number of techniques to enable a successful outcome, and it will come as no surprise that being a good photographer is essential, but what kind of photographer do you need to be? Wedding photography calls upon a number of talents to produce quality images that will not only be cherished but will also sell. Your skills will include portraiture, fashion photography, landscape and architectural photography, still life and food photography, and photojournalism.

You will need to produce creative and inspirational photography while exhibiting a wide range of social skills. Are you able to handle the pressure that the day will generate, dealing with timings that run late, shooting the groups in less than half an hour, producing quality images every time? Are you able to handle your camera functions and flash intuitively and instinctively, adjusting for the changing lighting conditions without interrupting the flow of the day? Can you communicate your instructions and directions effectively to the wedding party and all the time keeping an eye on the timings? If not, then wedding photography is not for you.

However if you thrive on challenging situations and enjoy an adrenaline rush and can handle all the above, then there is nothing more rewarding than completing a wedding shoot successfully, taking stunning, creative and quality images and at the same time receiving compliments from the bride, groom and guests on how you have handled the day in a humorous and professional manner. Your role as a wedding photographer is to capture the memories of the day through your images and imagination. After all, in years to come it will be those images that will evoke the couple's memories.

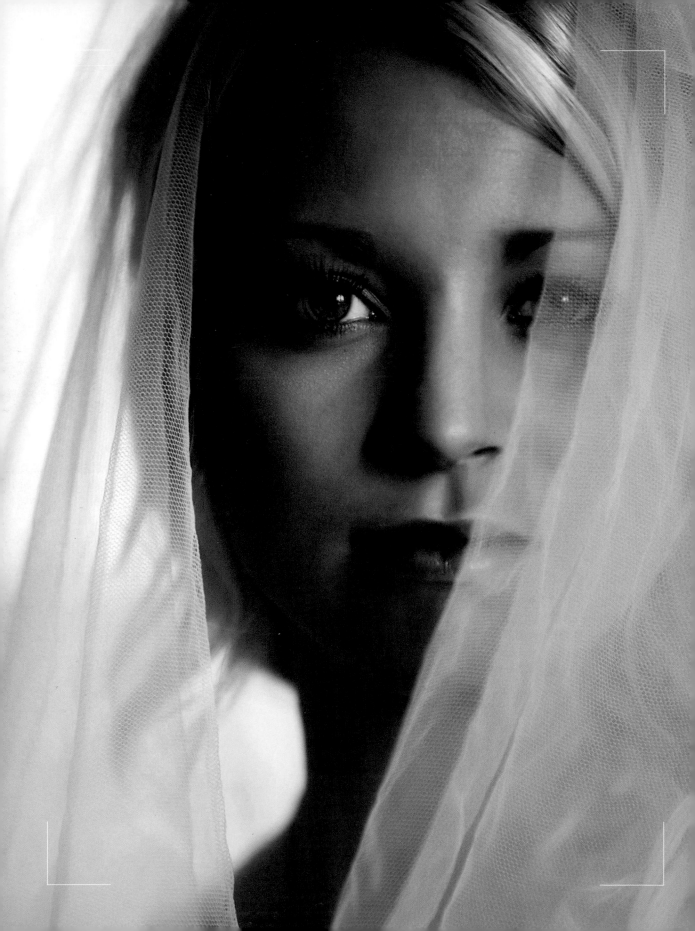

Chapter 1

Developing Your Style

Any wedding will call upon a diverse range of photographic styles. The photographs will inevitably include some formal elements sprinkled with the candid shots. So the best advice is to broaden your skills and make your style eclectic. Your photography should reflect all of the following.

REPORTAGE, PHOTOJOURNALISTIC OR STORYBOOK

The current trend is towards photojournalistic wedding photography. As a photographer with this style you are more than likely to consider yourself a storyteller as opposed to just recording the day. You could be asked for photography that is natural and candid, less rigid and not intrusive, that is, to take images that capture moments unobtrusively. You will respond as the timeline unfolds with possibly unpredictable results; however, it is that unpredictability that can be so enchanting about this style.

This style of wedding photography may only represent about ten per cent of the total shoot, the balance being taken up with more formal images and records of the ceremony. The style lends itself to more oblique angles and a spontaneous approach to the day. More often than not you will be using on-camera flash (not the desired position), or on a flash bracket, using natural light in an informal style.

You will provide the story of the day, recording events as they happen with a natural feel. You will take photographs as the day develops, capturing elements as they happen, rather than shooting

▲ Photojournalistic/Reportage tells the story of the day, capturing events as they happen. *200mm @ f2.8 1/50sec*

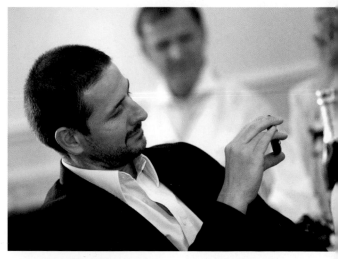

▲ The digital age has opened up the opportunities for photographers producing a storybook style of wedding photography. *200mm @ f3.2 1/60sec*

set-up shots. Not to be confused with natural shots, storybook will not show any specific group or have any kind of structure.

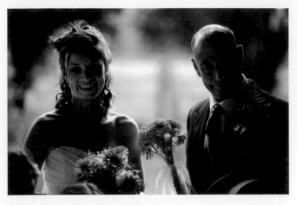

▲ Try to capture the details at the speeches that reflect the mood and occasion. *200mm @ f4 1/60sec*

▲ Arrival at the ceremony, using a 70/200mm lens to reduce the depth of field and make the subject stand out from the background. *190mm @ f2.8 1/160sec*

▲ Look out for the impromptu cameo images that happen only once. *155mm @ f4.5 1/100sec*

It is possible to take natural and spontaneous images with an element of control being exercised by the photographer: the fitting of the dress, pageboys and bridesmaids, groom and the best man and ushers. As the photographer, you will need to take some control, whilst at the same time being virtually invisible, possibly being a little forward and somewhat assertive to capture the moment.

This style of photography has evolved over recent years since the advent of digital photography, given that you can now shoot hundreds, if not thousands, of images without increasing your costs. However it does impose a greater workload upon the photographer in post-production. With this style of photography there is the danger of machine-gun shooting instead of the sniper approach. There is more to reportage or storybook wedding photography than putting your camera on power drive and hoping for the best. Be sure that you know why you are shooting an image and what you want it to convey to the viewer, and do not leave it to chance.

During the day you will be looking for the spontaneous romantic moments – the loving kiss, holding of hands, affection and humour that are spontaneous and will disappear in an instant.

Providing a diverse mix in the couple's wedding album will ensure that it reflects the emotional tone and feel of the day, and will help add balance to the layout, producing an album that reflects the whole day and tells the story.

FORMAL/TRADITIONAL

In the days before digital the number of images was dictated by the amount of film that was taken to a wedding, and if shooting in medium format, you would more than likely be restricted to twelve rolls of film that would produce 144 images, requiring the photographer to be very selective and make every shot count.

This formal approach produced very formal images, contrived and orchestrated, giving this style a rather tarnished reputation, somewhat undeserved. In any wedding there will always be the requirement to capture the families and generations, providing a balance to the opportunistic and photojournalistic style.

The formal approach to wedding photography is a thing of the past and is not generally desired by the current generation of couples getting married, who are influenced by contemporary magazines that depict natural and spontaneous images.

This does not mean, however, that the formal shots should be boring and mundane. On the contrary it will be your responsibility to put people and groups at ease, posing them naturally and producing an image that does not look too contrived.

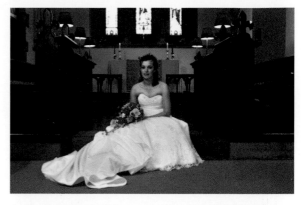

▲ After the ceremony, if the couple wish to do so, consider going back inside the venue for a formal pose or signature shot.
34mm @ f4 1/60sec

▲ At some point during the reception, you may be able to find some time to shoot the couple in a more relaxed environment.
24mm @ f2.8 1/160sec

▶ The exchange of rings is a 'must-get' shot, representing the union between the couple.
25mm @ f8 1/250sec

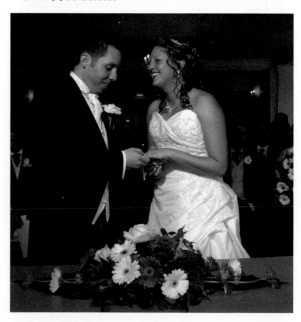

AVANT-GARDE/ CONTEMPORARY

Avant-garde is a style that can be related to art, music, written texts and photography. It was first introduced by a group of musicians, artists and writers who wanted to experiment with ideas that were very different to the norm, and these included new concepts and techniques. This genre edits the conventional methods, and is made up of a variety of informal characteristics of photography and other arts.

Avant-garde is a French term meaning a vanguard or advance guard that goes forward ahead of the rest. In art and photography it is synonymous with modern and applies to those that are experimental and innovative, and very often pushing the boundaries exploring new forms, the result of a creative mind. Salvador Dali was a key player in the avant-garde movement, a master of surrealism, taking the movement to a whole new level.

Given the experimental nature of this format and the fact that it will not suit every couple, you should use it sparingly.

Avant-garde represents an artistic theatrical approach that by its very nature will no doubt in time become the merely accepted, much like photojournalistic photography has become the norm these days.

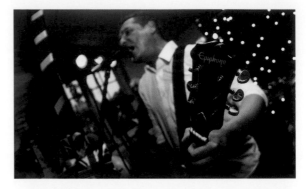

▲ Using unconventional angles will add something to your images.
15mm @ ƒ2.8 1/100sec

▶ Look out for the creative shots that are different.
155mm @ ƒ22 1/60sec

▶ A fish-eye lens is not everyone's choice of lens; however, creative imagery can be captured, producing shots that are different.
15mm @ ƒ5.6 1/60sec

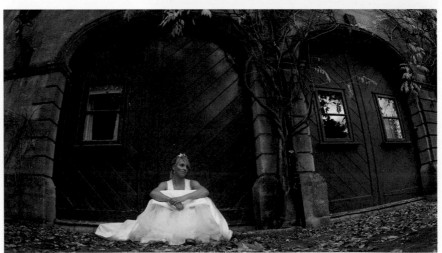

ROMANTIC

Capturing the love, laughter, romance and affection of a couple is what romantic wedding photography is all about, playing with soft images, different angles and capturing the romance of the wedding.

Very often these are what could be called the signature shots or creatives, taken at the time when you are alone with the couple – maybe after the ceremony or at some point during the reception. In post-production you will do some judicious processing using vignettes and soft-edge focus to add to the atmosphere.

Romance should be evident throughout the day. Not only the couple themselves but guests who have just become engaged, or new and developing relationships will all produce imagery that has a romantic element.

▲ The romance, working around the couple as they take their first dance together. *35mm @ ƒ2.8 1/100sec*

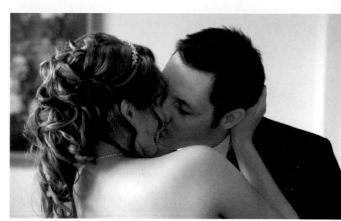

▲ Watch out for the spontaneous moments that will pass in the blink of an eye. *70mm @ ƒ3.5 1/100sec*

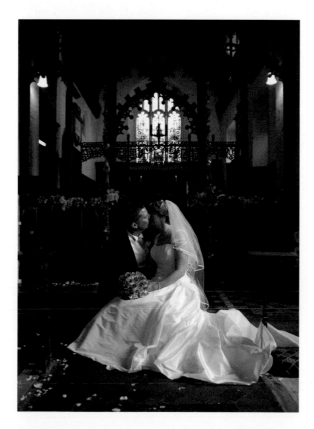

◄ This image conveys the love and affection between the couple in the church after the ceremony. *24mm @ ƒ3.5 1/60sec*

CREATIVE

The creative style is a crossover between various styles and allows you, the photographer, to be really creative and to improvise. You can use your artistry to wow the couple, working with new lighting effects, shadows and angles, viewpoint and imagination to add energy and dynamism to your work. The advent of cameras that seem to do almost everything for you does not enhance photography as a unique art form – that is still up to the photographer.

Creativity is the ability to generate new ideas, making your work stand out amongst the crowd, so it becomes a work of art and not just a record of the day. The ability to think outside the box will expand your work beyond the average. Aim for something different, so that every time the viewer looks at your photography they will experience elements they had not noticed the first time of looking.

With the advent of the digital age and all the post-production options available these days, wedding photography has moved into a new vibrant era with techniques like HDR (high dynamic range) imaging, panoramic format, colour manipulation, creative lighting techniques and using a photojournalistic style as you are not limited to shooting ten rolls of medium format film on the day, resulting in just 120 shots.

▼ Photographing children can produce some charming candid images, particularly if they are shy of the camera. This can work well in black and white. *190mm @ f2.8 1/160sec*

▼ Look out for the creative angles, turning a mundane image into a work of art. *130mm @ f13 1/200sec*

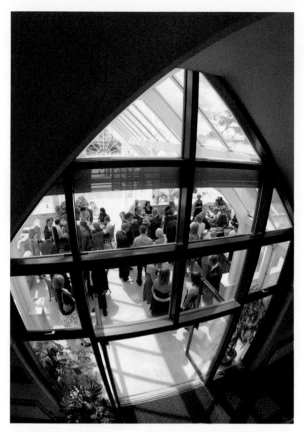

ILLUSTRATIVE

Illustrative photography produces an unambiguous, sometimes edgy image that speaks a thousand words, creating the right mood and attracting careful consideration through the use of an appropriate location, lighting and light modifiers that reveal a third dimension in a medium that has only two. High technical skills and a complete understanding of how light works, the placement of the subject and attention to detail and design are a pre-requisite for this style.

Be careful when working in this style, however, as there is a danger that in the quest for perfection and careful attention to detail, by scripting the image you miss out on the spontaneity, freedom, atmosphere and mood of the day.

▲ Selecting a high viewpoint to show the reception will add another dimension to your photographs, in this case using the architectural constructions as a lead into the festivities. *15mm @ f4.5 1/200sec*

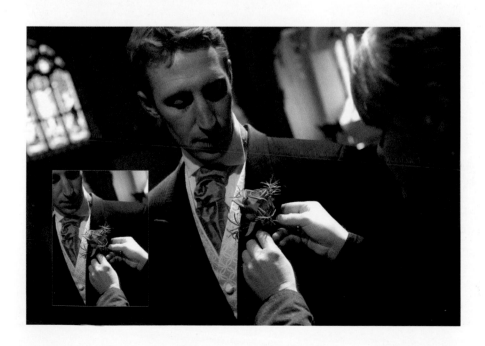

◄ The fixing of the buttonhole will provide many a shot during the process of getting ready and can be taken from many angles, using tight cropping if required, just to show the hands.
30mm @ f2.8 1/160sec

GLAMOUR/BOUDOIR

There is a growing market for brides who want you to create a loving, sexy image to please their partner and commemorate the day. This field of photography is so easy to get wrong and needs a great deal of experience not to make it look tacky.

Most boudoir photography is done in the studio or hotel suites, where the lighting and environment can be controlled to produce sensual and flattering images. It is not advised that this genre of photography is done on the wedding day due to the pressure and time constraints the day will impose. If the bride wants some sensual images it is best to either arrange the shoot prior to the wedding or upon the couple's return from their honeymoon.

▼ Boudoir photography is a developing market and should be taken cautiously, as it is so easy to get wrong. This genre of photography should not be done on the day of the wedding. *60mm @ f10 1/200sec*

▼ Boudoir is often requested by the bride for her partner and requires a delicate approach. *70mm @ f7.1 1/125sec*

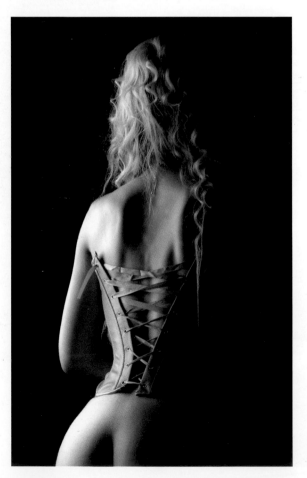

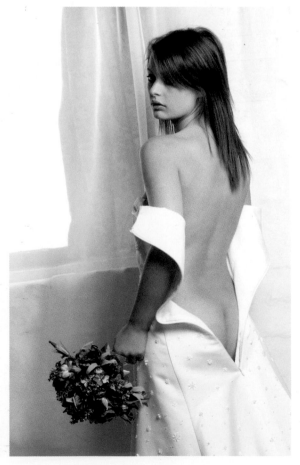

BLACK AND WHITE

Black and white stands out in a sea of colour and is increasingly popular. Whilst appearing to be the simplest and at the same time the most sophisticated style, it can look artistic and very flattering, as it displays shades and contours beautifully. Black and white images are timeless, evoking atmosphere and nostalgia, and they allow the viewer to make their own interpretation, whereas colour is more a statement of fact (assuming your colour balance is correct).

Shooting for black and white requires close attention to lighting, composition and subject matter, as the eye will not be distracted by any colour. The image will need to show black and white with a wide range of mid tones. There is the danger that black and white is used simply because the original colour image has not been balanced correctly and it seems the easy option.

▼ The processional is an important part of the build-up to the actual ceremony. How you shoot this is your choice; however, bear in mind that the bride needs to be shown walking down the aisle with her guests looking on, so a wide-angle lens is required. *15mm @ ƒ6.3 1/125sec*

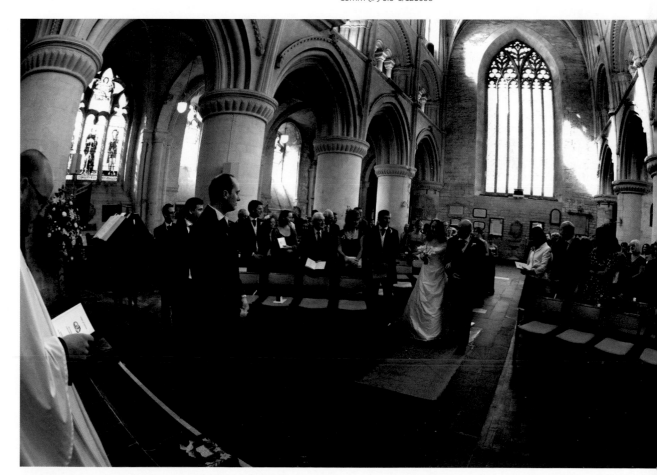

▲ High jinks – if the groom's men are having fun, then capture the occasion. Shooting with a 70/200mm lens on shutter priority at 1/500sec ensured that the subject matter here was sharp.
70mm @ f6.3 1/500sec

Most people will shoot in colour and convert to black and white, as it doesn't work the other way around. It is not advisable to shoot entirely in black and white, as details such as the flowers, table decorations and bridesmaid's dresses will be remembered more clearly when shot in colour. You should ideally be shooting in RAW (if your camera allows you to do so) as it allows greater control when translating to black and white. When shooting in RAW on some cameras, switching to the black and white mode will enable you to see your image on the rear of the camera in black and white, with the camera recording all the information, including colour.

Noise can be an issue with black and white images so shooting with the lowest ISO is advisable. However grain and noise are often used for creative effect. Noise in digital imaging is similar in nature to that of grain in high ISO film images; it manifests itself as random dots or grains and is generated by heat in the sensor that might free up electrons contaminating the image capture. Noise can also be generated when using higher ISO settings, but the latest generation of cameras is improving this situation.

COLOUR POPPING/SELECTIVE COLOUR

Before the introduction of computer technology and digital cameras photographers would paint onto the negative to highlight a particular object. Nowadays a similar effect is created on screen.

This is a somewhat overused technique that is designed to draw attention to elements or focal points within the image in colour, and leaving the rest as black and white. The technique is frequently used on the bride's bouquet where the flowers are shown in colour but the rest of the photograph is black and white. Whilst this can be recognized as a style it should be used very sparingly. Keeping the selective colour understated will add a subtlety to the procedure. Beware, as it could easily be one of those techniques that moves out of fashion as quickly as it entered, making images somewhat dated.

▼ Pew end flowers or flowers at the reception make for a great image, in this case using selective colour or colour popping to accentuate the flowers. *15mm @ ƒ3.2 1/100sec*

▼ Colour popping has been a popular creative element, demonstrated famously in Stephen Speilberg's film *Schindler's List*, with the little girl in the red coat. *24mm @ ƒ5.6 1/60sec*

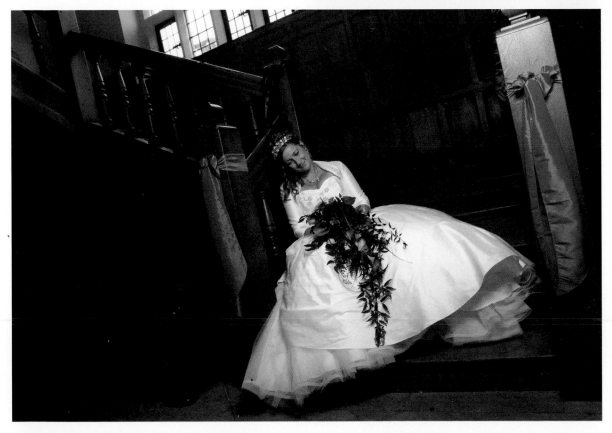

USING DIGITAL EFFECTS

Gone are the days of grey and cloudy skies in wedding photographs. If the sun decides not to appear on the wedding day, then there is no need to worry because a good photographer will be able to change photographs of dull weather into a bright blue sky in post-production. Digital effects have been around as long as photography, with manipulation of the final print from the negative in the darkroom, with techniques such as dodging and burning as well as vignettes. So today's manipulation is just a natural extension of those techniques, with the computer offering greater creativity. In wedding films these days couples are subjected to digital effects to the extent that it has almost become an accepted style in its own right.

The downside with this technique is the corruption of the original image to such an extent that the photographer changes the memory map of their client; in other words, it is not as it was on the day and as they want to remember it. However, there are occasions where, for creative effect, some digital manipulation will add a punch to the image and turn a somewhat ordinary image into something artistic.

One consideration when using digital or computer enhancement is the amount of time that can be spent on working a single image – you can get carried away with the creative process. The danger is that you could be spending far more time in front of the computer than taking the photographs, and after all, in the professional world time is money.

▼ Adding a couple of dogs, mist and sunburst has added extra interest to the image. However, only add additional elements if the couple request it as this is not what happened on the day. *24mm @ f8.0 1/125sec*

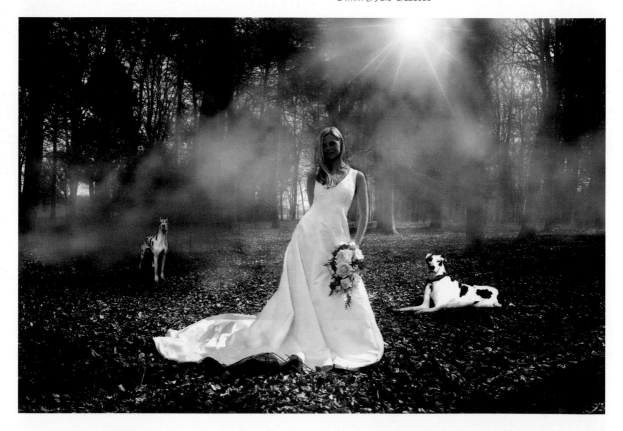

▲ Digital manipulation can be an effective tool. However, it must be treated with care; if it is what the couple want then so be it, but only use it on images that work well with it. *66mm @ ƒ5 1/200sec*

▲ Colour enhancement has lifted this image – the star burst may be an acquired taste. *27mm @ ƒ11 1/125sec*

◄ Creative use of the shutter speed and balanced flash help develop the sky detail. *16mm @ ƒ20 1/200sec*

Chapter 2

Starting Your Business

It may be the case that not everyone reading this book will be interested in developing a full-blown wedding empire. However it would be remiss not to include a short introduction to the business of wedding photography.

Remember that there are three unique selling opportunities in any wedding photography business. First there are your images: these will be the first impression your potential clients will have of your work, so make sure you display your very best. Secondly your pricing: keep it competitive, but do not undersell yourself. And finally there's you: your personality should shine through when you meet your clients – after all, you are going to be so much a part of their important day.

DIGITAL VS ALBUM?

What are you going to provide your clients? In this digital age technology is moving rapidly. There is no guarantee that years from now the digital format in which you supply the images will be capable of retrieval, unlike a printed wedding album that transcends generations and will become the family heirloom to be cherished.

▼ Portfolio images are those photographs that showcase your work and style. However, when showing a couple your work make sure it also shows a complete wedding and not just your 'cherry-picked' images. *70mm @ ƒ2.8 1/1000sec*

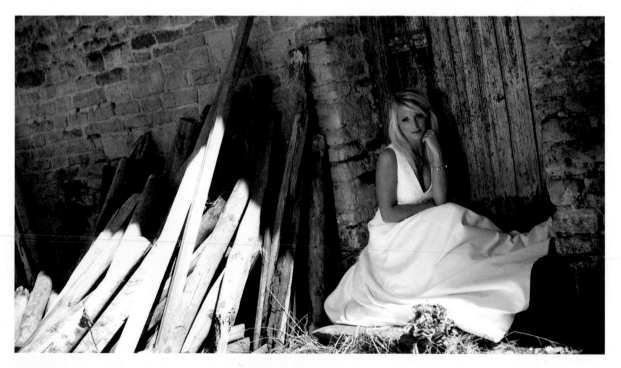

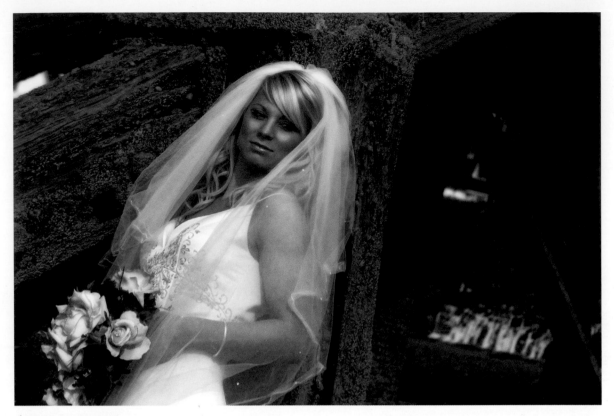

▲ Look out for interesting locations that showcase your work; very
often a derelict location will help emphasize the softness and
beauty of the bride. *54mm @ ƒ4.5 1/2500sec*

There is a market where couples just want the
digital negatives on a disc, not worrying about
having them printed by a professional laboratory;
after all they can have them printed very cheaply
from a local outlet. The problem with this strategy is
the total lack of control you will have over the final
results. The images subsequently passed around
friends and family as your work may be produced
on poor quality paper or compiled into a homemade
album, designed without any creativity and not
doing justice to your work.

All couples will have budget limitations; however,
these days there is no reason why a modest album

cannot be created that tells the story of their day,
designed in a professional manner with impact,
something that a disk of images cannot provide. The
album should be a work of art that reinforces the
couple's memories as well as displaying your work
in a format that does you proud and will continue to
inspire and promote your business to all who view it.

These days there are many suppliers offering a
wide variety of albums ranging from the photobook
through to the top end magazine format albums.
You will be able to find one that allows you to pre-
sent the couple's images in a creative and imagina-
tive format while keeping to a reasonable budget.

FINDING YOUR MARKET AND CLIENTS

It is a mistake to jump straight into the market with the notion that it is an easy route to making money. Many a photographer, having been asked by friends or family to photograph their wedding, can testify that it is not as easy as it looks. However if it is an arena of photography that you think works for you, here are a few indicators to finding your market and building the business.

Market Research

As an artist will combine the paint on his palette to create a work of art, mix your products and pricing in such a way as to create the desired marketing mix that you think best suits your clients. For example do you reduce the emphasis given to the price, in favour of the brand or end product, or are you or your images the key selling point?

Research into your competition in what is a saturated market is an integral and fundamental element in the foundation of your business. What competition do you have, what threats do they represent, how much are they charging, what is their work like, does it justify the rate being charged? All these questions, and many more, need to be answered before you go into business.

▼ Descriptive backgrounds can add something to the wedding images. It's amazing what some photographers find to shoot against – it need not be the traditional background. *32mm @ f11 1/200sec*

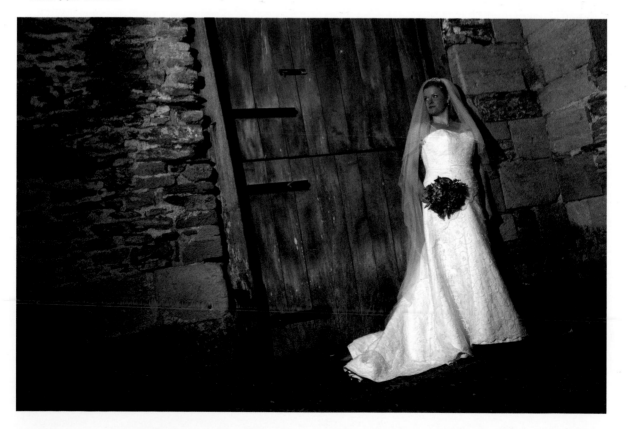

10 KEY MARKETING QUESTIONS

1. Is the market saturated in your area?
2. Do you have what the market wants?
3. What are your unique selling points?
4. What is your brand?
5. What is the competition doing?
6. Do you match your charges to your promises?
7. How do you reach your target market?
8. Where should you target your advertising?
9. Do you need a website?
10. Can you meet the demands of the market?

First and foremost you need to set out your principle objectives, in both the short and long term, and set out your route to market. You will need some kind of financial plan setting out all the costs, when and where they occur. You will then need to take a look at the geographical area in which you intend to work: are there enough weddings in the area to support your intended lifestyle, and how far will you have to travel to fulfil the commitment to the couple, given that you may well have to meet them on more than one occasion. What and where is the competition, and what will you be offering that gives you the edge and elevate you to the top of the tree?

Photographers in your area will no doubt be charging a range of prices from low-end budget to high-end quality, as well as offering a diverse assortment of products to the couple. Whilst your pricing strategy should reflect your level of expertise, underpricing yourself will make it difficult for you to obtain a decent income and will become a problem when you need to make the transition into the higher-end market – in other words do not undersell yourself. Making yourself unique in the marketplace and creating a brand that is distinctive is the challenge, not offering the same old product that all your competitors are providing,

▶ Looking for different angles from which to shoot, even at the signing of the register, will add diversity to the photographs.
27mm @ ƒ3.5 1/60sec

Advertising

Reaching your target market, once you have established where it is, can be a little like casting fine sand into the wind, hoping that some will land in the bucket. A strong website is paramount, with good strong content and clearly visible contact details.

With the advent of social networking the route to market has become more immediate. Communication to potential markets is now achievable on the move, developing your own market segment and community, generating immediate response and measurable responses.

Consumers are relating and accepting social media into their lives to a greater extent, which provides advertisers with significantly more opportunities than hard copy advertising does, and this helps to improve the targeting and relevance of your advertising. Never forget that as a photographer you are selling images and memories, and therefore a strong portfolio of pictures is vital. Your advertising needs to go after your target audience, hence you need strong market research to determine your niche market. To highlight your competitive advantage and grab attention and interest at the outset, illustrate the key benefits with a clear and concise message: why should a couple book you as their wedding photographer in preference to someone else? And remember, saying less is often the best way.

Wedding Fairs

Wedding fairs can be a superb opportunity to place yourself in front of both brides and grooms, showing them your latest work. Couples will attend these fairs with the intention of sourcing various providers, including dress and suit suppliers, cakes, rings, chocolate fountains and photographers. One common problem with fairs is the high number of photographers booked to attend, diluting considerably your opportunities, so it is important to undertake careful assessment regarding the balance between service providers at the fair. Competition is great; however, most couples will not look at more than four or five photographers, focusing upon those displaying stunning and diverse portfolios of work.

Position within the fair is critical to maximize your visibility, with corner sites commanding a great position no matter what direction the couples approach from. Your stand must be loaded with creative impact clearly demonstrating your unique style.

You will hope couples will arrive with an open mind despite maybe having a particular photographer in mind. Your task is to encourage them to change their minds and select you instead. In the mix there will be the literature collectors as well as potential clients with a desire to talk to you and view your work and albums. With that in mind a generous supply of distinctive brochures with your finest albums on display is paramount. Here is your opportunity to demonstrate your personal chemistry, together with your skills as a wedding photographer along with a competitive pricing structure – not too cheap and hopefully within their budget.

10 QUESTIONS CLIENTS WILL ASK

1. Have you previously photographed a wedding at the venue the couple have chosen?
2. Do you work with an assistant?
3. How long will you attend the wedding for (when will you start and finish)?
4. What style do you shoot in?
5. How many weddings have you photographed?
6. What does your price include?
7. How many photographs will you take?
8. What albums do you provide and how many images do they include?
9. Will you supply high-resolution images in a disc?
10. Are you able to show the wedding images on-line?

◀ When arriving at the bride's getting-ready location, look out for the small details like buttonholes, as they help complete the story. After all, someone has chosen them and bought them and maybe even made them.
195mm @ f4 1/250sec

BUILDING YOUR PORTFOLIO

One of the problems most aspiring wedding photographers have is how to build a portfolio of work from the outset when you have never done a wedding. After all, without a superb wedding photography portfolio, you will struggle to be accepted as the photographer the couple want. First impressions count for a great deal in what is an extremely competitive market. People have suggested using models to develop their portfolio; the problem with this is the nature of the images, after all your clients are not likely to be models and therefore the portfolio can look a little contrived without the spontaneity often acquired when photographing a real wedding.

Photographers are often asked by friends or family to capture their wedding, and these commissions, usually at no charge, are a great way to start building your portfolio. There may also be an opportunity to either second shoot with a professional or to shoot your candid images at a wedding that you have been invited to.

When you put together your portfolio it is important that you show clients a complete wedding portfolio or presentation slideshow, and not cherry-picked images. You need to convince them that you are capable of capturing all the elements of the day, and to do this you will at some point need to photograph a wedding from beginning to end. The way you can achieve the full wedding portfolio is first to generate a number of relevant images to show potential clients, and from this evidence encourage them to book you for a day – with no charge, but ensuring that they at least buy your prints or album. If that proves successful, then an arrangement can be made to shoot their wedding, thereby helping you create your own portfolio. This exercise only needs to be done once or twice, as it should provide you with a wealth of images to create an album or presentation slideshow.

▲ At the venue there will be many details: all you need to do is observe. An assistant to provide an extra pair of eyes is always useful. *125mm @ ƒ3.2 1/800sec*

WEBSITE

In this digital age it is vital you have a clear and striking website that is easy to navigate, and shows the best images that clearly represent your style and will attract clients. On page one be sure to display clearly your contact details; there are so many sites around today where you struggle to find a telephone number.

There is little point in designing the finest website if people cannot find it, so you will need to invest in some web optimization – a process whereby the website is pushed up the Google ranking. If you are not sure how to proceed then you should seek help from a reputable professional who will be able to take you through the process.

The first task is to develop a really innovative and catchy domain name that is easy for people to remember; keeping it short will also help prevent potential clients from mis-spelling when searching online. Always make sure the name scans well and cannot be misinterpreted in the pronunciation and that it reflects your business, as this will help the search engines find you. The problem today is that so many of the great names have been taken in either the *.co.uk* or *.com* formats so consider *.me*, *.biz*, or *.info*, for example. Once you have chosen

your domain name you will need to register it for a small fee.

You will then need web hosting that will store your website on their servers, transmitting it to the internet. The hosting service you choose must be easy to contact in the event of any problems – a site that is down is not paying its way, so a responsive hosting company is important. Test the service yourself by calling them at awkward times of the day to see if they respond, because you can be sure that a site will crash at the most inappropriate time. (Are the providers local to you or in another time zone?)

You will need a plan that fits your budget, but do not be lured into a cheaper plan as it may not provide all the capacity you need. If you intend uploading a large number of images you may well need at least 50MB of storage, which will cover you for most eventualities as you will no doubt reduce your images to mere kilobytes in size to help the client's upload times. These days with cloud storage you can acquire off-site storage starting from 100GB enabling transfer of files sizes up to 16GB. File sizes this large should not be uploaded to your website as it will bring your client's download speeds to a virtual standstill.

There are many ways to market with a website. You can choose a ready made template driven site that will meet your needs in the short term; however these sites do have limitations. Does the site provide e-commerce, enabling the sale of prints and taking bookings? Even if you have no direct need for on-line sales, the ability to place your cards on the wedding breakfast tables with a username and password will help drive people to your site. (Do not place business cards on the table; however, couples are usually more than happy to have the cards on their table that relate directly to their wedding images.)

You can always go to an independent website builder although it may cost you a small fortune; or you might opt to build one yourself – not something that should be considered by those who are faint of heart. Whether you decide to use an outside contractor or are building it yourself there are certain principles that need to be considered.

Like the domain name, keep the site simple and full of your images – after all, that is what couples will buy into. Avoid non-web colours and fonts, and ensure that Flash opens quickly. Music and sound files can drive people away – not everyone will have your taste in music. If you show them what you are about on the home page they are more likely to dig deeper if it is of interest to them. Avoid using pop-ups, as they are really annoying and will have a bearing on whether visitors stay or not.

Once the site has been completed you will need to upload it to your hosting company.

CONTRACT AND INSURANCE

Contracts

You have all the marketing in place and are ready to take your first bookings, so all you need now is the contract. You will promise to provide the couple with a set of images from their day that may also include an album, therefore a contract exists between you both. Whether you are just performing a favour for the couple as a friend or working professionally, it is vital you draw up a contract so each and every one knows their responsibilities.

A contract will help smooth out some of the problems you are likely to face, and it places everything on a sound foundation. The contract should be as specific as possible and cover everything the couple is entitled to, as well as the clauses that protect you.

The contract will require everyone to sign, and it should include all the services that are to be provided by you and what rights both you and the couple have, should the promised services not be delivered. It must also include your cancellation policy, with the cancellation fees clearly stated.

Weather and or delays outside your control must also be covered, and any additional fees that may be required, for example an extension to your time, any requirement for a pre-wedding shoot or any travel expenses outside your normal considerations. You will also detail the amount of photographic cover you are contracted to provide within the limitations of the venues.

Reference must be made to colour matching, particularly with the dress, when you will be shooting in a variety of lighting conditions, stating that you will always take reasonable steps to ensure all colours are recorded accurately.

You may like to add a clause about the copyright of the images taken – that it is always held by the originator of the work, in this case, you the photographer. There have been cases where the couple considers the copyright is vested in them as they are in the photograph, which is not the case. Your terms must clarify that you are the owner of the copyright and you are only granting them unlimited licence to use the images for their own personal use. You should also make it clear that they provide you with the right to use the images for your own promotional and advertising needs.

Copies of contracts are usually available either on line or from reputable photographic societies, and it is strongly recommended that you use their services to ensure your contract is watertight.

Insurance

You should have insurance in place should things go wrong. After all you are more than likely to have insured your equipment, so it is only a short step to take out public liability insurance and professional indemnity insurance for those unforeseen accidents and failures. We live in a litigious society where photographers, friend or professional, run the risk of being sued when things go wrong.

A CONTRACT CHECKLIST

- Include the couple's names, date and time of the wedding.
- Ensure both sign the document.
- Venue details for both wedding and reception.
- All the addresses, including where the bride is getting ready.
- The booking fee (not a deposit) which is payable upon booking.
- All the payment due dates – with the final payment prior to the wedding date.
- Your cancellation policies and fees.
- Problems with weather and/or delays.
- Requested photographs.
- The coverage you are going to provide – whether it includes the bridal preparation/ceremony/reception or first dance.

PHOTOGRAPHIC INSURANCE

Equipment
It should go without saying that you will have all your equipment insured.

Public Liability
It is extremely important to have public liability insurance, even if you are just doing a couple of weddings for friends. A claim could be made if you (or your assistant) accidentally cause damage or put any other person at risk of injury.

Professional Indemnity (PI)
Mistakes are always possible, and you should ensure that you are covered should there be a problem with the images.

Cancellation
The PI insurance will not cover you for illness and not turning up at the wedding – for that you will need a health policy, which can be quite expensive. The best advice is to encourage the couple to take out their own wedding insurance package, which will not cost them a great deal of money and will cover them for most eventualities at a wedding, including the photographer not turning up.

TERMS OF BUSINESS

It is mutually agreed that the following terms form an integral part of this contract and that no variation or modification shall be effective unless accepted by [the photographer] in writing.

Booking Fee

A booking fee is required when the client signs the contract. Dates are reserved only when the booking fee is paid. This sum will apply towards the contract fee.

Payments

The balance of the payment for the services contracted for must be paid not later than thirty days prior to the wedding. Payment for additional photographs and albums is made when these are ordered. Any bank charges incurred due to returned cheques will be debited to the client.

Cancellation

In the event of the Client cancelling a booking for wedding photography [the photographer] reserves the right to charge a cancellation fee in accordance with the following scale:

(i) £200 (the booking fee), if cancelled more than twelve months prior to the wedding date.
(ii) 35% of the agreed fee if cancelled between six and twelve months prior to the wedding date.
(iii) 50% of the agreed fee if cancelled less than six months prior to the wedding date.
(iv) 100% of the agreed fee if cancelled within thirty days of the wedding date.

Should the cancelled wedding turn out to be a postponement, then at the discretion of the [photographer], and subject to availability, monies other than the booking fee may be applied to the new wedding.

Weather and/or Delays

Weather permitting the photographs will be taken as agreed. In the event of inclement weather the photographer, in co-operation with the client will make the necessary changes to the schedule and will do his best to produce coverage of the wedding within the time allocated to him. Similarly, when delays occur due to circumstances outside his control, the photographer will stay on beyond the agreed time but will charge an additional fee for extra time involved.

Requested Photographs

The photographer will honour requests for specific photographs subject to the following: weather and time permitting; availability and the co-operation of the person(s) concerned. All such requested photographs must form part of the client's final wedding order.

Coverage

[The photographer] cannot be held responsible for the lack of coverage caused by the bride, bridegroom or other members of the wedding party not being ready on time, nor by restrictions placed on the photographer by officials of the church, register office or licensed marriage venues. The photographer does not guarantee any specific picture nor to include any specific background, location, props, or arrangement, although every effort will be made to interpret the client's wishes. The photographer is limited by the guidelines of the ceremony official or reception site management. The client agrees to accept the technical results of their imposition on the photographer. Negotiation with the officials for moderation of guidelines is the client's responsibility. The photographer will offer technical recommendations only.

Colour Matching and Sizes

Owing to photochromatic anomalies caused by a combination of certain dyes and materials, especially in man-made fibres, it is sometimes impossible to record on camera the exact colour of materials as perceived by the human eye. When processing images, the photographer will endeavour to achieve a pleasing overall colour balance based on natural flesh tones. It is understood that some colours may not remain consistent throughout a set of photographs owing to variations in lighting conditions. It is also understood that all photographic printing is undertaken within the technical limitations of the process and that colour may not be identical over the whole range within a subject. The colour balance of prints made at different times or in varying sizes may also be variable. Due to the limitations of computer monitors it is understood that images may appear differently according to the specification of each monitor and that prints will not match images rendered on any particular computer monitor. Where images are made available for use on a DVD player reasonable steps are taken to ensure compatibility, but DVD discs may not play on all DVD players, particularly older models. All print and presentation sizes quoted are approximate and subject to the discretion of the photographers.

Copyright

The copyright in all photographs created by [the photographer] shall remain the property of [the photographer] in accordance with the Copyright, Design and Patents Act 1988. The Client(s) shall have no right to reproduce, nor to authorise the reproduction of, by any means whatsoever, any photographs created by [the photographer]. This includes photocopying, scanning into computer, photographing with a film or electronic camera, including a video camera, and producing either a hard copy on paper, film, or similar medium, and also recording an electronic image on a computer hard disc, or any tape, disk or other recording medium. Nor is it permitted to transmit or allow to be transmitted such images by cable, radio waves or the internet. The Client(s) hereby acknowledges that infringement of [the photographer's] copyright is unlawful and may be a criminal offence. The photographer accepts no responsibility for the quality and colour reproduced from third party printers of images taken from Copyright free images supplied, due to variations in paper and third party printing processes and profiles.

Negatives and Electronic Images

All negatives and electronic images created by [the photographer] shall remain the property of [the photographer] who undertakes to store all such negatives safely and make them available for future reproduction. Photographic prints will become and remain the property of the Client(s). However the Client(s) specifically acknowledge that ownership of prints does not imply ownership of the copyright in the images on them, or any right to reproduce, or authorise the reproduction of, such images.

Albums

All images required for the album must be supplied to the photographic studio with three months of the date of the wedding. Failure to do so could result in increased costs for the manufacture of the album. Any such costs after three months will be passed on to the client. The photographer will supply the album and number of pages that has been ordered subject to any variations that the client may make. Any variations over and above that originally order by the client will be charged at the rate current at the time of commission, and will be included in the final account. The photographer agrees to allow 4 hours for the creation of the album with two hours travel time. Any increase on this allowance will be charged at the hourly rate in force at the time of the commission.

Model Release

The CLIENT hereby grants to the photographer the irrevocable and unrestricted right to use and publish photographs of the CLIENT or in which the CLIENT may be included, for editorial, trade, advertising and any other purpose and in any manner and medium; to alter the same without restriction; and to copyright the same. The CLIENT hereby releases the photographer and their legal representatives and assigns from all claims and liability relating to said photographs.

Chapter 3

The Bag of Tricks

The ability to take successful wedding images is more to do with you than the equipment you are using. Great equipment alone does not ensure success. You will need to walk the line between having the right amount of gear and unleashing your creativity. Weight is a consideration when creating the kit bag – too heavy and you are more than likely to just leave it in the car. A lighter one will be easier to manage, so when selecting your equipment weight is important.

It is possible to carry out a wedding assignment with just a single camera. However this is a recipe for complete and total disaster when it fails and you have no back-up plan. Given the vast variety of equipment available, you could be encouraged to take everything, adopting a just-in-case policy. While you need to be prepared for whatever the day will throw at you, you are better off with less than you imagine. You will be required to work quickly and respond to situations intuitively with the equipment you have to hand; there will generally be little opportunity to set up lights, take meter readings or change lenses.

▼ A wide-angle lens can be put to good use when you have interesting locations. Here an old pack horse bridge was put to good use with consent from the bride. *70mm @ f2.8 1/1000sec*

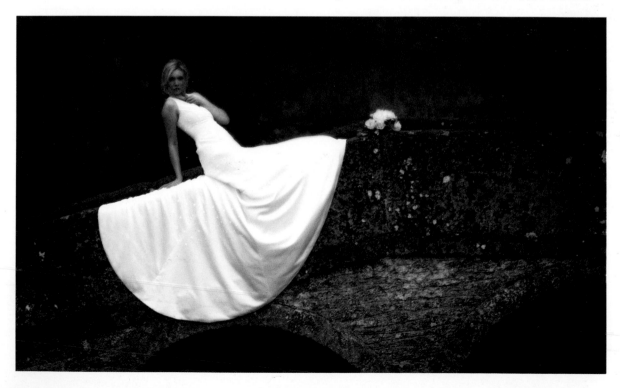

Your choice of camera is very much a personal one, providing it is up to the task with the ability to work in a range of settings – manual, aperture priority (AV) and shutter priority (TV) – with the ability to change the ISO settings, working with the available light. These days cameras are capable of extremely high ISO settings, enabling shooting in difficult lighting conditions without recourse to supplementary lighting.

CAMERA

Ideally the camera needs to be weather proofed as you could well be working in all conditions. Combine this with a good ergonomic design enabling a comfortable grip, as you will be holding it for most of the day. Neck straps work all right, but you can end up looking like a decorated tree with the camera swinging around, so consider using a hand strap if your camera will take one.

There tends to be a fixation with high pixel cameras, even in the little compacts and camera phones, so when buying a camera consider spending your equipment budget on a quality professional lens instead of higher pixel rated cameras.

You will need to be able to work with the cameras (do not forget the back-up camera) in a variety of modes – excluding automatic and programme – giving you the facility to change with the variable working conditions, accessing high or low ISO settings as desired. There are considerable advantages these days with modern cameras that enable the shooting of low ambient light shots at the ceremony without recourse to flash.

Weight is an important consideration when selecting a camera – the heavier it is, the more stable you are likely to be, and yet by the end of the day its very weight may well work against you, so find a comfortable compromise that works for you.

LENSES

The choice of lens is very much a personal one depending upon your style of shooting. With a wide range of options available on the market, the correct selection could well be a budget consideration rather than a creative one. You need to select the very best lens you can afford, in preference to investing in a top end camera body, as it is the lens that forms the image on the sensor. A high quality lens on a cheap body will more than likely produce results better than a middle of the road lens on a higher end camera body.

Short or Long Focal Length?

Focal length is an important consideration if all you can afford is a single lens. The variety of images that can be shot at a wedding is considerable. Zoom lenses these days have improved considerably so they have become a viable option and will offer the wide range of focal lengths you will need to use, whereas a prime or fixed focal length lens, while a faster and lighter option, will potentially restrict your shooting options on the day. The professional end zooms will give you a fixed aperture throughout their range, with the mid-cost range versions losing a stop of light as they zoom through their range, however they do tend to be lighter due to the smaller optics. Whichever focal length you choose, remember it is only a piece of expensive glass and will need to reflect your style – it is only as good as your own creativity in capturing the emotion and the special moments.

A good starting point is around the 24/70mm range whether you are using a full frame or cropped sensor. Cameras these days come with a variety of sensors from the top end full frame sensor (equivalent to 35mm in the days of film) to a digital crop of 1:6 to 1:3, all of which will have an impact on the effective focal length of your lens.

◀ Photographing the register once it has been filled out is illegal as it breeches data protection laws, so be careful. Invariably the register will be turned to a blank page before the photography. *15mm @ ƒ2.8 1/50sec*

The candid shots will more than likely be taken with a zoom, whereas the shorter focal lengths (17/40mm) will capture more of the surroundings and place the subject in context with the venue or location. With so much going on at a wedding, capturing the atmosphere and reactions is vital, especially if you are shooting in a photojournalistic style; the wide-angle lens brings in the energy and reveals the story.

Wide lenses will undoubtedly cause some peripheral distortion, especially of people, and prevent the image from popping out at you, as they have a much greater depth of field. This makes it more difficult to isolate the subject as can be achieved with a zoom lens. Shooting wide requires you to get in close and engage with the subject, perhaps causing a response as well as disrupting the moment, particularly if the couple are at all nervous in front of the camera.

Long lenses will enable you to isolate the subject from the background, creating depth to the image, with the inherent risk of isolating the subject to the point where there is a chance of disconnecting them from the story. Whilst it is nice to get in close, overuse will create a more sterile feel to the images by not placing them in context with the action. Shooting long can create a sort of tunnel vision, preventing you from visualizing the complete picture, missing out on those moments that illustrate and capture the day.

WHAT'S IN THE KIT BAG?

- Camera bag.
- Camera, plus back-up camera.
- Lenses, wide-angle angle and zoom.
- Flash gun and flash bracket, plus flash back-up.
- Flash triggers and receiver.
- Light modifiers, umbrella.
- Batteries for camera and flash.
- Storage media (CF cards).
- Light stand for camera flash
- Lens cleaning cloth.
- Water.

▲ The use of a stand alone flash, with either a soft box or shoot through umbrella, is required to produce soft light for the bridal creative. Balancing the light through the stain glass window is sometimes difficult and may require bracketing the exposure. *22mm @ f3.5 1/50sec*

LIGHTING

Flash

The first question is why do you need a flashgun? After all with the high ISO capabilities of the cameras and the considerable improvement in the image sensors, working with the available light has become a great deal easier and in so doing helps to minimize the effect of the flash on the subject. It is all about using the flash to either complement or help balance the ambient light or just using it for the creative effect.

A large number of wedding photographers will be seen using on-camera flash, the worst place it could possibly be, firing light straight into the couple in the belief that they are filling in the light, where in fact all they are doing is adding to it. The ability to either bounce your flash or just take it away from the lens axis will go a long way to help improve your photographs. That is why a flash bracket is an essential piece of equipment, enabling the specific positioning of the flash, used in conjunction with an appropriate trigger. In so doing you will add another dimension to your images and at the same time produce photographs that no one else at the wedding will be able to create with their compact cameras.

Many photographers will tell you that working with the ambient light is critical to your overall results, which is true. So what happens when the available lighting is not working for you, producing harsh shadows or just so low that it is virtually unusable, is that you may reach for the flashgun. Flashguns that are compatible with the camera will provide full through-the-lens capability, reading, measuring, adjusting and balancing with the ambient light and taking control of the exposure. Whilst this is of great advantage when working quickly and intuitively, there will be the time when it just does not work for you and either flash compensation or full manual control is desired. Modern flashguns these days will have a digital manual functionality enabling you to take full control over the situation. When you have the option to take the flashgun away from the camera without the option of a command unit on the camera then any make or mid range flashgun will work, providing you have full manual control and are able to fire it with a trigger.

Some photographers may well prefer to use continuous light sources, much like videographers, being able to see directly the light on the subject.

Triggers

There is a wealth of triggers available on the market that will fire a flashgun. However the preferred option would be a radio or wireless transmitter/receiver that will fire a flash when it is not line of site, that is, not visible to the camera or trigger. There are infrared triggers available as well as slave triggered flashguns (triggered by a flash) that will only work when they can see each other or the ambient light has not quenched the flash, and it could well be that you want to place the flash unit behind the subject, tree, column or obstruction to produce the desired result.

One of the inherent problems with camera flash units is their output, generally around 60/70Ws, which makes them problematic when working outside in very bright strong sunlight. When you need to either balance or control a high level of ambient light, say around ƒ22, then these modest flashguns could well struggle to balance or control the available light. You could of course combine them to increase the overall output, or alternatively invest in a portable battery-powered studio flash unit that will be able to achieve an output in excess of 400Ws, which will be able to work comfortably at the higher end.

▲ Young children usually require a soft diffused light; bounced flash works in this case. *70mm @ ƒ4.5 1/60sec*

LIGHT MODIFIERS

--

Modifiers are very important items in the wedding photographer's armoury, as they enable the modification and control of the available and artificial lighting either encountered or used during the day.

There are many options available including umbrellas (shoot-through and reflector types), soft boxes, reflectors, honeycombs/grids and scrims.

▶ Directional light can produce a different feel to the image. In this shot it is the attitude pose that supports the harder edgy light. *70mm @ ƒ4 1/60sec*

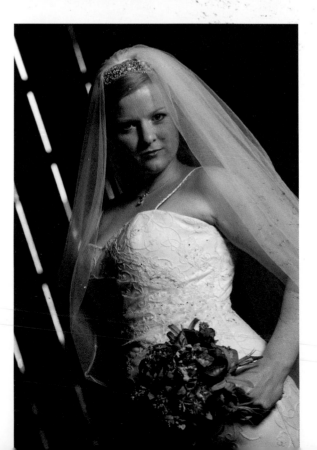

▲ The soft box has an internal diffuser as well as an external to help produce a softer feel to the light. However, it is the size of the light source relative to the subject that produces the softness.

▲ A shoot through umbrella is an invaluable asset on a wedding shoot, being light and easily transported. Some people, however, do not like the umbrella shaped reflection it can produce in the eye.

▲ A reflector can never overpower the light it is reflecting and, unlike with flash, you can see the result. If using the silver side on a bright sunny day, be careful as it can cause damage to eyes and hurt when directed at someone, so always warn them first.

Umbrellas are a low cost option to enlarge the light source from the flashgun or continuous light source. They are available in a variety of sizes. The shoot-through umbrellas (firing the light through the umbrella) will enlarge, thereby soften the light, producing softer shadows depending upon the light's distance from the subject. Bear in mind that the umbrellas have the ability to make great kites in high winds so you need either a weight bag to stabilize the stand or a VALS (voice activated light stand/assistant – that is, a person) to hold the unit.

Soft boxes are available in a huge range of options from square, rectangular and octagonal, with a range of sizes within each shape, but remember that the shape of soft box will be reflected in the subject's eyes. Soft boxes are more sophisticated than shoot through umbrellas and are designed to both soften and direct the light, utilizing internal scrims and diffusers in a variety of combinations to achieve the desired result.

There are many types and makes of soft boxes on the market ranging from the smaller units that are designed to fit onto a camera flashgun through to the full studio option that will connect to the portable battery powered studio lighting equipment.

Another low cost modifier is the simple reflector that is available in many formats, from triangular, round, square to rectangular, as well as a variety of sizes to suit the camera bag. The distinct advantage of the reflector – silver, white or gold, even a zebra finish, a combination of silver and gold in a chevron pattern – is their ease of use, lightness and convenience. Despite their ease of use there are still rules that govern their operation, and an understanding of light direction, quality and intensity would be helpful.

Honeycombs and grids, as they are sometimes called, will provide a directional light that creates vignettes, helping to focus attention on the subject. As the name suggests the honeycomb is a series of honeycomb shaped grids that are organized in a tight pattern to direct the light. The effect created

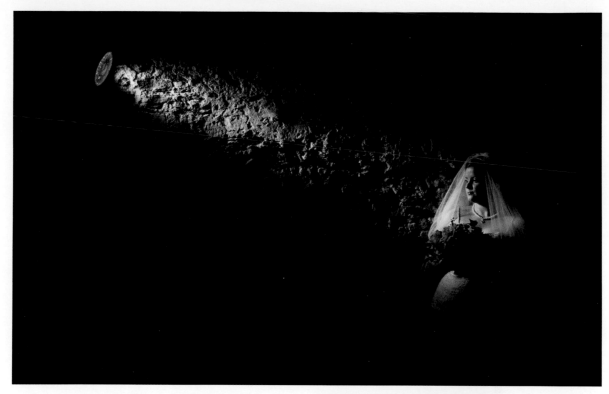

▲ A honeycomb, sometimes called a grid, will produce a narrow cone of light, the angle depending upon the size and type used, with the light falling away producing a softer edge than a snoot does. *27mm @ f8 1/125sec*

▲ Honeycombs come in a variety of sizes and depths producing a different 'shape' to the light.

by these modifiers is dependent upon the thickness and size of the honeycomb pattern.

Scrims are fundamentally diffusers that can be held in front of the artificial light source or used to modify the direct sunlight. Very often there is no shade available at a wedding venue and so the introduction of a scrim between the subject and sun can provide a softer, more diffused light. These diffusers are available in a range of stops – they will reduce the light by ⅓ or ⅔ f stops; used relatively close they will bathe the subject in a softer light with softer shadows. These scrims are generally only suitable for couples and, due to their size, will not work for large groups.

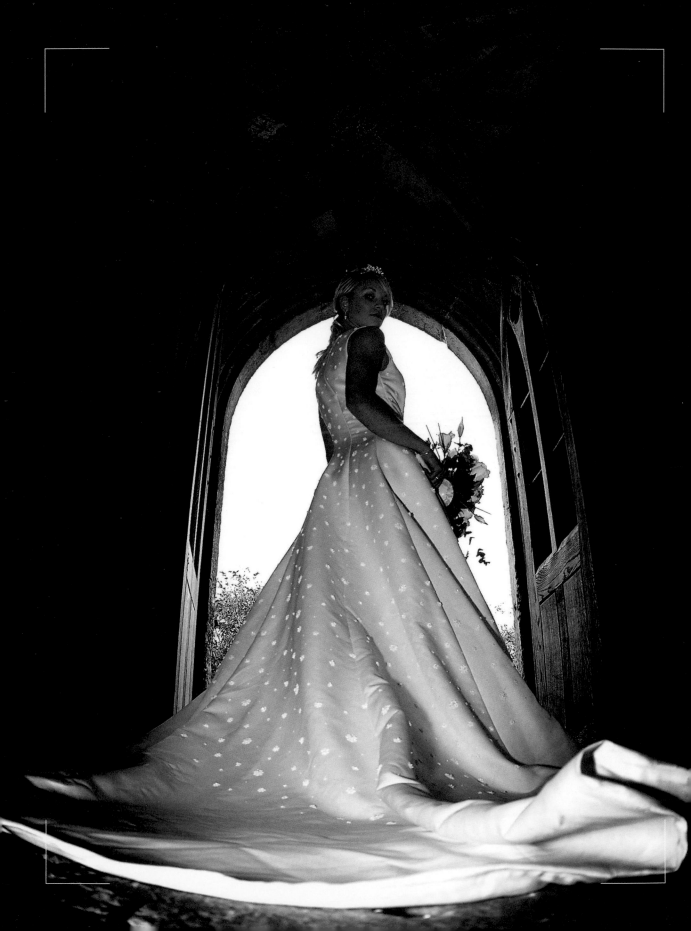

Chapter 4

Working and Shaping the Light

ight is a type of energy represented in the visible spectrum. As photographers our prime concern is with its colour, brightness and contrast. The colour of the light originates from its position in the visible spectrum; the brightness – the single most important quality – comes from the intensity of the light, and the contrast is generated by the size of the light source.

The colour of the light is a crucial consideration for wedding photographers, as working throughout the wedding period you will encounter a wide range of light with different colour temperatures ranging from tungsten light at the warm end of the spectrum to daylight at the cooler end. As your eyes adapt readily to the changing lighting conditions it is difficult to perceive the different colour of the light, whereas the camera will record what it sees and will need your intervention to make the required adjustments in camera before shooting – unless shooting in RAW format (see below), which enables you to make shot adjustments on the computer later.

One of the problems often encountered by photographers is the 'mixing' of light when using flash units. Most flash heads are balanced to midday sunlight at 5500 degrees Kelvin, and yet you may be shooting in a tungsten-lit environment at 2500°K, creating an imbalance, with the flash looking decidedly blue and the tungsten lit element look-ing yellow. This imbalance can be controlled when using flash by placing a warming gel CTO (colour temperature orange) over the flash; this will change the colour of the flash to that of the tungsten light-ing. The degree of CTO required will depend upon the saturation of the tungsten light and it may well require several gels to achieve the desired result.

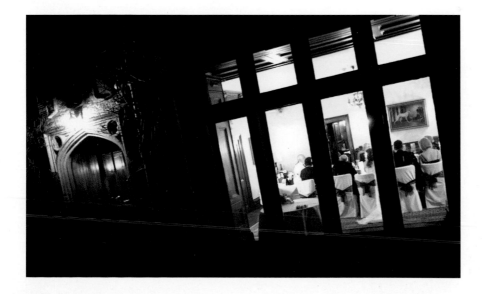

◄ When shooting tungsten, you may need to change the colour balance on the camera to either tungsten or set a Kelvin colour temperature that matches the colour of the light. *24mm @ f2.8 1/6sec*

CAMERA FUNCTIONS

At a wedding you are likely to use a number of the camera settings either on the exposure mode dial or the LCD screen, depending upon the visual impact you want the image to have, rather than shooting the complete wedding on P (programme).

Programme (P)
The P option will allow you to take photographs in an automatic mode (not to be confused with the automatic function available on some cameras), still allowing you to change the settings as a linked group.

Aperture Priority/Aperture Value (AV)
You will be able to lock the aperture you want and let the camera select the appropriate shutter speed; useful if you want a very shallow depth of field, pulling the subject out from the background.

Shutter Priority/Time Value (TV)
Here you can set the shutter speed and allow the camera to choose the appropriate aperture; used when the subject has movement and you want to freeze the action, such as guests arriving or the confetti throw.

Manual (M)
This will allow you set the shutter speed and aperture independently; provides full and complete control.

Drive
This will allow you to set either single shot, locking focus when you half depress the shutter (not advisable when shooting moving or action unless you fire the shutter without any delay) or servo or A1 servo, where the focus will track the subject.

▲ Camera settings on top of the camera will enable you to select the function you require; here the camera is set to a manual setting.

ISO (International Standards Organization)
In the days before digital you needed to buy a roll of film to suit the lighting conditions, so if you were shooting in low light then you would go for something between 400 and 1600 ASA and in brighter conditions between 50 and 400. The ISO setting on your camera does just that, so in brighter conditions you would set around 200 ISO and 800+ for low light conditions. These days, modern cameras are able to achieve ISO settings in the region of 6400 without any apparent indication of noise (this is what was called grain in the days of film). The latest generation of digital cameras can now achieve ISO sensitivity up to 25600, expandable to 102400. So working in low light conditions has become a whole lot easier to manage.

White Balance
While it is possible to shoot a complete wedding on AWB (auto white balance) where the camera makes its own decision about the colour temperature of the scene, there are now a number of other settings that the photographer can set, given the lighting conditions, for example Tungsten for some room-lit subjects, Flash when using predominantly camera flash or Cloudy on such days that are cloudy.

COLOUR TEMPERATURE

Most modern DSLR (digital single lens reflex) cameras will allow you to set the colour shooting parameters in the menu functions, for a specific dialled-in colour temperature.

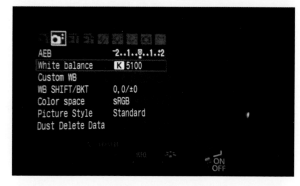

▲ Setting colour temperature at 5100 Kelvin in the camera's menu on a Canon.

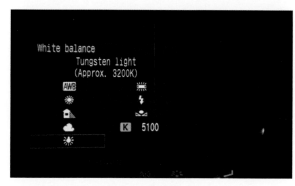

▲ Setting tungsten white balance in the camera's menu.

COLOUR TEMPERATURE

1000–1500°K	Candlelight
1500–2500°K	Tungsten light
2500–4000°K	Early sunrise
5500–6500°K	Daylight and electronic flash
7000°K	Overcast sky
10,000°K	North light (blue sky)

Measured in degrees Kelvin, colour temperature for photographers ranges from tungsten at 2500°K to midday sunlight at 5600°K up to early morning and late evening just before sunset to 6500°K.

SHOOTING IN RAW

RAW is a shooting format that retains all the shot data that can be accessed and adjusted on the computer. The default setting for digital cameras is to capture images in a compressed format, known as JPEG (Joint Photographic Experts Group) which is a lossy compression format (that is, it compresses data by discarding (losing) some of it). These uncompressed files will take up significantly more space on your storage media but the upside is a far higher quality than produced by the JPEG format.

The advantage of shooting in the RAW image file format is that the exposure and colour temperature settings are not applied to the image and it is saved in an uncompressed format. The practical application here is the opportunity to adjust those settings, not applied at the time of shooting, back in the studio on the computer.

To summarize the important differences:
- RAW files are much larger than JPEGS.
- RAW files may require more post-production.
- RAW files will take longer to write to the storage media.
- RAW files cannot be given to others unless they have the relevant software to convert them.
- RAW files will require a more powerful computer to process.

RAW Image Formats

One downside to RAW capture is that there is no standard format and every manufacturer will have a different format.

Adobe	DNG (Digital Negative)
Canon	CR2, CRW (CR2 is based in the TIFF file format and CRW is based on the Camera image format)
Nikon	NEF
Fuji	RAF
Kodak	DCR
Minolta	MRW (Minolta RAW image file format)
Olympus	ORF (Olympus RAW image format)

◄ Most modern Digital SLR cameras will have the ability to change the colour temperature more accurately than just setting tungsten, etc.

BRIGHTNESS AND CONTRAST

As a photographer you need a level of brightness that will enable you to take a correctly exposed image; however you will want to avoid cloudless hard direct sunlight. The brightness of sunlight will change throughout the day, rising during the day and peaking at around midday, then falling away through to the evening. The quality of the light will also vary from cloudless days to heavily overcast conditions.

In very bright conditions you may be driven to shoot at very small apertures, increasing the depth of field and not creating the visual effect you were looking for. These conditions will call for either using a scrim modifier, to reduce the brightness, or moving the subject to the shade where you should have greater control over the lighting.

Light will be said to have high contrast if the light rays hit the subject more or less at the same angle, characterized by the hard, deep shadows on a bright sunny day. Low contrast is delivered on an overcast day where the light is transmitted in all directions, striking the subject at all angles and resulting in softer and less intense shadows.

High contrast lighting is a hard light, whereas low contrast lighting is softer. A simple rule to remember is the smaller the light source, relative to the subject, the harder the light will be; and the larger the light source, the softer the light will be. That is why a small flash gun produces a very hard light with deep shadows when used unmodified, whereas a flashgun fired through an umbrella or soft box will produce a much softer, lower contrast light.

▲ High contrast light can produce an edgy shot that works for any male subject. Here the groom is lit with a single flash from the left, with a honeycomb attached, producing the fall off in light around the subject. *70mm @ f8 1/250sec*

FLASH SYNCHRONIZATION

Why is flash synchronization important with digital cameras that have a focal plane shutter? Some digital cameras will use an electronic shutter by switching the sensor on and off instead of an FP shutter. The mechanical focal plane shutter has a limit to the speed it can travel, which is considerably slower than that of the flash duration. When the shutter release button is fired the first shutter blind will start its traverse across the sensor, exposing the sensor fully before the second curtain starts its travel. As the shutter speed gets faster the second curtain will start its traverse sooner, producing a slit that travels across the sensor, and resulting in a shorter exposure time otherwise impossible due to the limitations of the mechanical shutter.

▲ Exceeding the camera's flash sync speed will produce a black band either on the side or bottom of the image, depending upon which way the shutter blinds travel. *60mm @ f3.5 1/320sec*

Everything will be all right up to the flash synchronization speed, where the shutter will traverse the sensor, fully exposing it when the flash fires. However, when the shutter speed exceeds the flash synchronization speed – in other words at the point when the slit traverses the sensor with the flash firing at the beginning of the process when the sensor has only been partially exposed – the result is the characteristic dark band on the image when the flash is the predominant light source. What is happening is the flash will fire normally around 1/1000sec, considerably shorter than the exposure time, usually at the beginning of the exposure (front curtain sync) hence the correctly exposed element of the image is at the start of the exposure and no flash recorded during the later phase of the exposure.

Usually when shooting in AV (aperture priority) the camera will cap the shutter speed to the camera's flash sync speed, and that can be a problem when working in ambient light that requires a faster shutter speed than the flash sync speed. There is a partial answer – high-speed sync – if your camera and flash support it.

High Speed Sync

High speed sync is sometimes called focal plane flash, FP flash or FP mode, but the principle is the same for all. Once high-speed sync has been selected on the camera or flashgun, and you are using a shutter speed that exceeds the flash synchronization speed of the camera, the flash will fire multiple, extremely fast, pulses of light as the shutter travels across the sensor. You can now select a shutter speed in excess of the flash sync speed, provided you understand that there is a potential problem with the process. As multiple flashes are fired the effective flash power will be reduced through subsequent discharges and the flash will not provide an even exposure across the sensor.

Not every camera/flash combination will support this facility, and there are some cameras that combine an electronic with a mechanical shutter that can exceed the flash synchronization speed.

Slow Speed Synchronization

There are huge creative opportunities in selecting a very slow shutter speed and firing the flash during the exposure (sometimes referred to as dragging the shutter). With fast moving subjects, using the second curtain sync function you will be able to produce great energy with the short shutter duration capturing the movement and the flash freezing the subject at the end of the exposure.

ON-CAMERA FLASH

Most people will have a flashgun that either fits on the hot shoe or is a simple pop-up flash on the camera. However on-camera flash is considered to be the worst possible place for the flash, producing direct hard light straight at the subject with no flattering attributes. (This is particularly the case with pop-up flash, which is not considered suitable for wedding photography.) This is unfortunately how a number of wedding photographers work with their flashguns, unsure how to control it, blasting the subject with light that has a lifespan of milliseconds, far too short for you to visualize or interpret the contrast range or where the shadows will fall. Many photographers may well add a small translucent light modifier to the flash in the mistaken belief that it is softening the light. One of the characteristics of light is that its softness is a factor of the size of the light source relative to the subject, and adding the small translucent modifier does not significantly change the size of the light and therefore not its softness.

In circumstances where you are compelled to use the on-camera flash then you will need to tame the beast and befriend it to the point where you understand all its idiosyncrasies. When the flash is on-camera letting the camera and flash take control, detecting light levels too low for an accurate ambient exposure, the flash will flood the couple or subject with a direct full frontal light, producing either a rather satanic looking red eye or a hard dark shadow behind if shot against a white wall, with radical light falloff, producing an overlit subject and a very dark background.

Red eye is a common problem frequently associated with small compact cameras. The creation of red eye in the subject's photograph is a consequence of having the flash too close to the lens axis and the flash bouncing straight back from the retina of the eye. One solution is to bounce the flash with care, watching out for colour shifts from the surface

▲ On camera direct flash lighting is both flat and unflattering and should be avoided at all times. *55mm @ ƒ4.5 1/500sec*

you are bouncing off. Expanding upon the problem of light falloff, this is a consequence of the dear old inverse square law that states that intensity is inversely proportional to the square of the distance. In practical terms this means double the distance of the light from the subject you will lose two stops of light. This will manifest itself in a rapid falloff of the light behind the subject, for example ƒ8 on the subject and ƒ16 on the background, if the background is double the distance away from the light source as the subject.

Be aware that there is the risk when shooting everything with the flash on the camera that you will create sameness to the images with the light emanating from the same position every time it is fired, making for potentially very boring pictures.

▲ 0 flash compensation ▲ +1 flash compensation ▲ +1.5 flash compensation

▲ This set of images demonstrates the use of flash compensation settings that can be controlled either from the camera or on the flashgun itself.

Flash Compensation

Fully automatic functions are fine until it all goes wrong and you need to take control of the situation. This is where the ability to use the flash compensation is useful, adjusting and controlling the output of the flashgun, balancing it with the available light.

There are four ways you can control your flash. Firstly you can change your aperture; however this will also affect the ambient light, which is not great when you are looking for independent control. Secondly you can adjust your distance from the subject, which will also reduce its size relative to the subject and require a great deal more power to provide the same exposure. Thirdly you can use the diffusers, if you do not mind walking around with large appendages. Finally you can adjust the duration of the flash pulse through the flash compensation function.

Where you have taken an ambient reading and are happy with the direction and quality of the light,

all you may need to do is pop a very small amount of light just to fill the shadows and maybe place a small catch-light in the eye. To do this you will need to adjust the flash compensation either on the camera or directly on the flashgun, reducing the output of the flash and thereby not adding significantly to the light on the subject. With modern cameras and dedicated flashguns you will be able to take control and either reduce or increase the flash output by up to three stops either way.

You will encounter many situations where a refined flash compensation control may be required. Consider what happens when you want to shoot indoors due to bad weather for example, and there is a large window or door behind the subject with ambient sunlight flooding through that needs balancing. You could just set everything onto Auto and hope for the best; however if the subject looks flashy (in other words, overlit) then recourse to the Flash Compensation button could well be required.

PRACTICE SHOTS

Here is an exercise to give you practice using flash compensation.

Start by composing an image, preferably with some sky in the picture.

Setting your camera to manual mode, take a meter reading of the ambient light flooding through the window, with your shutter speed set to 1/60sec; this can be taken either with a light meter or your in-camera light meter. So let's assume you have a background ambient light that reads f8, taking care that with the in-camera reading you will be taking a reflected light reading, where you could easily be taking an incident light reading with a hand-held light meter.

Place your subject in front of the window and, with the flash turned off, take a photograph in manual mode at 1/60sec with an appropriate ISO setting, and the aperture set to the correct meter reading for the background. The resulting shot should be a background that is correctly exposed (subject to overall contrast range) and the subject is in silhouette. If the background exposure is not quite as you would like, then just change the aperture until you have achieved your desired result.

Now switch on your flashgun, working with ETTL (evaluative through the lens) or ETTL II (both used on Canon EOS systems). Set the flash compensation, either on the camera or on the back of the flashgun, in the middle or neutral position. Take a photograph of the subject without changing your subject-to-flash distance. The result you should have is the subject lit by the flash with the background correctly exposed.

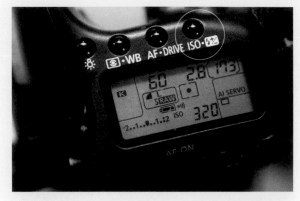

▲ ISO/flash compensation button.

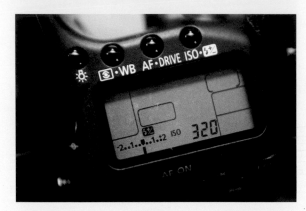

▲ Flash compensation set to neutral.

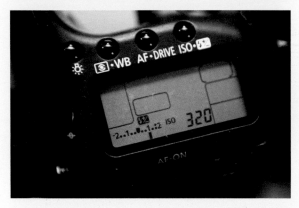

▲ Flash compensation set to +1 stop.

▲ With some cameras the flash compensation button is on the camera body, but may be in the menu system on others.

Finding the Balance

It may be that the flash on the subject is either insufficient or too hot, and needs adjusting to achieve an acceptable balance with the background ambient. Change the flash compensation to either +1 or –1, depending upon the desired result (+1 will add one extra stop of light, whereas –1 will reduce the flash output by one stop).

Take another photograph. Continue to adjust the flash compensation, usually in ⅓ stop increments until you have the desired result.

Shutter Speed

Once you have a balanced shot, start playing around with the shutter speed. Firstly increase it to your maximum flash synchronization speed, usually around 1/200sec, and look at the results.

If you have changed nothing else, including your position from the subject, then what you should find is the ambient light has been reduced by about 1½ stops, pulling back the sky that may well have burnt out.

Finally try a shot with a much slower shutter speed of around ¼ second. Stand as still as you are able, holding the camera steady (do not use a tripod) and take another image, ensuring you have virtually no ambient light recording on the subject as this may well record at the slower shutter speed. What you should find is that the background ambient has blown out – in other words it is considerably overexposed and maybe a small amount of the ambient inside may well have recorded. It's all about balance. While there will be loss of detail around the peripheral elements of the subject, what you have created is a pseudo high key image. When you get the balance right between the flash, ambient and shutter speed you will be able to produce very acceptable results.

Why is it that when shooting at very slow shutter speeds, with flash, there is distinct sharpness in the centre of the image, providing you have held the camera steady? The answer is because the flash duration is measured in milliseconds and it is the flash that is exposing the subject, providing the internal ambient is not so high that it is having an impact. You may not produce award winning images with this technique used at the extremes; however, once mastered, you will be able to produce stunning photographs for the client.

This technique can be adapted and used throughout the day, balancing your flash with the available light, especially if the ceremony is in low light conditions where flash is acceptable to use.

FILL-IN FLASH

When the available light is producing very high contrast images you may think a clear solution is to add additional light into some of the shadow area, thereby reducing the contrast range. However, this needs to be done with great care if using the flash on-camera and is not the ideal solution.

When adding fill light you will need to make sure it is as soft as possible and with sufficient intensity to do the job. To do this properly a small flash unit is not what is needed. You will require as large a light source as possible (remember, the larger the light source to the subject the softer it will be). A flash fired through a shoot-through umbrella of about 1m in diameter should be sufficient to soften the light to a more than acceptable level.

When adding the fill light you ideally need the flash to be about one stop less than the main light. With modern cameras and dedicated flash guns they will work out the levels, firing a pre-flash and exposing automatically, generally with acceptable results.

There will be times when the camera and flash, despite conversing with each other, just do not get the balance right. In this case you need to take control and manually balance the amount of fill required. This is where flash compensation can help deliver the right results.

Many flashguns these days are dedicated to your camera, meaning that they have been designed to communicate with the camera, knowing automatically what ISO setting is being used, the aperture, shutter speed and subject distance from the camera being used, firing a pre-flash and measuring the amount of flash that is required for the given settings and ambient light. With the increasing sophistication of modern cameras this function can work extremely well.

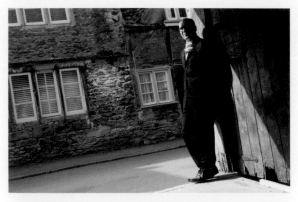

▲ No fill flash.

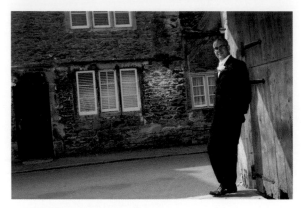

▲ Fill flash balanced with the ambient.

▲ With back lit subjects it is important to get the fill flash balance right as it is all too easy to over light the subject. Control of the flash compensation function will ensure you get perfect results almost every time.

WORKING WITH
FLASH LIGHT METERS

The question is often asked, do you need a light meter these days? The answer is probably not, given the technology behind the latest generation of cameras where it is all done for you, unlike in the days of film where every shot counted. If you are happy working that way, relying upon the camera to do all the thinking for you, or you just work intuitively, then please skip this section.

However, if like me, when shooting with off-camera flash you ultimately find it quicker to read the light with a meter that is not dedicated to the

camera (a little like working in the studio but with the added complication of the available light to calculate) then the skills in using a meter can be an advantage. Flash light meters have the advantage of being able to take both reflected and incident light readings

When starting out in photography, one of the biggest single issues can be the interpretation of the available light and how to balance it with the off-camera flash. To do this a light meter can be an asset, saving time instead of the shear experimentation on the day, with multiple exposures until you get it right.

When buying a light meter, all you will need from it is to be able to read the ambient and the flash independently – nothing more, nothing less. That means a relatively low-cost unit is all you need.

Incident light readings

A light meter will enable you to take an incident light reading, unlike the in-camera metering that reads the reflected light. With an incident reading you will be taking a reading of the light falling on the subject by pointing the meter towards the camera with the diffuser dome covering the sensor.

Reflected light readings

The problem with reflected light readings is the difficulty of evaluating the tonal range of the subject with dense blacks and bright white, of which a particular example is a bridal couple with a white wedding dress and the groom with a black suit. When taking reflected readings uncover the translucent dome and point the meter towards the subject, and you will notice that the reading changes depending upon the tonal range of the subject, as dark subjects will absorb more light and lighter ones less.

To evaluate reflected readings it helps if you are able to assess the correct exposure using the Ansel Adams zone system, where each level of brightness is attributed with a zone rating, ranging from white to black. You will need to aim for a reading knowing

TAKING A LIGHT METER READING

Ambient readings
- First set the ISO setting.
- Select the reading mode – Ambient or Flash.
- Select the desired shutter speed.
- Hold the meter towards the camera with the dome over the sensor (incident).
- Press the button to take the reading and read off the aperture.
- Set these readings on the camera.

Flash readings
- Set the mode to the flash symbol.
- Follow the same procedure as for the ambient reading and press the flash trigger.
- The flash meter will record the flash exposure.
- Now adjust the flash to produce the desired result, by either 1 stop over for the flash as a main light or 1 stop under for a fill.
- Now fine-tune the flash until you achieve the lighting you want.

◀ A somewhat underused piece of equipment is the light meter. Some say it is not necessary with modern cameras; however, it can ensure perfect lighting balance at all times when using off-camera flash.

that it will produce a mid grey, usually referred to as 18 per cent grey.

Despite being extremely sophisticated, a fundamental flaw with in-camera metering is that it can only take a reflected light reading, so a clear understanding of its limitations is important. Camera meters are calibrated to standardize on 18 per cent grey so if the camera meter is directed at any subject lighter or darker than mid grey it will either under or over expose.

Camera metering

Different camera makes will vary in the matrix adopted for metering, with centre-weighted, partial and spot being the most common.

Centre-weighted metering copes reasonably well with a bright sky and a darker landscape; however

these days evaluative and matrix is a more common metering mode, controlled by the camera's electronics with complex algorithms.

Partial and spot modes, where the ambient light is really working for you but difficult to balance, will enable you to unlock your creativity. While working with backlit subjects, taking a reading from the face or group will help in preventing the subject from becoming underexposed due to the bright background illumination. Spot metering however needs to be conducted with care – when metering from a white wedding dress, the dress will have its own highlights and shadows, and taking a reading from either will run the risk of over or underexposing the dress.

Cameras these days have the facility to turn on what is called highlight alert, producing a flashing warning or 'blinkie' in the LCD screen when any element of the image has been blown out, in other words overexposed. Again this needs some judgment, as it may well be that the part of the image showing signs of overexposure is in fact white anyway. Control for both under and overexposed elements by adjusting it using the exposure compensation function. Highlight alert, while distracting at first, should become your friend, especially at a wedding with the high contrast range between the dress and the groom's suit.

TRIGGERS

Now it is time to move away from the comfort zone where almost everything is done for us by the camera and flash on-camera. Taking the flash away from the camera will open up a realm of possibilities. The first problem when working with the flash independently is how do you trigger it and what has happened to the ETTL function?

Using a PC sync cable has been a tried and tested method of firing a remote flash or camera and provides an element of reliability. However it limits you

▶ One of many flash radio triggers available on the market.

▼ This is a flash plus receiver configuration that works well. However, there are many other options available.

to the length of the cable, and of greater importance creates the undesirable situation of cables all around. Also cables have been known to break. Some of the more modern flashguns do not have a flash sync socket and so will not support a cable connection.

Proprietary infrared triggers and sensors use an invisible beam of light transmitted from your hot shoe to the flash; indeed some flashes can be fired with a visible flash pulse. One inherent problem with this form of triggering is that it usually requires line of sight, unless you are in a location that can bounce the signal around until it reaches the recipient flashgun. If your flash is in another room or hidden from the trigger there is every chance that it will not fire. Some infrared triggers mounted on the camera hot shoe will be able to talk to the flash unit and support ETTL and offer the ability to use the flash compensation.

These days more people are using radio triggers to fire their flashguns. Once the domain of the professional, these days inexpensive units have brought them into the financial reach of most people. With the trigger connected to the hot shoe, a radio signal is transmitted to the receiver connected to the flash,

either with a proprietary hot shoe or a PC sync cable with a PC sync connector on one end and a 3.5mm jack on the other that connects into the radio receiver. Some of the higher end cameras these days are being supplied with a built-in transmitter which talks to the dedicated flashgun.

There has been a trend towards the purchase of secondhand or low cost flashguns that support a PC sync socket and firing them with a radio triggering system. With these bespoke systems there is no ETTL; however, when you have an understanding of how light works and can either take meter readings or work intuitively, then working without ETTL is no longer a problem. Releasing yourself from the confines of the automatic functions will help elevate your photography to a completely new level of creativity.

USING OFF-CAMERA FLASH

So now that you have the ability to fire your flash remotely you can start imagining new shots, and will be able to deliver well-exposed and stunning images to the client. Taking the flash away from the lens axis will open up considerably more opportunities, and working with the ambient will help you take full control over the light.

There are many pieces of equipment that will support a flash unit, either on a light stand or just held in the hand. In all cases is it easy to add light modifiers to achieve your desired result.

When working with independent light units you will need to be able to assess the ambient, which may not be a constant and will change all the time throughout the day. The use of a light meter can be useful; however, getting a feeling for the light will help considerably to speed up your workflow on the day. Standalone lighting units would normally only be used at specific times of the day where you

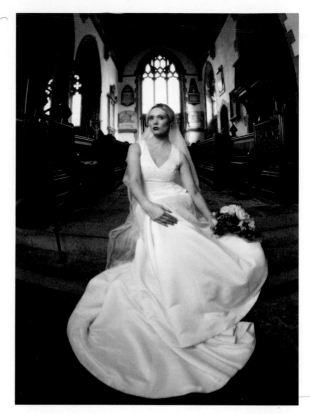

▲ Using a stand-alone flash and a shoot through umbrella you will be able to balance even in the lowest of lighting conditions, as here in the church. *15mm @ ƒ4 1/100sec*

will shoot the signature shots of the ceremony or when you take the couple around the venue for their specific 'must get' shots.

Out on location your first port of call is to assess the available light; this is your starting point, deciding upon an appropriate ISO setting for the given level of light. The ISO setting will depend considerably on your location; you may be fortunate enough to have a constant light throughout the year, but whatever your situation the principles remain the same.

First ask yourself if the ambient light is working for you. If not, how can you improve it? Are the shadows dark? Is the contrast range outside the capabilities of your camera to record without clipping (a losing either highlight or shadow detail)? Are you getting the right creative feel to the image? What direction is the light coming from, and can you move the subject to help improve the situation?

The biggest single reason for using off-camera flash is the creativity that it provides. You are no longer confined to the camera position and you will be able to produce structure to the light, working with the shadows, creating depth and interest in your images.

WORKING WITH AMBIENT

Working with available light provides a liberation and freedom to shoot without the consideration of balancing with flash. What's more it is free, with no flash guns or stands, umbrellas or soft boxes to purchase. On the down side that leaves you working with the light as it occurs. (The usual advice for using ambient light is not to shoot around midday, but the obvious problem is that weddings are often conducted around this time.)

The first thing to do is look at the angles where the ambient is casting the shadows, not only for the shade but also shadows on the couple or groups. In some cases the only option is to position yourself to shoot with the couple backlit and expose for the shadows, letting the background go. This can produce a very dramatic 'through the veil' shot.

As the photographer, you will need to either find the shade, if there is any, or work around the problem with the equipment you have available – and not everyone will have the latest generation equipment. There is however a way around the problem which will enable you to modify and control the adverse conditions.

Your first objective is to find the shade, whether it is a tree, building, portico or a large scrim. If you have a tree to work with, first make sure there is no adverse colour cast from the foliage. Find the transition edge, the point where the shadow finishes and the sunlight starts. Place your subject(s) on this edge, backlighting them so that their face is in the

shade, and use either a reflector or off-camera flash offset from the camera position to add light to them, balancing the added light with the background ambient, working within about 1 to 1½ stops of the background ambient. This is where the exercise earlier will help, as the process is the same, taking a reading from the background light and working around that reading for your flash.

Working in bright conditions is challenging in that you will more than likely be working with smaller apertures. One of the problems this attracts is that the background will be relatively sharp causing a distraction from the subject, as using larger apertures will make your subject pop out from the background. This is a case where a faster shutter speed would help, enabling you to open up the aperture, reducing the depth of field to the point where the background no longer competes with the subject. Using a reflector will also eliminate the problem associated with high-speed synchronization.

If it is possible to leave a number of the 'must get' shots or signature shots until later in the day, when the light will either be lower in the sky, producing a softer more delicate and sculptured lighting, or the day has become overcast, then consider it as an option and adjust your day's planning to suit. If the day has become overcast you may then need to add a main light to prevent the image from becoming flat, adding those catch lights that make the eyes sparkle and jump out at you by using off-camera flash with an umbrella or soft box. When the sky is flat and uninteresting then crop the image to reduce the amount of sky in the shot, unless of course you want it for creative effect.

As the available light starts to fall off some adjustment to your ISO setting may be needed to maintain either the aperture or shutter speed that you want.

Throughout the day there will be many occasions where the outside ambient light is not the problem, it is more the lack of ambient inside the church or the venue. This presents a very different problem in that with so little light you will be working with

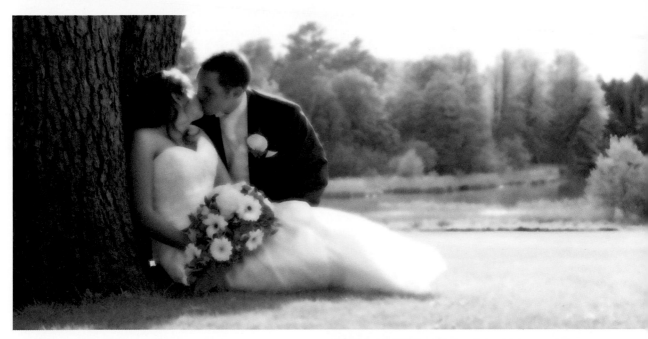

▲ With back lit subjects it is important to control the amount of fill light. This light can be from either a flash unit or a reflector; in both cases it needs to be balanced with the ambient light.
57mm @ f9 1/250sec

▼ Some times post-production can add that little extra to an image. *27mm @ f8 1/125sec*

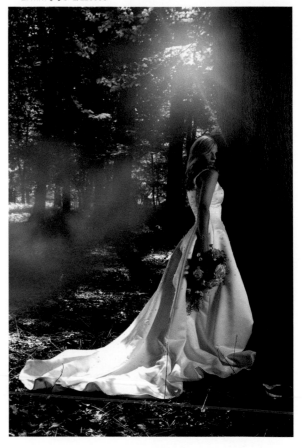

elevated ISO settings as well as relatively slow shutter speeds and larger apertures, which in itself may not be a problem.

The human eye has a wonderful capacity to adjust to different lighting conditions and none more so than inside a dimly-lit venue such as a church. You must be aware that your eyes will quickly adjust, whereas your camera will record the scene as it sees it, dark and under-lit, unless you proceed to take control. So you are inside the church, the wedding service has been completed, up to this point there has been little opportunity to use any kind of flash, not that you wanted to. You will have the register signing to shoot, usually with flash, and the couple have asked to have some signature shots back inside the church, with the bridesmaids, in front of the stain glass window and alter. This situation can be as challenging as working in bright sunlight, with the risk of the flash overpowering the ambient and feel of the shot, producing brightly lit couples with a black background.

Again the first part of the process is to determine the ambient light in the church, by using a light meter, taking an incident reading or using the in-camera light meter. Alternatively take a photograph on P (programme), adjusting the ISO, exposure compensation, aperture or shutter speed until you have the desired correctly exposed image. Set your off-camera flash with either a shoot-through umbrella, soft box or just bounce it from a reflector, metering it to about ½ stop more than the ambient. Take your shot and adjust either shutter speed (which will only effect the ambient) or the flash output until you have achieved the result you are looking for.

WORKING THE SHADOWS

One of the natural characteristics of light is that it creates shadows and it is these shadows that will help provide depth to the image and interest to the image. Shadows will add mood and help 'place' the couple within the scene.

Once you have mastered this playing around with the light, manipulating the shadows will lift your photography to another level. The derivation of the term photography, from the Greek, means 'drawing with light'. However it is more useful to think of it more like 'painting with shadows'; whilst not a literal translation, it will be the shadows that will either work for you or compete with you.

Shadows will manifest themselves in many forms, hard edge, soft edge, directional, unobtrusive, intrusive and constructive and it is the type and direction of the light that determines the nature of the shadow.

LIGHT MODIFIERS

Light modifiers are reflectors, soft boxes, umbrellas (shoot-through and reflecting) snoots, honeycomb, or grids as they are sometimes called, or anything that changes the shape or the quality of the light.

Reflectors

These are probably the simplest forms of light modifier and one of the lowest cost options to help control the light. Reflectors come in a variety of shapes and sizes – it is a personal choice, maybe with price considerations.

In its simplest form, a single sheet of white paper will work as a reflector. Using a reflector is often a very quick and simple fix. However, caution is advised in strong sunlight when using the silver side of the reflector, as the reflected light can in some conditions be more like a searchlight than a fill light. Control of the reflector is achieved by changing its angle to the main light source, moving it around until you get the desired result. A useful technique is to use the edge of the reflected light, allowing its intensity to fall off or reduce. Distance and the inverse square law will also be working for you by allowing the strength of the light to fall off the further you move it away from the subject.

In using a reflector always remember the rule that the angle of incidence equals the angle of reflection; in other words, light travels in straight lines and when hitting a subject, the light that is not absorbed by the subject will be reflected back in the opposite direction but at the same angle as it hit the subject. Throw a tennis ball and see how it bounces – that's how light works.

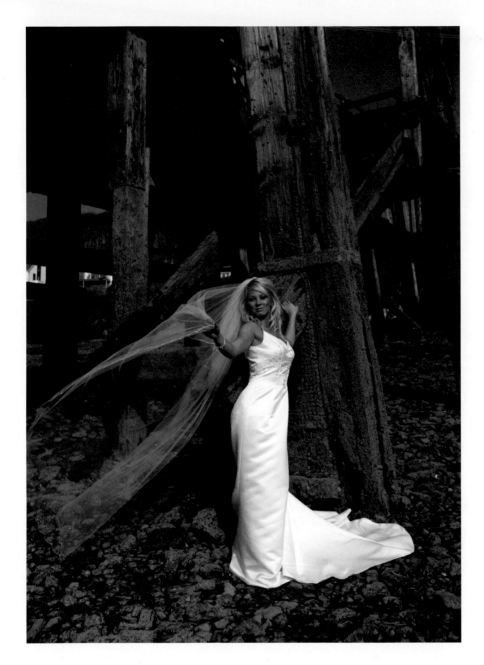

◀ A simple reflector helps to control the strong sunlight falling on the bride from the top right hand side; without the reflector the lighting would be hard.
27mm @ ƒ4.5 1/4000sec

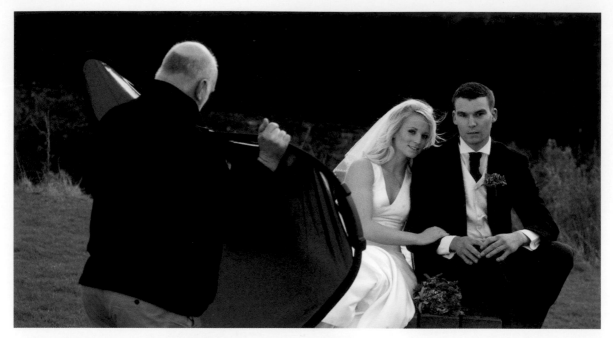

▲ Here the author is holding a reflector at one of his
wedding workshops while the delegates shoot the couple.
70mm @ f4 1/250sec

Soft boxes

Many shapes and sizes of soft boxes are available,
and the type and shape will no doubt be governed
by the lighting units you have, whether strobes or
portable studio-type battery powered units. The
strobist (those using camera flash units) amongst
you will be able to use proprietary brands of soft
boxes that fit to the flash heads directly with Velcro®
or through purpose designed brackets, increasing
the size of the emitted light.

It is usual for soft boxes to be provided with a
single diffuser panel, and some provide an addi-
tional scrim to add further control. The larger the soft
box the softer the emitted light is going to be; adding
additional diffuser layers will not soften the light but
will help reduce the intensity to a level that may be
more manageable.

The larger boxes for the portable studio lights are
available in a variety of shapes and sizes – square,
rectangular, octagonal and so on, and all with a
specific function. The larger the soft box and the
closer it is to the couple, the more you will be able to
wrap the light around them. A rectangular soft box
provides a considerable degree of flexibility: in the
horizontal position it can be used to throw light on
the couple as well as throwing some light onto the
background, and in the vertical position it will light a
standing couple.

Umbrellas

Another simple and effective tool to help soften the
light source is the umbrella. Unlike a soft box it is less
directional, in that the light fired through the shoot-
through umbrella will radiate in many directions and
so may spread light where it is not wanted. You can
have a very subtle control over the nature of the light
by simply adjusting the distance of the light source
from the umbrella: the further the flash is from the
umbrella the softer the light on the couple is likely to
be; the closer it is to the umbrella the harder it will be.

Umbrellas can also be used as reflectors, in con-
junction with a flashgun, and in so doing there are

▲ This is the 40cm soft box in action providing a main light 1 stop over the ambient light. *73mm @ f9 1/125sec*

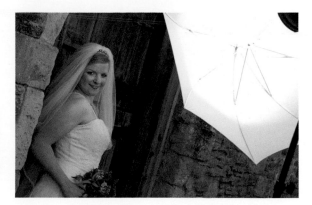

▲ The shoot through umbrella in action, producing a soft main light demonstrated by the soft edge to the butterfly shadow under the bride's nose.

◄ Reflectors are also called cans or spill-kill reflectors. *24mm @ f5.6 1/50sec*

a number of reflective surfaces, much like reflectors, that are available ranging from white through silver to gold. The latter may have the tendency to turn the couple a little jaundiced so use with care, in particular on some skin colours.

Incidentally a conventional white umbrella, very often purchased by the couple for the day in case of rain, can also work as a scrim when held by the couple; a parasol will do the same but somewhat more decoratively.

Snoots and honeycombs

A snoot is a conical funnel that controls the spread of the light, producing a circular high contrast spotlight effect with a very hard edge, and is often used to provide a hair light to the back of the head or a focused light through the veil. Beware, however, as it does produce very hard edge shadows and if not placed correctly could produce an unwanted light on the face.

The honeycombs, or grids as they are sometimes called, are available in a variety of configurations with different grid sizes and depth producing a light similar to that of the snoot but with a softer edge. The size of the light will be dependent upon the grid size and depth. The grid can be used for greater creative impact where you want the light to vignette away from the area that is illuminated, producing softer shadows with a more gradual transition between the lit and unlit areas.

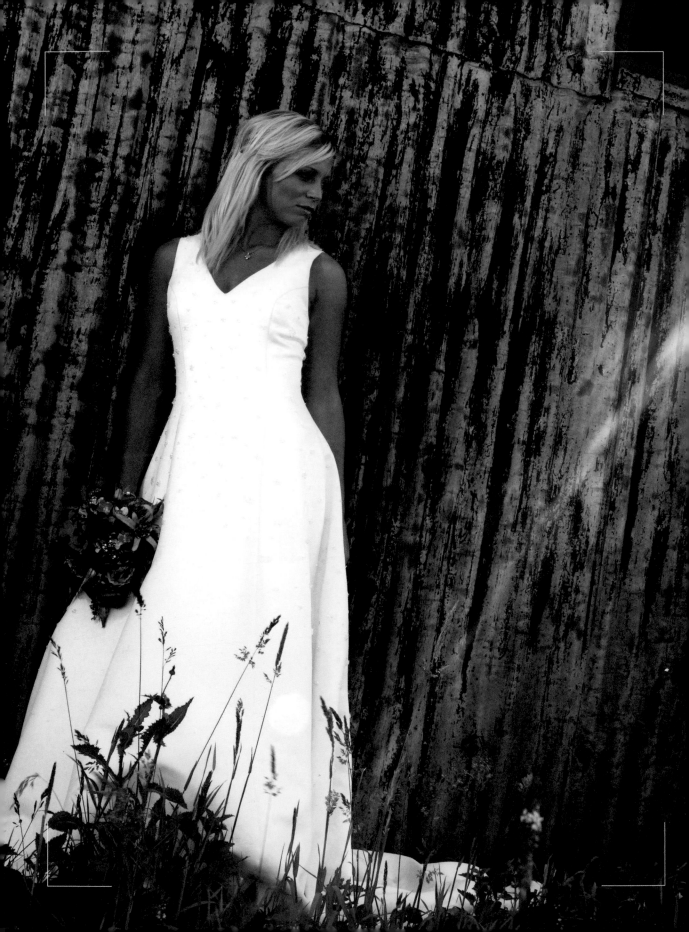

Chapter 5

Seeing the Picture

It may not always be appreciated that photo-graphy is an extremely subjective medium, and we all see things differently. However, if you are to lift your work from that of a general snap to something of beauty and creativity, you should give consideration to the rules experienced photographers have found helpful, even if you have reasons for breaking them. The key to seeing is to start looking for those visual aspects in a scene that produce the right lighting and composition and that make you re-evaluate your preconceptions.

In the days of film cameras the process of pho-tographing a wedding was formulaic; with a limited amount of film, photographers produced predictable formal shots. Today with digital opportunities we can shoot with greater freedom and imagination, and produce really imaginative and distinctive images using angles, lighting, form, selective focus and perspective to name just a few. It is this visuali-zation and perception of the image that will lift your wedding photography from the mundane to the inspirational.

"Vision is the art of seeing what is invisible to others."

Jonathan Swift (1667–1745)

▼ Using perspective in an image will add depth and help draw the viewer into the picture. *24mm @ f8 1/160sec*

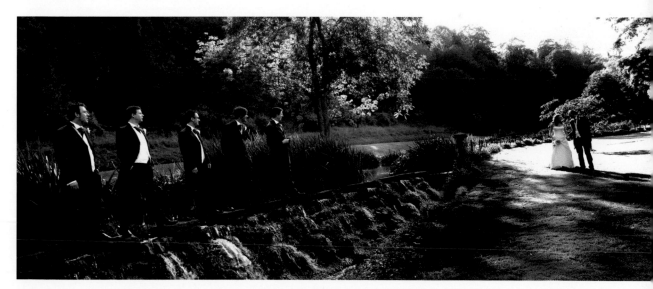

THE SUBJECT

While the subject is obviously 'that which you are photographing', if you take this a step further the subject will have its own characteristics of shape, form, lighting, proportion, pattern and dominance, all of which produce an almost infinite number of ways to shoot it. Through the simple but vitally important process of viewpoint, using your feet to work around the subject, looking for the angles and filling the frame, giving consideration to your position in relation to whatever you are shooting, will start to produce powerful images. Taking the process further, the subject need not be solid; it can be an arrangement of shapes, shadows, colour or light, with a progression of tones, producing visually entertaining pictures.

The conventional wisdom is that you should isolate the subject or make it the focal point of the image. Very often the approach you need to take is governed by everything that is going on around you – busy activity in the background that needs to be isolated out of the picture, unwanted signs or windows that reflect you or your flash in the picture.

Selective Focus

Selective focus is an extremely effective technique used when you want to isolate your subject from the background; it can be achieved by using the widest aperture (ƒ stop) you can select and focusing in on the key element of the subject. With most DSLR cameras there will be the option to set your camera to AV/A (aperture priority) which will simplify the process: when you set the desired aperture, the camera will automatically set the shutter speed for you, making sure you have a fast enough shutter to shoot with given the lighting and other conditions. If you find that the shutter speed is too slow for you then you will need to adjust your ISO setting higher (for example, changing from ISO 200 to 400 will give you an extra stop – 125/s to 250/s) to compensate for the slow shutter speed.

▼ Setting either a bland background or shallow depth of field is a great way to help isolate the subject. *70mm @ ƒ10 1/160sec*

Depth of Field

The depth of field (DOF) is the distance between the nearest and farthest objects that appear acceptably sharp in an image. It can be one of the most imaginative and powerful effects available to you as the photographer. The DOF will generally depend on a combination of the subject's distance from the camera, the focal length of the lens being used and the f stop.

The impact depth of field has on a wedding photographer is that a long focal length lens with a wide aperture (200mm at f2.8) will isolate your subject from the background far more than a short focal length lens will with a smaller aperture (28mm at f11).

DEMONSTRATING DEPTH OF FIELD

This exercise illustrates the process of subject distance from the camera and its effect on DOF.

Place a subject about three feet in front of you and focus your eyes on it, and you will notice that all the peripheral areas are reasonably clear. Now place the subject half the distance towards you and focus on it, and you will notice that the surrounding areas are not quite so sharp. If you now place the subject as close to you as you can focus with your eyes, you will find that all the surrounding regions are not very sharp at all.

This process works in the same way your camera views the subject when you focus on it, combined with higher magnification the results will produce a very tiny depth of field. So if you are looking for very shallow DOF your choice of lens is important, the longer the focal length and greater magnification will result in a shallow depth of filed and a shorter focal length lens, as used in landscape photography will produce a much greater depth of field.

▲ When using a shallow depth of field, be careful that the subject in the background is sufficiently in focus to be recognized. *108mm @ f3.2 1/800sec*

◀ A busy background can be distracting in an image, so having a fast lens that will enable the shallow depth of field when the aperture is at its widest helps subject's isolation. *57mm @ f2.8 1/125sec*

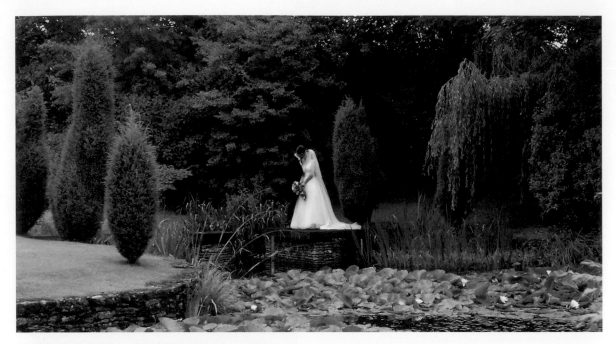

▲ In this image the composition is OK; however, it is not ideal
as the couple are centrally placed. They ideally need to be
placed on one of the thirds as dictated by the rule of thirds.
27mm @ f4.5 1/200sec

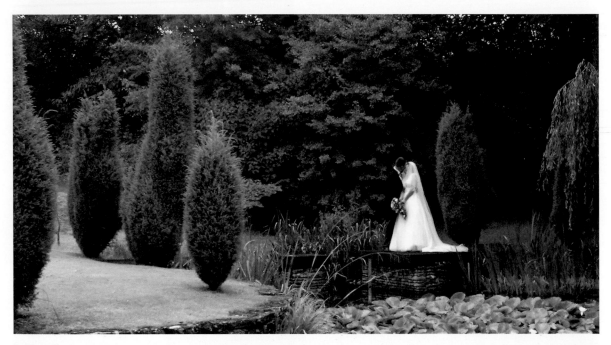

▲ Here the same image has been cropped to work with the
rule of thirds and makes a stronger compositional image.
27mm @ f4.5 1/200sec

SUBJECT PLACEMENT

Rule of Thirds

In composing a picture a starting point is to decide where to place the subject in the frame. The prime rule for this is the rule of thirds, which will determine which part of the image your eye is drawn to first, and then other placement elements should flow from that.

What good photographers generally avoid is splitting the picture in half, either vertically or horizontally, and also avoid placing the subject in the centre. However, there are many occasions in wedding photography where centre placement is fine, for example formal group shots and the ceremonial shots when taken from the back of the church or venue, producing an almost architectural format.

So what is the rule of thirds? If you divide the image into thirds, horizontally and vertically, creating nine equal squares, by placing the focus of interest on an imaginary intersecting point one third along in any direction you will produce a stronger image compositionally.

Rule of Odds

In looking at an image the viewer may focus directly on your subject, or you may encourage them to travel around the image by creating a more dynamic picture. In the case of more than one person or object, this movement can be achieved by using odd numbers in the composition like three, five or seven elements instead of two, four or six. Why do we naturally group elements in pairs? Is it because we have two eyes, ears, arms, legs and so on? When there is only one element the eye will remain focused on that point; however, when there is anything other than a single reference point, the eye will travel around the image trying to pair up the various elements; and having an odd number means the eye will want to continue looking.

▼ Three is better than two and four. The eye moves around the image and is not brought to a standstill as it may well be with an even number of clutch bags. Arrange the groups to work for you. *34mm @ f4.5 1/40sec*

▼ The same rule of odds works for almost any subject, in this case the confetti boxes placed on wooden bench. *200mm @ f7.1 1/500sec*

Leading and Diagonal Lines

Another weapon in the armoury of composition is the use of leading lines designed to draw the viewer through the picture, either to a focal point or around the image like a signposts, helping to create the visual narrative. The vertical lines can be used to create an impression of movement or a sense of depth, with horizontal lines considered to be stable and strong, and diagonal lines adding energy and dynamism as well a possible insecure element to the image. The lines must lead to some point in the image, holding the viewer within the frame rather than drawing them outside and away from the focal point; you need to retain their interest and attention.

Diagonal lines, either visual or perceived, will give you a more dynamic and energetic feel to the image, leading the eye to an element of the image, producing depth and movement into the picture. Diagonals are created either by the physical elements within the image such as stairs, columns or buildings or the eye line created in groups of people as well as their body position, combined with the angle of the arms or legs. Diagonals formed by viewpoint will generate a sense of depth, as with perspective and be careful you do not split the image into two elements, instead look for the shapes and patterns they create.

Negative and Positive Space

The ideal is to have the subject positioned so that it is creating the visual effect of moving or looking into, and not out of the frame, which naturally draws your eye into the picture. When you achieve this, it is called positive space. Creating dead space will force your eye out of the picture. When the subject is looking out of the image, it can create a retrospective mood in the picture with the subject possibly contemplating the past.

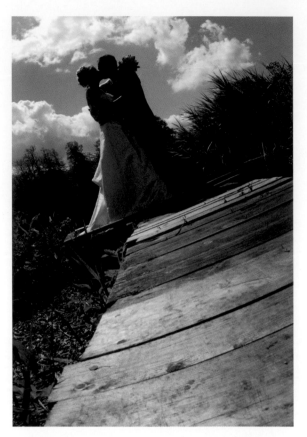

▲ Lead-in lines and perspective help draw the viewer into the picture, shot from a low viewpoint making full use of the jetty. Always consider the angles and viewpoints for that creative edge. *15mm @ ƒ14 1/500sec*

▲ If you look around there are many subjects that work with lead-in lines and draw you to the action. Visualization is a great tool for the creative photographer. *15mm @ ƒ4 1/250sec*

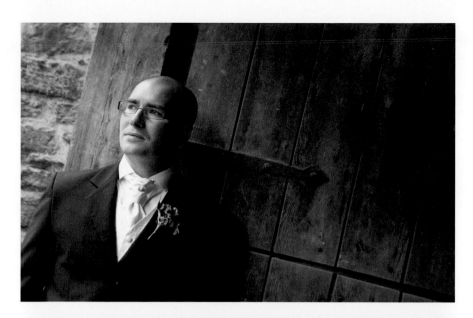

◁ Here the groom is looking
out of the image to his
right, producing a negative
space on his left (our right
as we view it), drawing
the eye out of the picture.
59mm @ f2.8 1/60sec

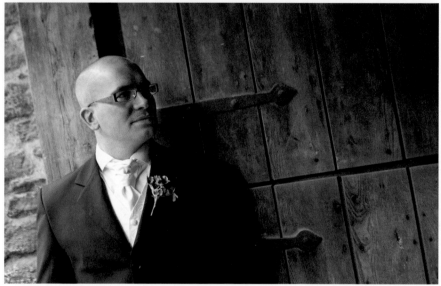

◁ Positive space, on the other
hand, is created when the
groom looks into the picture.
59mm @ f2.8 1/60sec

◁ Using the bench lines
has produced linear
perspective, drawing the
viewer into the picture and
producing a vanishing point
somewhere in the top third.
40mm @ f5.6 1/160sec

PERSPECTIVE: THE CREATION OF DEPTH

As a wedding photographer you invariably have to create a three-dimensional subject in a two-dimensional medium (although at the time of writing 3D imaging is starting to develop some momentum). With photography there are a number of tools at your disposal to create this third dimension, the key process being perspective, which manifests itself in many forms. A camera will automatically create perspective, such as converging verticals. However, having a complete understanding of the process and skills involved in creating depth, form and shape will enhance your imagery.

Linear Perspective

The eye judges distance within a scene by diminishing distance and the convergence of angles. This phenomenon, called linear perspective, dates back to at least the fourth century BC and is attributed to an artist called Aristarchus, who made realistic depictions of depth in the spatial layout of buildings as well as solar studies. A term sometimes used to describe linear perspective is parallax and is most commonly seen in architectural photography if the verticals have not been corrected. Our eyes and brain exploit parallax due to the different views from each eye creating the perception of depth and distance; in the two-dimensional medium of photography you sometimes need to exploit and develop this process to create any form of depth in the picture.

Camera subject distance and the choice of lens focal length will have an effect on the perspective. For example just changing the focal length will not change the viewpoint or perspective, but may change the apparent viewpoint and change the image object size, whereas changing both the focal length and camera subject distance will help to change the linear perspective, altering the relationship between objects. This is most marked for example when shooting groups walking towards you, such as the *Reservoir Dogs* shot taken at so many weddings of all the guys walking towards the camera. As they move closer the camera/subject distance changes, and if you have more than one line of people then those in the back line will start to disappear behind the leading line – something to watch out for.

The use of a wide-angle lens or short-focal length lens will create greater depth (not to be confused with depth of field) whereas the longer focal-length lens will produce an image with less apparent depth.

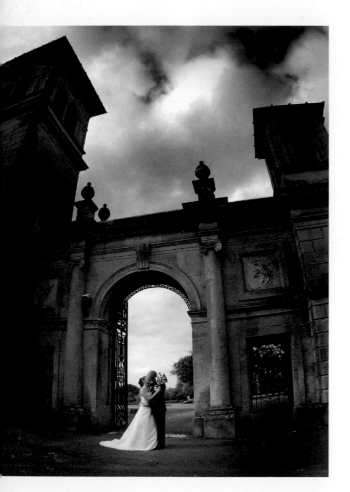

◀ Most lenses will produce a rectilinear perspective except the fish-eye, which produces a false perspective usually not liked by architectural photographers as the verticals are not straight. *f10 1/1400sec*

Rectilinear Perspective

Most lenses (apart from fish-eye and panoramic lenses that produce a false perspective) produce a rectilinear perspective, which is closely related to what the human eye sees in that lines are straight. Fish-eye lenses will produce a false rectilinear perspective.

Vanishing Point

When we view parallel lines, either vertical or horizontal, they produce the sensation of meeting at a vanishing point either within the image or outside the perimeter of the image, at what is presumed to be infinity; this has been used in art since the 1400s. This concept explains why railway tracks appear to meet at some point despite being parallel.

▼ Painters and artists will be familiar with the concept of the vanishing point. It is an effective tool in producing scale and depth to an image, even when the subject is candles. *40mm @ f2.8 1/60sec*

▼ Using perspective to create the sense of depth in a two-dimensional medium, making subjects smaller as their distance increases. *28mm @ f9 1/200sec*

▼ High viewpoint is a useful tool to capture large groups as here with the confetti throwing. Consider shooting this sequence three times, once with a high viewpoint, then a neutral viewpoint and then with a tight crop on the couple – providing there is enough confetti. *15mm @ f13 1/200sec*

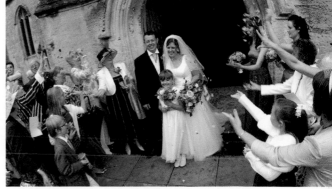

Height Perspective

In essence the higher the subject is in the frame in relation to the bottom of the image, the further away it appears and the greater its height perspective.

Overlap Perspective

This is another clue to distance when subjects are roughly on the same plane or line of sight. The objects closer to the photographer will overlap more distant objects, partially obscuring the subject behind and creating a sense of depth and therefore a perception of the relative distance between them. The perspective will also be effected by the choice of focal length lens, the shorter producing greater apparent depth and the longer focal length a shorter one, much the same as linear perspective.

▶ Here overlap perspective as well as a shallow depth of field has been used to draw the viewer to the main subject, the groom. *200mm @ f4 1/320sec*

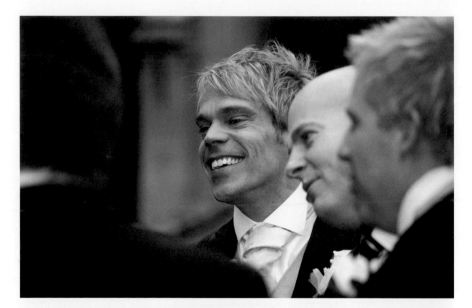

▶ The further away a subject is, the smaller it appears. This is known as size reduction perspective. Here the bride and groom have been lit separately, but with the same exposure on both. *70mm @ f8 1/125sec*

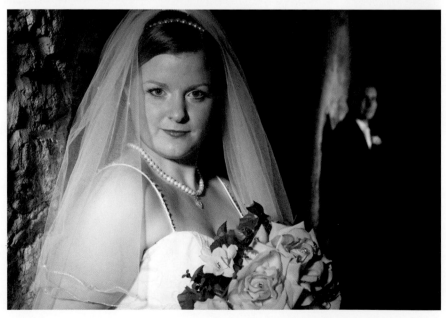

Size Reduction Perspective or Scale

This is a technique used by many in wedding photography, in situations where for example the bouquet is photographed in the foreground and the couple or subject is in the background, producing an apparent size diminution in the background subject. Now no one is going to think that the couple are the same size as the bouquet, they assume that the closer object is nearer in this example. Conversely a person standing close to the subject will appear taller than someone standing in the background despite being the same height. Therefore the further away the object from the viewpoint, in this case the camera, the smaller it appears, thus producing some scale to the picture.

So be careful not to create an image with people growing out from bouquets or tops of heads; change your viewpoint or shooting angle to prevent this from happening.

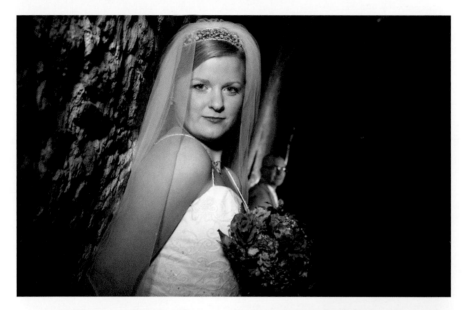

◀ Be careful with size diminution as some amusing and strange results can ensue. *70mm @ ƒ8 1/200sec*

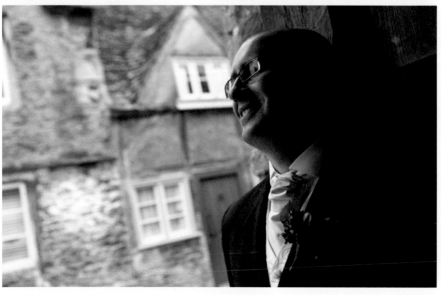

◀ A lower viewpoint adds some importance to the subject, combined with a slight tilt of the camera. Here the available light was left unbalanced to produce a slightly more edgy feel to the shot. *40mm @ ƒ3.5 1/200sec*

Volume Perspective: Shooting the Shadows

While photography means drawing with light, to create depth and volume in your images consider it more like drawing the shadows, as it is the shadows that produce the shape, form and depth to the subject. Without shadow you will have flat lighting, characteristic of on-camera flash, producing uninteresting images.

On a day when the light is flat and overcast, the lighting will struggle to produce any real depth, whereas on a sunny day strong directional light will produce the opposite and possibly undesirable imagery, particularly on faces and groups in full sun. When the right balance has been achieved with the lighting then the result is pleasing, atmospheric and will add character as well as shape and depth.

Atmospheric Perspective

As air contains very fine particles of dust, water vapour and so on, in subjects that include land-scapes, these particles scatter the light and change its direction and quality, resulting in a haze effect that increases with distance.

This haze will have a marked effect on the contrast, brightness, sharpness and colour saturation of the distant subjects.

ANGLE OF VIEW

One of the most important elements of composition is the viewpoint, the position from which you take the photograph. There are many more angles to be explored apart from the traditional position, standing upright. Besides changing the perspective on the background, the viewpoint will tell you something about the subject or person.

High, neutral and low viewpoint

A high viewpoint – looking down on the subject – is a passive approach, conveying a sense of submission in the person. This viewpoint will help to draw attention to the eyes as well as making the head larger in relation to the rest of the body.

Neutral viewpoint, often taken at eye level, puts the person or couple on equal terms to the viewer; the composition will not draw attention to any particular part of the subject or indeed create a strong aura or attitude. It will work for direct eye contact, but runs the risk of producing rather mundane images.

◀ Shooting table sets from a high viewpoint will capture the caterer's art and proved an accurate record of the layout. Try not to shoot the table layout before any tea lights have been lit.
15mm @ ƒ4 1/500sec

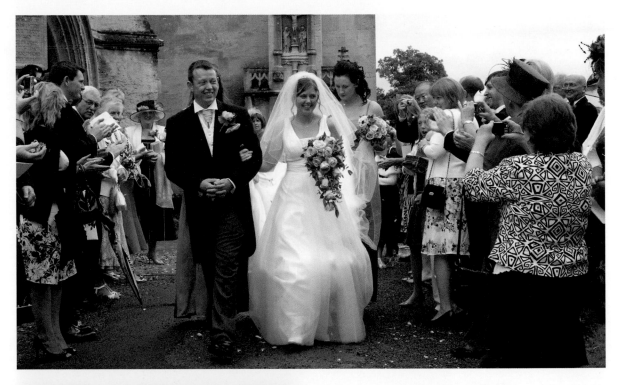

▲ The neutral viewpoint is more traditional; however, combine it with a higher viewpoint as well. *59mm @ ƒ11 1/200sec*

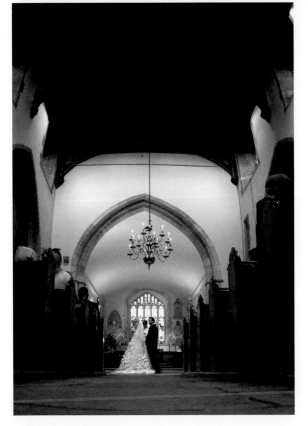

◀ 'Kissing' the floor will provide another approach to the ceremony shot. The low viewpoint allows the pews to draw you into the picture to where all the action is. *15mm @ ƒ2.8 1/60sec*

▶ Foreground interest and
a low viewpoint was what
the couple wanted with
this shot; the important
element, apart from
them, was the lavender.
110mm @ f10 1/160sec

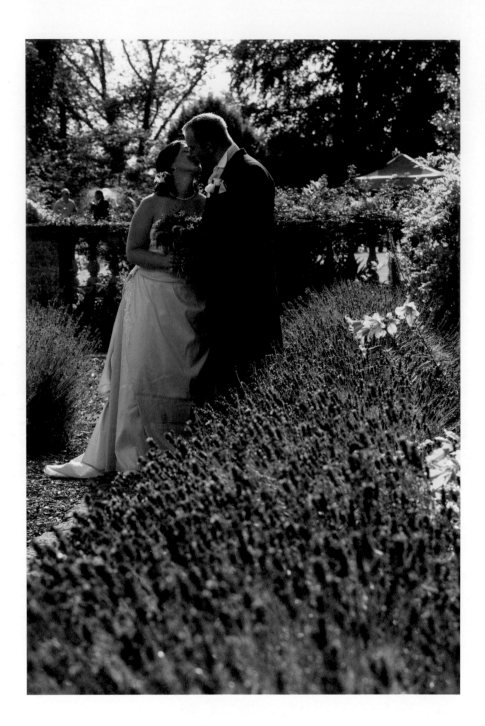

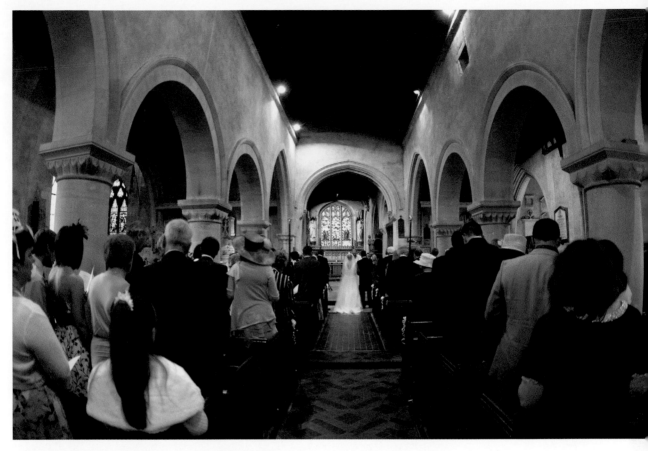

▲ The choice of a landscape format or portrait format is as much
determined by the position you want it to be in the album as the
nature of the image. Here the same shot as the following one
was taken landscape to provide an alternative for the album.
15mm @ f2.8 1/40sec

Low viewpoint on the other hand will generate
a strong dynamic and dominant attitude in the
subject, and can work extremely well especially with
shots of the groom and best man. When shooting,
pay attention to choice of lens, as a very wide-angle
lens will create unnatural distortions and could well
be undesirable.

FRAMING

Framing ideally needs to be carried out in-camera,
reducing the amount of post-production work
needed to produce a strong image. Included in
this discipline are most of the elements previously
discussed, combining to create the perfect image.
What is it that lifts an image from only a snapshot
to a creative thoughtful piece of work? Photographs
often include irrelevant elements that add nothing to
the story; careful cropping in-camera will eliminate
any extraneous matter, thereby allowing the viewer
to become absorbed into the picture. Your choice of
lens will have an impact on your framing, so careful
selection is important.

▶ The same shot but
in portrait format
15mm @ f2.8 1/40sec

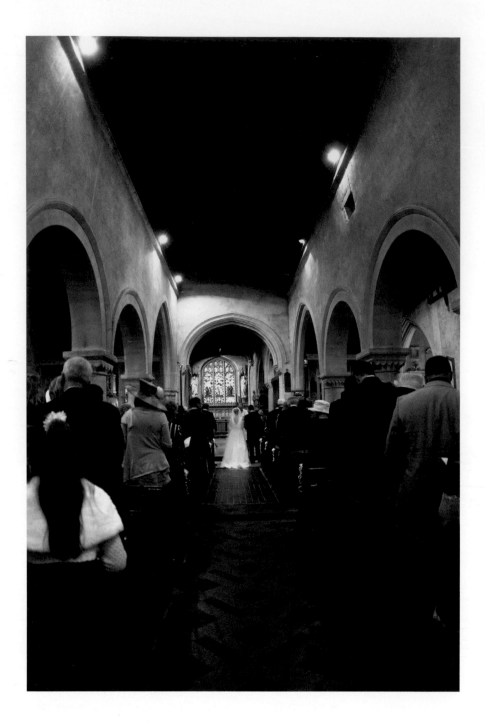

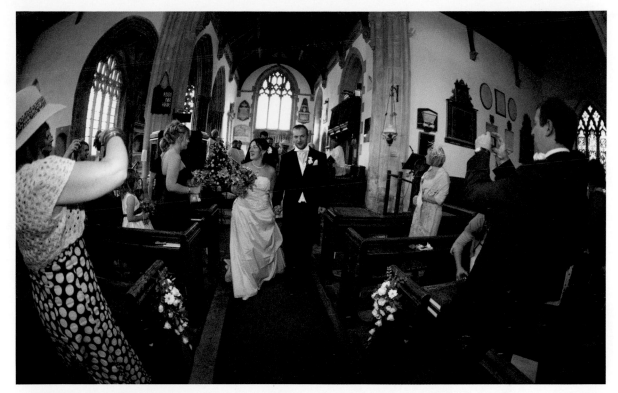

▲ A considerable depth of field was required for this recessional shot, so the choice of lens was the fish-eye. An alternative would be a 15mm wide angle if you do not like the effect from a fish-eye lens. *15mm @ f2.8 1/160sec*

Landscape vs Portrait

Landscape (horizontal view) or portrait (vertical) format is one of the initial and fundamental choices you will need to make before shooting, as getting it wrong will diminish a large amount of the impact. The subject matter will very often dictate the format you use. With judicious cropping, a portrait image can be cropped to a landscape, adding greater impact; however, the human eye, in conjunction with the brain, perceives the world as a landscape and the portrait view is a little more alien. The traditional format for portraits is the vertical view, so be unconventional and develop the landscape option, positioning the subject appropriately.

WHAT TO INCLUDE?

The Long Shot

Some subjects lend themselves to the long shot, bringing in the environment or surroundings. This is a technique that works well with the bride walking down the aisle, pulling in the whole of the church and congregation with a wide-angle lens, or maybe a fish-eye, as opposed to a tight crop of the bride processing towards her groom that could be in any church in the land. Producing this wide-angle shot places the bride in context within the church or ceremony location.

The long shot will also work in the landscape, bringing in the large skies or stunning scenery, with the couple suitably framed as part of the surroundings.

▶ Shooting from the back of the venue you will have the opportunity to produce both long, medium and close cropped shots.
145mm @ f2.8 1/125sec

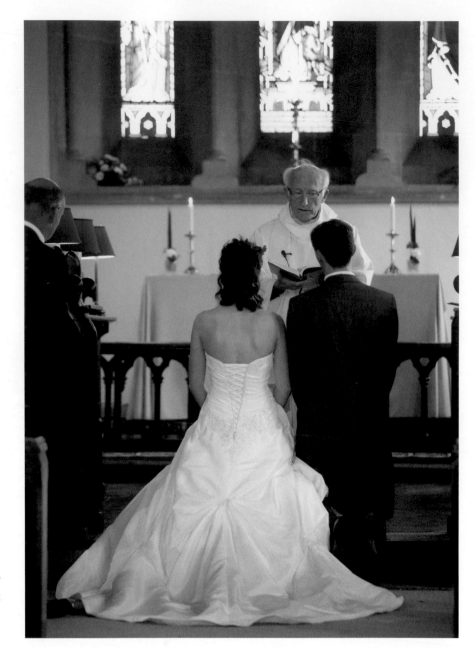

The Medium Shot

The subject will take a more dominant role in the medium shot, where you shoot maybe just a three-quarter shot of the couple or groom with best man. The surrounding environment takes a less important role in the image, and very often differential focus will add additional emphasis to the shot.

The Close Shot

A close shot would generally be a head and shoulders shot, cropping tight to eliminate most of the background and drawing attention to the subject.

How close you get will depend upon the degree of impact you are looking for; a really tight close-up of the eyes, for example, will eliminate any background. Careful focusing is critical, as any slight out of focus elements will be obvious; the tighter the crop the more important is the focus point.

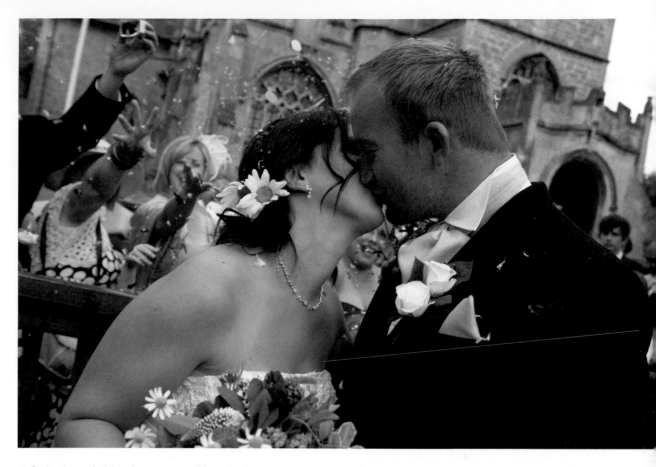

▲ During the confetti throwing, you may well have shot from the high and neutral viewpoint so for the final shot move in close and have the couple kiss with confetti falling over them. *40mm @ f7.1 1/400sec*

◀ The use of diagonals in an image will add energy and interest. *66mm @ f2.8 1/125sec*

Chapter 6

Planning the Day

As the wedding photographer, your planning skills are essential for ensuring that the day runs properly. You must make a forward plan, and that will include alternatives for any deviation to the plan that may occur on the day. Time taken at this stage, and in consultation with the couple, will ensure that you are not hit with anything that you cannot cope with. Naturally you cannot plan for everything; however, there are contingencies that can be factored in so that on the day hopefully nothing will come as a complete surprise to you.

Before the big day, in your briefing with the couple (and maybe their parents, but it is usually just the couple) you will need to discuss timings, venues, contingencies, participants and images required, as well as the wet weather option. The briefing session can be carried out any time prior to the wedding date; however, the closer to the date the better, so as to keep it fresh in your mind. The briefing process will allow you to develop your relationship with the couple, helping to produce great images from a relaxed couple on the day. The process will help you demonstrate your professional approach to the day and help to instil confidence in the couple.

THE BRIEFING

The meeting is best conducted at the reception venue, which may indeed be the same as the ceremony location; this gives you the opportunity to reconnoitre the location looking for preferred shoot locations as well as confirming that you do have the right location. If the venue is new to you, then arrival a good thirty minutes prior will give you the opportunity to walk around and familiarize yourself with its layout and gardens, if it has any, as well as look at the inside photography options in case the day turns out wet. You will ideally need to find some shade to shoot the bride in, without the hassle of dark shadows, so it is a good idea to take a compass to the briefing should the day be overcast and dull, with no indication as to where the sun is and consequently the shadows.

Confirming Information

Have a briefing sheet prepared, with all the relevant data available to you, so you can check details and add new information from the couple. The sheet should include the date of the wedding, confirmed by the couple at the briefing, together with all relevant telephone numbers, email addresses, and the venues, including the church or ceremony venue if different from reception. It is advisable that you visit the church prior to the briefing, to ensure there are no problems such as parking access. Also if it is not a church known to you, you can see how it is set out inside.

During the brief it is useful to obtain the names of all the participants, bride and groom's mother, father, the best man, the bridesmaids, ushers as well as any flower girls or pageboys. Establish if there are any special conditions that relate to the wedding party, such as a guest in a wheelchair or with difficulty standing, this may have an impact upon the group sets later.

You must confirm all the times, the ceremony and wedding breakfast times being the most critical. These are the times that are set in stone, and are very unlikely to change, subject of course to the bride's arrival time at the church. It is backwards from the ceremony time that you determine your arrival time at the bride's getting ready location. The time from the ceremony completion to the sitting down for the wedding breakfast is the time that you have available for all the reception photography, but more of this later.

THE BRIEF SHEET

Required information
The couple
Full names:
Telephone numbers:
Email address:
The wedding
Date:
Ceremony venue:
Ceremony time:
Reception venue:
Reception time:
Wedding party
Number of ushers and bridesmaids:
Flower girl, if there is one:
Pageboy, if there is one:
Number of guests:
Possible leads for future marketing
Wedding dress supplier:
Cake supplier:
Flower supplier:
Car supplier:
Caterers:

In Case Things Should Go Wrong…

You need to discuss the possibility of major problems. The best advice is to encourage the couple to take out their own wedding insurance package, which will not cost them a great deal of money and will cover them for most eventualities at a wedding, including the photographer not turning up.

Reassure them that should you at any time become aware that you cannot cover the wedding, you will advise the couple immediately and do your utmost to try and find them an alternative photographer with similar skill sets to yours. It helps of course if you work with a second photographer who can step into the breach.

Which Shots?

Once you have all the paperwork done, it is time to talk about any specific group sets the couple may want. It is helpful if you ask the couple to bring along to the meeting a few photographs they have seen that they particularly like. These can be from any source, and it helps you determine the couple's perception of their own wedding photographs. Indeed they have booked you because they like your style and work; but they may also have in mind some favourite images that may not be in your repertoire of work. If they have provided a number of images, no more than six ideally, then make sure you do at least re-create these images for them.

It may be helpful to the couple to talk them through the day, detailing how you will be shooting the various elements and also outline any restrictions that may be imposed by the ceremony or reception venue. Talk to them about the photographs you will be taking, as they may well have ideas of their own.

You will have your own favourite shots you want to try. A good visual guide or crib sheet – a collection of images you have collated from various sources, produced into a small booklet or A4 sheets – will help you through these difficult moments. Showing a couple an image that you wish to re-create will help move the day forward and also convey to the couple the vision you have for the shot, placing you all on the same wavelength.

It is at this point that you may well identify any specific problems with their perception of the wedding photography; for example they may want images of the ceremony from the front, but the church or venue or those actually taking the ceremony or service may well have restrictions that prevent you from delivering the couple's wishes. There are distinct differences between various religious and civil ceremonies that need to be taken into account, so you should familiarize yourself with the procedures and programmes that relate to their particular ceremony.

Logistics

Apart from discussing the day's events with the couple you will also need to determine the logistics involved on the day. The appropriate planning at this stage will help to ensure that you are not confronted with any nightmares that can be avoided.

In travelling between the various locations, taking note of any possible restrictions that may occur on the day – your local football team playing at home, for example – that will place an additional strain on the road network close to the venue. Are there likely to be any road closures? How long does it take you to travel between venues, including where the bride is getting ready or the groom is having his last drink as a single man? All of this will have an impact upon your ability to deliver on the day.

When you arrive at the ceremony venue, it is very likely you could be the first, so give careful consideration to where you park your car. You need to be as close to the building as possible because of the

equipment you could be carrying, but you will need to be away from the ceremony promptly to ensure arrival at the reception before the couple. This will require you to park your car strategically to ensure you do not get blocked in by the wedding guests.

Give consideration to any possible vehicle breakdowns that could prevent your arrival. Ensure your vehicle is well maintained and that it is full of fuel. As a safeguard have a second vehicle available or at least the telephone number of the local reliable taxi service. Remember you are under contract to provide wedding photography, and failure to comply could leave you open to big problems.

Plan for having an assistant on the day, even if they only carry the equipment for you. It is your duty to capture the day in all its glory, and it is difficult to do that effectively when you are worrying about where you have left your equipment or spending time on preliminaries such as setting up lights. Make sure your assistant understands all the equipment, what it does and when you are likely to need it. They should have the programme and shoot list to hand, as well as being the eyes in the back of your head, directing you to developments that you may not be aware of.

PRE-WEDDING SHOOT

It is always a good idea to set up a pre-wedding shoot. Freed from the time limit of the wedding day, it is the ideal opportunity to help build trust and confidence, and to develop your relationship with the couple. Your attitude will go a long way towards quelling their nerves. Show them how much fun you can have. Create an awareness of image choices, and they can see how you work, introducing new ideas and experimenting.

If the pre-wedding shoot is at the wedding venue it is the opportunity to explore the locations and try out the poses and lighting. It helps if the shoot is at the same time as the wedding reception so as to provide an indication of the lighting you can expect on the day – not that there is any guarantee of that.

The pre-wedding shoot will help build your reputation and provide you with the confidence and foreknowledge to shoot confidently on the day during the signature shots. Since you will have as much time as you wish to shoot the couple, you might include engagement style informal images that may find their way into the wedding album. The shoot will also provide an opportunity for sales prior to the wedding.

10 WEDDING PHOTOGRAPHY TIPS

1. Prepare a plan and a shoot brief before the day.
2. Discuss with the couple what they want included in their photography.
3. Visit all the venues to check where the light will be.
4. On the day make sure you have the 'must get' safe shots in the bag before moving on to more creative locations.
5. Use different viewpoints to add greater interest to your images.
6. Look out for framing opportunities – a window, doorway or an avenue of trees.
7. When posing the couple, ask them to adopt their own pose as this is more likely to be natural; then adjust any details that may be needed.
8. Look out for steps or a high vantage point to shoot the groups.
9. Always have back-up equipment, should your equipment fail.
10. Check the weather the day before and on the morning of the wedding, to avoid surprises on the day.

DIFFERENT TYPES OF CEREMONY

Whichever type of service you have been asked to shoot, it is paramount that you understand fully the process, as they differ in many fundamental ways. If you have never attended a particular type of service it would be prudent to do so. Familiarization with the whole procedures, timings and protocols will help prevent embarrassing episodes occurring during the day. Make it your business to know the timings throughout the ceremony, as you will need to position yourself appropriately as well as having the right lens for the job at hand.

A church wedding can last at least forty-five minutes, whereas a civil wedding, register office or registered venue will not contain any hymns or religious content and will only last around fifteen minutes depending upon how many readings there are.

Religious Wedding Ceremonies

These are the more common religious ceremonies, but this list is by no means exhaustive.

Church of England

A Church of England wedding will usually last about forty-five minutes, from the bride's arrival to the recessional down the aisle at the end. During that time there may well be several readings, hymns and the vicar's address, including the vows, during which it is common for no flash to be used. Towards the end there will be the official signing of the register. As a rule you will not be allowed to photograph the actual signing as it is illegal to photograph the register due to data protection regulations; however, you may be allowed to re-create the signing after the official part has been completed, with the page turned on the register.

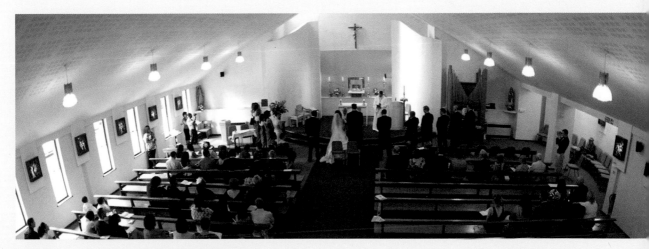

▲ The use of a balcony can provide a wide perspective of the ceremony, as in this Roman Catholic wedding. Panoramic cropping can also be very effective. *15mm @ f2.8 1/100sec*

▶ As a rule photography isn't allowed during a civil ceremony. However, there may be many opportunities to set the scene with some candid images, in this case the harpist.
15mm @ f2.8 1/125sec

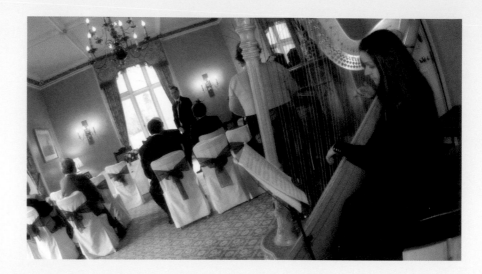

Catholic

There are two forms of Catholic ceremony, one during mass (Holy Communion service) and one outside mass. Timings vary; however, as a rule the mass is divided into five parts: the gathering and entrance rite, liturgy of the word, marriage rite, liturgy of the Eucharist and the concluding rite, lasting a little over one hour. It is important to check with the priest about where and when you can take photographs at Catholic venues as each priest may well have a different approach and attitude to photographers depending upon past experiences. Providing flash is not used it may well be possible to take photographs during the whole ceremony both during and outside the mass.

Jewish

In Jewish weddings it is customary for the bride and groom not to see each other for one week prior to the wedding date, so prior to the ceremony you will photograph the women and the men separately. Key stages during the ceremony are the veiling of the bride, the marriage canopy, the blessings (with cup of wine), the ring, the reading and signing of the marriage contract and the groom smashing the glass.

Hindu

A traditional Hindu wedding can last for days, though there is a shorter version. It is traditionally conducted outside, under a canopy; however, it can take place inside with seating on the ground or sometimes on chairs, with a sacred fire, usually in a dish. Key stages are the arrival of the groom and his party on foot; the bride's entry carrying the groom's garland and later when they garland each other; the bride's parents washing the couple's hands and feet; the exchange of flowers; the exchange of rings; and the priest putting the sacred rope around the bride and groom's necks signifying they are married. Later the couple walks around the fire four times, and there is a presentation of gifts. Refreshments are then provided, and there is the opportunity to take the group photographs, which may well be quite a formal procession through the canopy.

Civil Wedding Ceremonies

Civil weddings, either at a registry office or at a civil venue registered for civil weddings, will usually be about fifteen to twenty minutes in duration, with invariably tighter restrictions on photography than at a church wedding.

◄ There will be opportunities
to shoot details such
as the orders of service
being handed out; it's
all part of the 'story'.
200mm @ f4.5 1/1000sec

Registrars at civil weddings will usually meet the couple beforehand. You will have determined where your shooting opportunities are within the venue and also asked the officiant if they have any problems with you shooting from those locations. In the UK civil ceremony, either conducted at a registry office or more likely a registered venue, you may be allowed to shoot from behind the ceremony table as the bride makes her entrance (this is where the officiant will be standing). Then there usually will be no photography until after the register has been signed, on the table in front of the guests. You may find that some registrars will have a slightly more relaxed approach and allow photography during the ceremony from a fixed position as long as flash is not used. In all cases in a civil ceremony there will be an absolute ban on shooting the actual signing of the register due to data protection as it is illegal to photograph the register, apart from blank pages.

There will, however, be the opportunity to set the important shots after the registrar has completed the signing. Consider placing the couple with their backs to their guests, the position they would more than likely have been during the ceremony, and photograph the re-enactment of the exchange of rings. They do not need to take their rings off for this process to work. The next shot would be the kiss; you will have watched the couple kiss during the actual ceremony so ask them to re-create the positions, with some guidance from you. Then move the couple around to the other side of the table, the side where they would have signed the register, and re-enact the signing followed by images of the witnesses. Once completed turn your camera on the guests, who will now be taking their own photographs.

There will be opportunities throughout for you to shoot details that help tell the story of the day, so keep an eye out for those creative and story-telling moments.

Chapter 7

Signature Shots

It is not unusual for most of the wedding photography to consist of a true record of the day, either shooting from the hip in a photojournalistic style or managing group sets for posterity. This however is only part of the day; the couple will also want some imaginative signature images for their album and hopefully prints or canvases on the walls in their new home.

Your plan for the day needs to allow for these signature or creative shots – images that are taken when you are on your own with the couple, where you have a limited amount of time to develop poses, locations and lighting.

It is important that you devote sufficient time during the day to produce a collection of shots that reflect the couple, their love for each other – images that they will be happy to look at day in and day out. Most of the wedding images will evoke so many memories of the day, capturing the story of the day, whereas the signature images will require a little more time to prepare and shoot in order to produce creative imaginative shots.

It is important that this private time with the couple is just between you and them, with maybe just the best man or just a single bridesmaid to assist with either carrying equipment or helping to set the dress out so that it looks its very best. These shots are also the ones that no other guest will shoot, providing you with those extra sales opportunities.

When you are shooting these images take with you only the minimum amount of equipment: camera, stand-alone or dedicated flash on a lighting stand, lighting modifiers and triggers to fire the flash remotely. These days the more modern cameras are also able to fire a dedicated flash remotely, offering full control from the camera. Dedicated flash units can also work remotely without the need for a trigger. It is inadvisable to work with on-camera flashes; all that will do is produce flat uninteresting lighting. When working with the stand-alone flash, balance it with the available light to produce the feel and quality you have previously planned for.

◀ The couple may well ask you for specific images from the day, so make sure you capture them.
64mm @ f2.8 1/200sec

CHURCH SHOOT

There may well be a number of opportunities where you will be able to have time with the couple, the first being immediately after the religious ceremony. If you have the confidence to set up and balance during the actual shoot then there is no need to pre-set everything. Otherwise during the ceremony take time to set up the lighting you are going to use, taking either a flash meter reading (before the ceremony starts) if you are using a light meter, or just through trial and error, balancing with the available light, which will save you time during the actual shoot.

Once the official part of the ceremony has been completed and the couple has done their recessional, they will end up in the church porch or doorway where you will shoot some of the more formal images. If you have agreed with the couple to go back inside the church for some creatives then it is important you move the couple away from the porch doorway; otherwise you will create a receiving line, which will have a major impact upon your timings. So move the couple around outside the church to a location ideally in the shade, and shoot some group sets, as the parents and bridesmaids and so forth are likely to be with them.

When your assistant has told you that all the guests have left the church you can now take the couple, and maybe the bridesmaids and flower girls back inside, at the same time telling the guests that you will be about fifteen minutes and could they be ready with the confetti throw as soon as you come back out. You can now start to shoot some formal and maybe less formal couple or group shots inside, on the chancery step or indeed any other location that suits the vision you have developed. Remember, this is your time alone with the couple, no guests.

▲ You must allow time during the day to take the couple away and produce what are called either the signature or creative shots. *50mm @ ƒ4 1/500sec*

You should allow only about ten to fifteen minutes for the church shoot as you do not want to leave the guests outside for any length of time; they will get bored and start to disappear back to the reception. Make sure that the dress is displayed properly, the groom's suit jacket is sitting correctly with invariably jacket buttons undone when he is sitting, and the bridesmaids and flower girls are holding the bouquets correctly and in balance. Once completed move straight on to the confetti throw.

This outdoor/indoor process is naturally a dry weather option. When wet, a little rethinking needs to be done as you will not leave guests out in the rain, so maybe consider having everyone remain in their seats and when the couple have done their recessional, something the vicar or priest will insist upon, the couple can return to the front of the church – not an ideal situation because of the huge audience you will have (so no pressure then), and there is the potential for it to become a paparazzi feast. You will need to take control and encourage the guests to remain in their seats. Alternatively if the couple is happy to give it a miss don't shoot back inside the church.

AT THE RECEPTION

The signature images at the venue can either be started as soon as the couple has arrived at the reception, or dovetailed in at an appropriate point during the reception phase of the wedding day. How you work this will depend greatly upon the logistics of the day, for example if the guests take time to arrive back at the venue long after the couple, or the weather is variable and the signature shots are of greater importance to the couple. All of this will have been discussed during the pre-wedding chat to establish the couple's priorities.

Work around the venue, in those locations previously agreed with the couple, paying particular attention to the lighting and composition – both with each other, but also in relation to the camera – and in this comfort zone you can produce natural and unstaged images of the couple. Having visual guides or a crib book to hand will help the flow of ideas and also provide direction to the couple in times of need.

During the whole process keep talking to them to make them feel relaxed, and remember they are not models and so may still feel uncomfortable in front of the camera. It is your responsibility to make them feel at ease and relaxed; a good sense of humour helps, not necessarily cracking jokes but observational humour to put them at ease and in their comfort zone.

The type and style of shots you produce will depend very much upon you, the couple and the venue, working from a plan previously conceived. You will ideally need your mobile lighting units, speed lights on stands with a modifier, to balance what will invariably be difficult lighting conditions.

Photographers will often direct a couple to pose, and this is meant to look informal but inevitably appears false. The trend is for more informal images, not the sterile stereotypical shots that have been done for years. Traditional poses look dated, where a more natural approach is preferred these days, with for example the couple walking, either towards or away from the photographer.

As a rule, if the couple are comfortable and their position/pose looks right then all should be well. Throughout the whole process, from pre-wedding brief and shoot to the actual day, you will have developed an understanding of the couples' performance in front of the camera, and they in turn should feel relaxed with you so little direction should be required.

During the day there may be times when you lose your way in the process; this is where your visual guide will be invaluable. Showing the couple an image that you wish to re-create will help move the day forward and also convey to the couple the vision you have for the shot, placing you all on the same wavelength.

10 TIPS FOR PHOTOGRAPHING COUPLES

1. Make sure a pose reflects the couple's personal style.
2. Develop a plan and work to it, but keep it loose and free.
3. Use the crib book or visual guide.
4. Talk to the couple to make them feel relaxed and develop the mood.
5. Have the couple place their weight on the back foot.
6. Hands in pockets can help to relax a pose.
7. Give constant confirmation on how good they look.
8. Use tight crops for more intimate portraits.
9. Encourage the couple that things are going well.
10. Look for emotions and individuality.

Chapter 8

Group Shots

The group shots are one part of the whole day that both guests and photographers enjoy least. The shots will tend to be more formal in nature, and the potential for the whole process to take an inexorable amount of time is always present. During the pre-wedding process you will have established the group shots that are required and planned the process for a seamless flow. With careful planning and a great deal of control you should be able to complete the process without having a coronary and at the same time impress the guests with your management skills.

CHOOSING THE LOCATION

Try not to shoot groups at the church because gravestones are not appropriate in wedding photographs. Remember all your planning will fly out of the window if you have not developed your wet weather option and the day is raining. Taking groups inside the church will present its own problems with the lighting and space available.

On your recon at the pre-wedding meeting you will have taken time to look at the inside of the venue and determined which location works for smaller groups and whether there is any location that lends itself to the big group shot. If there is no location inside that works for a creative group, then consider photographing everyone after they have just sat down for the wedding breakfast, ensuring they are all looking the right way so some will need to turn their chairs around, this is very often the case in marquees on wet days.

Try to select a location that works for you and has some relationship to the venue, so all the group images are in context and reflect the location. Group shots in front of a hedge or bushes could be anywhere and will not convey a sense of being there.

Not only does the location need to work visually but try to choose one where the lighting is under control. If you have a background that is not important, consider backlighting the group so they are not looking straight into the sun. You will then need to either expose for the shadows, letting the background blow out or overexpose, or add light from flash or continuous lighting, balancing with the background ambient.

When shooting the overall group it is helpful if you could find an elevated position, a balcony, set of stairs or a window, as looking down on the group will ensure you see all their faces. If there are no opportunities for an elevated position at the venue then take some steps with you, elevating you above the group.

If the background is important, such as a grand venue or landscape, then you may have no option regarding group placement. For example: the steps are in front of the architecturally distinctive building, and it is all facing south on a really bright sunny day. In such a situation try and place the groups at an angle, watching for where the light is falling on them, or just hope for an overcast day where the lighting will be softer.

WHICH GROUPS?

It is common to work from a pre-prepared list, confirmed with the couple. It may be that traditional parent groups will not contain all parties for a number of reasons and therefore adjustment to the formal layout may be required.

At the pre-planning meeting some photographers will offer the couple a list of shots that covers several A4 sheets of paper, asking them to select the images they want. This will inevitably encourage them to tick every shot, a scenario you ideally do not want, as it will impact upon your valuable time.

Using a core set of images will ensure that you only produce group shots that are requested by the couple and not from a generic list. The core set of group photographs might consist of ten shots, including the whole group shot.

The group shots may well enable you to produce fun shots of the groom's stag party or the bride's hens, not to mention the university friends. These group sets can be more informal in nature, allowing you some degree of creativity. Having a crib book to hand will also help when the mind goes blank.

You will work through the group sets in a methodical fashion, either building the groups or working in reverse; you can start with everyone and strip out guests back to the smaller groups or grow the groups, ending with the big group. Essentially the choice is yours as there is no right or wrong way – just whatever works for you and the dynamics of the group. Bear in mind that if you have group sets that require individual shots of the bride, with her mother for example, taken either before or after the parents shot, then move the other guests instead of the bride, as you will not want to reset the dress every time.

▲ When you are shooting groups, try not to have them in a straight line; turn the shoulders towards the camera. *24mm @ f3.5 1/200sec*

▲ With smaller groups, you can stagger the line and use a shallow depth of field to draw your attention to the groom. *122mm @ f4 1/320sec*

POSITIONING

Do not start positioning the main groups until everyone has arrived, as you do not want people standing around waiting for the missing guest to arrive. Apart from the time lost you will no doubt have restless guests who will become bored, which will be reflected in the final images, or they may just disappear. If you are missing key people then consider shooting some candid shots while you are waiting.

During the day there will be moments where you need to take control; this is such a time. Having an assistant pulling in the relevant guests would be a

considerable help; however, they may be involved in helping set the group or managing the bride's dress. It may be that the ushers are available to help, but they may not know everyone on both sides of the families, so a strong humorous but determined approach by you can help to pull in the people needed.

It will help if you keep up a dialogue with everyone. Developing a rapport goes a long way to getting attentive, interested or smiling faces – the last thing you need is a group of disinterested guests just going through the process as that is what is expected. Group photography should take no longer than thirty minutes – any longer and you run the risk of losing people and producing 'get me out of here' expressions.

Watch out for vibrant colours in the group sets that will draw your eye away from the couple. Move people around to produce a balanced shot, with vibrant colours either at the back or partially masked by their partner, if they have one.

Take your time, making sure you can see everyone's face. If steps or elevated sections are available then try to use them to your advantage, ranging the guests on the steps at appropriate levels so that all their faces are visible. Watch out for the guests who will want to hide at the back.

Try to avoid straight lines, and watch out for the lines that develop within the group. Triangles are strong, so try to arrange people so that the tallest are close to the couple and then develop the slope of the group outwards to maybe the shortest at the end. Children need to be in front. When arranging groups up steps, ensure that children in particular are visible, and that the couple's parents where relevant are alongside the couple. Remember when posing the subjects that the spine should not be forming a vertical line, the shoulders should not form a horizontal line and the hips should not be square to the camera.

10 MUST-GET GROUP PHOTOGRAPHS

1. The couple plus the bridesmaids.
2. The couple plus the bridesmaids and groomsmen (distribute so the group is balanced).

Take the bridesmaids away.

3. The couple with the groomsmen.

Take the groomsmen away.

4. The couple plus bride's parents.
5. The couple plus bride and groom's parents (distribute so the group is balanced).

Take the bride's parents away but keep them near.

6. The couple with the groom's parents.
7. The couple with the groom's parents and relations.
8. The couple with the groom's parents, relations and the bride's parents and relations.

Take the groom's parents away.

9. The couple with the bride's parents and relations.
10. Everyone.

10 TIPS FOR PHOTOGRAPHING GROUPS

1. Ensure you can see everyone.
2. Either use a high vantage point or place them up steps and shoot upwards.
3. Look out for shadows cast by people onto other guests.
4. Re-arrange the group after they have found their natural positions.
5. Place their heads at different levels – straight lines are boring.
6. Keep the group tight.
7. Allow enough space at the edge of the group for the 10" x 8" crop.
8. Look for shapes in the group, such as triangles.
9. Have the couple place their weight on the back foot.
10. Always shoot more than one shot of each group to allow for blinkers.

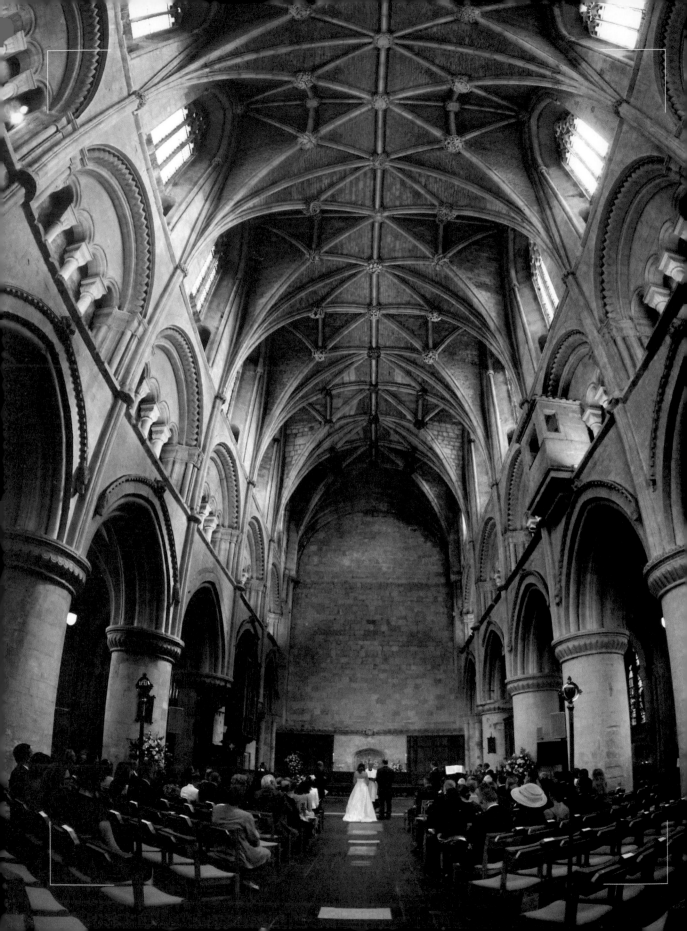

Chapter 9

Working the Day: The Ceremony

Here and in the next chapter we will be running through the complete wedding day, from preparation to completion, using a timeline that will provide an insight into the workflow for the day. This is just a sample day, in this case a church wedding; your job may be a civil ceremony where times are usually shorter, or it may be a religious ceremony in a venue dedicated to such, or a civil ceremony at a registered venue. Where consideration is given to the choice of lens, shot settings and so on, these choices and settings are provided only as a guide, as every wedding is different and maybe will require a different approach.

Every venue will have its own lighting challenges, so flexibility and the ability to adapt for any given scenario are an important part of any wedding photographer's repertoire. You will therefore need an armoury of equipment that will help you control the lighting; however, try to keep it as simple as possible. Whenever possible, work with an assistant, whose responsibility it is to carry and organize it all, while you concentrate on just the photography.

Whilst the process will need to be altered according to the religious denomination, the basic shape of the day will be common to most weddings. There are of course types and styles of wedding that may not involve photographing the bride or groom getting ready. You will develop a workflow that you have agreed with the couple at the pre-wedding chat, shooting both formal and photojournalistic styles.

There are generally three scenarios that do not lend themselves to images the couple will want: photographs of the bride or bridesmaids before they have their hair or makeup done; people smoking cigarettes (however, cigars and pipes are ok; cigarettes are considered more a habit, whereas a cigar is a status symbol); and people eating (a mature person with food around their mouth is not attractive, whereas a toddler with chocolate around their face is somewhat endearing, so you must be the judge of what you consider appropriate).

During the day there may be times when you lose your way in the process, so a good visual guide will help you through these difficult moments. Showing a couple an image that you wish to re-create will help move the day forward and also convey to them the vision you have for the shot, placing you all on the same wavelength.

In the plan that follows, the wedding is a Church of England ceremony starting at 1pm (13:00) and the guests will be sitting down for their wedding breakfast at 4:30pm (16:30). These times will be cast in stone and are the parameters you will be required to work within.

PHOTOGRAPHER'S TIMETABLE

Arrive at bridal preparation	10:30 latest
Leave for church	12:00 latest
Arrive at church	12:15
Ceremony starts	13:00
Register signing	13:45
Recessional	14:00
Formals inside the church	14:10
Bridal departure for reception venue	14:40
Reception	16:30

BEFORE YOU LEAVE HOME

The great day is now upon you and all the preparation has been completed.

All the master and reserve batteries are fully charged, enough for a complete day, reserves in the bag. CF cards or storage media have been formatted in the camera you intend to use so it is ready to shoot; camera and lenses are all in working order, lenses cleaned and flash guns functioning correctly. Set the shooting format to RAW. If there will be a slideshow at the evening function, ensure you have a camera set to shoot JPEGs, as there will not be time to process RAW files. If you are working with more than one camera ensure file numbers do not conflict with each other and the times set on all cameras are the same.

The planning sheet has been printed with extra copies for the ushers, or indeed anyone who offers their support on the day. Water bottles are filled and all the required equipment loaded into the car, not forgetting all the backup equipment.

Your vehicle should be in perfect working order. However, you must have the number of the local taxi service should you need them, or alternatively you have someone who has transport and is available for a quick rescue. Set the sat nav with the location where the bride is getting ready; compare with the printed hard copy of the church and venue location, to ensure it is not going to take you out of your way or down a cul de sac, as it may well be a location you have not yet visited. A hard copy map is essential as satellite navigation can have its own agenda, taking into account any potential road works that may be in place requiring significant detours, thereby impacting upon the allowed timings. When planning your route consider your options between major and minor roads or motorways or freeways; the latter, when closed, will provide you with no options to detour. Make sure as best you can

that there are no road works that will impact upon your planned timings resulting in time-consuming delays. One last check of the weather forecast and travel conditions on the route you intend to take to ensure nothing has changed from the night before.

Once the car is packed, before you leave, make one final check that you have everything you need for the day; there will be no going back. Have a checklist of all the items you need, including back-up equipment – do not rely upon just your memory.

SHOOTING THE PREPARATIONS

10:30 The Bride Getting Ready

With the ceremony time scheduled for 13:00, you should plan to arrive at the location where the bridal party is assembling in sufficient time to allow photography of the hair and makeup being done, concluding with the dress being put on.

Upon arrival (invariably earlier than you told the bride so as not to place yourself under any pressure), take time to look around the location, which may well be new to you. Look for where the light is; it may be better for you to ask the bride to have the dress shots done in the conservatory instead of the box room if it is cluttered with empty boxes, clothing and so on, and provides little room for you to work in. There may be wedding paraphernalia around the house that is relevant to the day, providing the opportunity to shoot candid still life shots – not images that will go on the wall, these will be shots that provide background images for the wedding album, developing the story of the day.

Having looked around and satisfied yourself where the shots are, start shooting any of the preparation that is available to you. Maybe the mother has prepared some food and drinks for everyone, the champagne is out of the fridge and the glasses are ready for charging, or maybe the father has placed an apple and chew bar in his shoes on the floor and that's his food for the day – it is all part of the story.

Your choice of lens may be varied, depending upon the opportunities, it may be a long focus 70–200mm for the candid bridesmaids shots, or a wide-angle/fish-eye for some close quarter work developing your creativity. Throughout most of the day you will be working with either manual mode, aperture priority or shutter priority, depending upon the type and style of image you wish to create. Still life may require a shallow depth of field at f2.8 separating the subject from distracting backgrounds, or you may need a greater depth of field from f8 to f16 when shooting candid groups. Given the degree of clutter that may be present around the house, a larger aperture could prove useful. Keep your eyes and ears open for scenarios that may be developing and be prepared to change either lenses or cameras to suit the situation.

If the hair and makeup people are working, look out for opportunities to shoot this stage of the preparation. Watch out for reverse mirror shots, details of the back of the hair, and the veil, before placement on the head, as a still life, or as it is being fitted.

Maybe the makeup artist has done their work so you will need to mock up this element of the process to obtain the shots. During the morning ensure that the bridesmaids will have their dresses on in preparation for the bridal shot when the dress is being put on. You will need to orchestrate certain situations throughout the morning to ensure that your timeline is not compromised.

▲ During the bridal preparation you should allow time to shoot all the details that are relevant to the day. *38mm @ f3.2 1/60sec*

▲ Sometimes you will need to set the shot to produce a creative image. This image is for the album. *200mm @ f4 1/100sec*

▲ The lacing on the back of the dress is an important part of the process, but hands add interest. *45mm @ f2.8 1/160sec*

Flowers

At some point the flowers will arrive, and you will want to photograph the bouquet and the button-holes for the father of the bride, father of the groom, the groom, ushers and others who have qualified for one.

Shoot still life sets, using available light where practical; the use of flash is not mandatory, after all there is an off switch. If the available light is working for you then go for it. If flash is required, and it is on the camera (but better on a removable bracket taking it away from the lens axis), then bounce from an appropriate surface, preferably white, as coloured surfaces will produce an undesirable colour cast. Place the flowers in a location that produces the correct visual effect you want, maybe by a window, on a table with a useful background, such as a dark wood with a great patina that works for the image, even a slatted bench, using the lines of the bench to draw you into the image can produce a stunning creative shot.

▶ Do not forget the corsage and button holes if they have arrived.
200mm @ f5.6 1/200sec

▶ Boutonnieres or buttonholes can be placed on a suitable background to help isolate the subject.
195mm @ f5.6 1.125sec

The Dress

Before the bride has put her dress on, have your assistant set out the dress for a still life shot of all the elements the bride will be wearing on the day. Great care is needed during this process, as any damage to the dress will be unforgivable. If this component fills you with dread then leave it out, it is not worth running any risk for the sake of a single image. However, if you are happy to proceed then set the dress out on, say, a bed, displaying the bodice and placing the shoe, or shoes, jewellery and flowers in a imaginative way to produce a tight still life shot. Be very aware of any dirt on the soles of the shoes if placing on the dress; if in doubt place alongside.

◀ You should allow time to photograph the dress, jewellery and shoe details before the bride puts them on. Be careful when placing the shoe on the dress, and check the soles are clean.
15mm @ f2.8 1/60sec

▼ Sometimes you may have the opportunity to photograph the hanging dresses if they are not in protective covers.
40mm @ f4.5 1/250sec

Also watch out for the bouquet, as very often florists will spray them or have placed them in water to keep them fresh. If in any doubt, as with the shoes, do not place them on or touching the dress. Finally be alert to any flowers that will present a severe problem if placed anywhere near the dress, such as lilies. It may be that the florist has removed the offending stamens a day or so before they turn fluffy and ripen. However that is no guarantee that they are clear. Lily pollen from the stamens will stain almost anything it touches.

Shoot the dress still life with the lens that produces the image you are trying to create, maybe a shallow depth of field using a 70–200mm or a deeper depth of field with a 24mm or maybe a fish-eye, watching out for background interference.

The more traditional dress shot is with the dress hanging, shoes on the floor, getting down to floor level shooting with a deep DOF to ensure both shoes and dress are sharp.

Getting Dressed

Time is moving on and it is now time to consider shooting the bridal dress being placed on the bride with the lacing up being carried out by the brides-maids. You will need to leave for the church by 12:00 noon at the latest if your travelling time to the church takes fifteen minutes, so keep a close eye on the bride's progress and if needed just suggest, not demand, that she may consider putting the dress on. The last thing you must do is place the bride under any additional stress or pressure than she may already be under; you are there to help and support, not obstruct.

Get all your equipment ready for the shoot; maybe a standard 24–70mm lens will suffice due to the close environment; however, consider a wide-angle or fish-eye for the more innovative images. It is at this point the female photographer may be able to produce a complete process, while the men among you will retire to the other side of the door, unless the bride is happy for you to stay.

▼ If the bride has chosen designer shoes, then make sure you capture the label – she has paid a lot of money for them! *42mm @ f2.8 1/125sec*

▶ A still life set of the dress, shoe, bouquet and jewellery. Proceed with extreme caution when producing this shot so as not to damage the dress. *200mm @ f4 1/200sec*

As soon as the dress and undergarments are on and the bride is happy for you to rejoin her, come back in and shoot the lacing of the dress or any other process that presents itself. Look for busy hands, the bridesmaids' expressions, the bride's expression; time is getting close for her so the emotions may well start to take hold, and you can develop the story.

Final Shots before Leaving

At this point you will either leave for the church or stay to photograph the bride and whoever is giving her away. More often than not you will be able to capture them when they arrive at the ceremony venue so there may be no requirement to record their leaving, but this will depend upon the bride's

choice. Usually they will prefer to have photos of guests arriving at the church instead so that is where you need to be, unless you have a second shooter who can cover for you.

One last opportunity may present itself with the arrival of the wedding car, so find a few minutes to photograph any details of the car, especially if it is a vintage vehicle or anything out of the ordinary. Use the angles, get down low, look for oblique viewpoints so as to create imaginative pictures, not just record shots. These images could well work with reduced opacity as background images for the album, as part of the preparation process.

If you are happy that you have captured every-thing that is on offer say your farewells and travel to the ceremony venue.

▼ These images of the bridal preparation involved the photographer getting down low for the shot. *50mm @ f6.3 1/25sec*

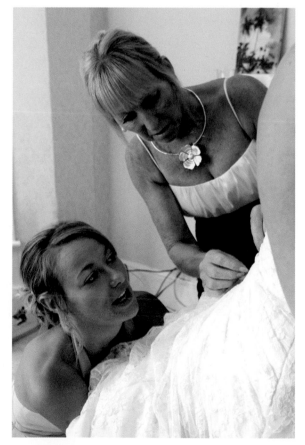

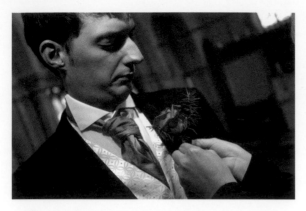

▲ When preparing the groom, make sure that the cravats are tied correctly, tidy and tight. Not like this. *30mm @ f2.8 1/160sec*

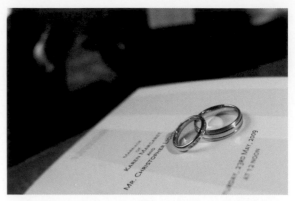

▲ The ring shot is an important image and can be photographed in many ways. Try to be creative. *15mm @ f3.5 1/500sec*

▲ Another approach for the ring shot is to use an LED light to create the heart shape shadow in the spine of the bible, selecting appropriate text. *70mm @ f4.5 1/1000sec*

10:30 The Groom Getting Ready

At the same time as the bridal party photography the groom's group may want images of their preparation. To comply with this request, and if you are shooting on your own, it will help if the couple are getting ready in close proximity – the same hotel for example – as you may well be required to be in two places at once. This is where a second photographer is a considerable asset as they can concentrate on the guys whilst you work with the girls.

The Rings

Check that the best man has the rings, and produce the ring shots, developing your lighting with off camera flash and knocking back (under exposing) the ambient light to create an edgy but striking shot.

Use your assistant to hold a speedlight on a pole with a soft box directly over the groom, best man and ushers. If the ambient is relatively low, say f5.6, consider setting the flash output to its maximum f22 and shoot at this aperture. The resulting background will underexpose by four stops and go dark, isolating the hands with the rings and the faces. This will make a stunning double page spread in the album, on a black background with the groom on the left hand page looking to the right at the ushers and best man holding the ring facing to the left.

Cravats and Buttonholes

Guys struggling to tie cravats may also present a humorous interlude with tight cropped images concentrating on confused expressions. It is not unusual for the guys to have some difficulty tying the cravats, so if you have a knowledge of how to tie cravats it could well be helpful at this stage.

At some point the buttonholes may appear, having been delivered to the bride's location and carried over by a helpful usher, providing the occasion to shoot the placement on the lapels. There will also be cuff links being fitted at this stage so look out for story telling episodes.

▲ When the groom's nerves start to kick in, look out for the quick slug of Dutch courage. *200mm @ f2.8 1/80sec*

12:15
YOUR ARRIVAL
AT THE CHURCH

During this phase of the day, the workload could be heavy, so planning and preparation are critical.

Upon arrival, if by car, ensure you park so that other guests' arrivals do not obstruct you, as you will need to leave the ceremony venue either just before or just after the bride's departure so park strategically in preparation for a speedy departure.

In the forty-five minutes you have, get yourself sorted with the equipment that you require for the signature shots in the church afterwards. Check your off-camera flash is functioning correctly and take a reference light reading, either with a meter or in camera if you feel confident to adjust the light without recourse to a meter. Preparation at this point will save you countless minutes later and help your work flow.

If you have not been to the venue before take a little time to explore the angles, and investigate the access to a balcony if one exists. If you are proposing to shoot from the chancery step then check your exit route when the bride is in position.

While you are in the church, before people arrive take a shot of the pew end flowers, if there are any, using them as the main focal point, and with a relatively shallow DOF and a wide-angle or fish-eye produce a creative shot, filling a third of the frame with the flowers and the stained glass window in the background. This should not be just a representative or record shot but an image that heralds the forthcoming ceremony.

If you are proposing to shoot from the back of the church then place yourself as far back as possible so that guests do not seat themselves behind you, and give yourself sufficient space to work. Set up the tripod, if you are using one in the church, and make sure all the equipment you anticipate using is close to hand: lenses, CF cards, batteries, cable release,

We all expect the bride to be nervous and maybe tearful, but consider that the groom may also be feeling exactly the same, so watch out for these moments of emotion. It could well be that Dutch courage, or even the hair of the dog is being indulged from a hip flask, which may well appear again in the church just before his bride walks down the aisle.

12:00 Depart for the Church

As soon as you have completed all the shots for the bridal/groom preparation leave for the church to arrive in good time to set up and catch the guests arriving. If the bride wants you to stay to capture her departure with her father then you will need to make some adjustment to your timings, but remind her that you will be seeing her at the church when she arrives with her father, and she may be happy with you going on ahead, whichever is the simpler option for you. However, you should have resolved all these options during the pre-wedding chat.

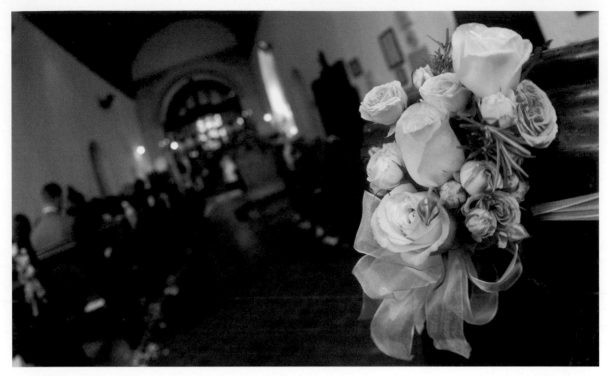

▲ During the ceremony, there should be time to photograph the pew end flowers, using a shallow depth of field to draw your attention. *15mm @ ƒ3.5 1/80sec*

tripod bracket, water and so on, as there will be no opportunity during the ceremony to collect forgotten equipment from the car.

12:10 Guests Start Arriving

Things will now start happening, with little opportunity to control developments as guests start to arrive in small groups or as couples. Consider working at 200 ISO (maybe 400 ISO in the winter or low light conditions), using your long focus lens 70–200mm on a monopod and working in AV (aperture value) with servo focus engaged. Ensure that you have a shutter speed sufficient to capture movement, maybe around 1/125sec or 1/250sec; however, given the lighting conditions your shutter speed may well be higher, enabling you to shoot without the monopod, recording the guests as they arrive. Shoot from 3/4 and tight cropped head and shoulders on maybe ƒ4 to produce the separation through DOF.

Nearly all of these shots will be candid in nature, and not every one will be successful as people tend to look either down or away, and as couples or groups move towards you the perspective will change.

12:15 Groom and Ushers Arrive

As soon as the groom and his wedding party arrive, consider getting the shots of the best man and groom including the complete groom's group as soon as possible. The ushers will have a job to do, directing the guests to their seats and handing out the orders of service, so catching them before that happens will save you time as trying to find and pull the ushers away from their duties could impact dramatically upon your timing plan. Shoot the shots with the ushers first so they can be released to exercise their duties.

◄ Sometimes a
photojournalistic approach
to the groom's arrival
is all that is needed.
70mm @ ƒ5 1/200sec

◄ With all the groom's party
requiring buttonholes, there
will be plenty of opportunity
to get the images.
105mm @ ƒ5.6 1/80sec

Start with capturing the groom's party's attempts to put the buttonholes on, if they have not already been fitted; if they have been fitted just mock up the shot maybe with your assistant's hands, as they know what image you are looking for and could save time. Traditionally the men's buttonholes are on their left lapel (your right). All the buttonholes, cravats and jackets need to be on before you attempt the groom's party's photographs.

Make sure that all cravats are tied uniformly and jackets are either done up or undone, so they are all the same and are hanging smartly, and ensure all pocket flaps are out and not crumpled. It is traditional for the bottom button of the waistcoat to be left undone. Watch out for cigarette packets, keys and so forth that create unsightly bulges in pockets.

▶ Find time to prepare the groom's wedding party for the ever-popular *Reservoir Dog* shot – either a straight line or staggered, depending upon the size of the group and the space available. *64mm @ f4 1/200sec*

▶ When shooting the groom's party, go in for the tighter shot. *140mm @ f6.3 1/400sec*

Working quickly, pull the groom's party together; ensuring you have them all together before you shoot, it may be the *Reservoir Dogs* shot you start with, setting them either in a line or staggered, at the start of the path to the venue. Work with your 70–200mm lens, instructing the group to walk towards you at a steady pace, shooting in TV at around f8/f11 to ensure sufficient DOF for the whole group. When you have large numbers, with several layers and some depth to the group, you should start with the whole group but will no doubt find that the perspective changes as they get closer to you, with the guys at the back being lost behind the front line, so you will start working on a tighter crop of the groom and best man as they get closer to you. Working this way will provide a variety of images from the same shoot, especially if you repeat the process several times, checking to make sure you are recording what you want and that your shutter speed is fast enough to freeze the action.

There may be occasions when the groom wants real action shots of them either running or maybe leaping in the air; if that is the case then you may need to increase the shutter speed. If you find that when you do increase the shutter speed, the aperture changes to a larger one then consider changing the ISO if you need to maintain the desired shutter speed/aperture ratio – the eternal triangle.

▲ And then tighter still, isolating the groom and the best man.
145mm @ ƒ6.3 1/400sec

How you shoot the groom's party is entirely up to you and will depend greatly upon the couple's choice of images, so be flexible within your plan. It may be they have no interest in the action shot and prefer more natural and candid images. As soon as you have finished with the ushers, release them to continue their duties.

You will be required to capture the groom with his best man with either 'man hugs' or just in the more formal shaking of hands. Do not be afraid to show your creative side and develop your imagination capturing the close bond between them. Shots of them both walking away, quirky images and if the ceremony is a civil one then maybe photographs of the groom seated at the ceremony table with clasped hands and the ring cushion in front and his best man behind. The use of a shallow DOF will also produce a different feel to the shot and add an element of mystery when focusing upon the groom, including the best man a few feet behind just out of focus looking at the groom.

Throughout this time guests will continue to arrive and create some distractions for the groom. It is important that you try and stay focused, ensuring you capture all the images the groom has requested.

As soon as you have finished with the groom, release him to meet and greet his guests, so you can continue working with your long focus lens, capturing the candid elements, working on AV at around ƒ4 to produce the separation and shallow depth of field. Remember that the longer the focal length, the greater the DOF available to you.

If you have had no opportunity to shoot the rings up to this point then consider shooting them inside the church when you are photographing the groom and his best man in the front pew, placing the rings on an order of service, using a wide-angle lens or fish-eye to produce a low viewpoint image of the rings in focus and the groom and best man out of focus shaking hands or with their arms around each other.

12:45 Arrival of the Officiant/Vicar/Priest

At some point you will need to touch base with whoever is conducting the ceremony, if you have not met them previously, to find out what restrictions they may impose on you during the ceremony. You will only need a couple of minutes just to establish the correct protocols. Every officiant will have their own way of doing things, ranging from no photography at all during the ceremony to a completely relaxed approach, allowing you free reign to shoot. Whatever the situation, there are certain conventions you must adopt out of respect for the situation or venue.

When you approach the officiant start by introducing yourself and stating at the outset that you understand the general protocols and that flash is generally not allowed during the vows or religious elements of the ceremony. This will be different from religion to religion, and it is incumbent upon you to ensure you understand the process. By introducing yourself in this way you are telling the officiant that you understand the procedure and will hopefully make them more relaxed and allow you some scope and freedom to shoot images that they may otherwise not allow.

◀ There may be another opportunity to photograph the ring when inside the venue or church. *15mm @ ƒ2.8 1/125sec*

Once you have satisfied them that you are a professional and clearly understand the potential restrictions, ask them the crunch question: can you stand at the front, on the chancery step in the case of the Church of England, to capture the bride's entrance? Generally there is no objection as they recognize that it is the couple's day and the bride and groom really want the bridal entrance images. If there is reluctance for you to shoot from the front, just try to establish how determined they are and consider pressing the question a little further. If they are intransigent, usually born out of a past bad experience with photographers who overstep the boundaries, then unfortunately you will have no option other than shoot from the back as the bride enters. Fortunately this is more the exception than the rule. Remember you are in their domain and a great degree of respect is required.

A church may offer you the opportunity to stand at the front right hand side, when looking towards the altar, usually where videographers place themselves. Should you decide to stand here then you will restrict your shooting opportunities as you normally will not be allowed to move during the ceremony, so all your images will have a sameness to them. If the couple want shots from this location it may be possible to use a second photographer or set up a second camera on a tripod, and trigger the second camera from your location using appropriate triggers that prove the firing of a shutter – this is a great way of capturing the same event from two simultaneously.

12:50 Arrival of Bridesmaids

Having established the permissible shooting options you will need to watch out for the arrival of the bridesmaids and bride. If they are arriving in separate vehicles then you will have briefed them to arrive with a reasonable gap between them to ensure you are able to photograph the bridesmaids before the bride arrives. Their arrival will be the point at which the groom needs to be inside the venue, as the bride's arrival is imminent. If you are working with an assistant have them ensure the groom is moving inside the venue, as you will need to obtain the groom/best man shots before the bridal processional.

As soon as the bridesmaids arrive, take a little time to photograph them as a group and individually, because you may not have achieved those images back at the house. Make sure they are holding their bouquets correctly for the more formal shots and also try to obtain a few artistic and candid images. A lens in the range of 50mm to 200mm, shooting at f4 and a shutter speed that works with your choice of focal length lens would be ideal. Arranging the bridesmaids at the lych gate or close by as a group, ensuring small flower girls are at the front, take a few formal images. For the group shots consider using a long focus lens that will provide you with more separation from the background, and when arranging the group look out for symmetry, shapes and balance in the group. As soon as you have finished the group set, separate the bridesmaids and photograph them individually using the same lens, positioning them so they are standing comfortably and not square to the camera.

At all times when photographing people start a dialogue with them; there is nothing worse than people with blank expressions – you need them smiling. Very often people feel uncomfortable in front of a camera and it is your job to elicit the right feelings and emotions from them. As soon as you have finished start preparing for the bride's arrival.

12:55 The Groom, Prior to Bride's Arrival

You will now have about five minutes before the bride arrives, maybe a little more if she is traditionally late, but do not count on it. Leaving your assistant outside the venue to keep an eye out for her, you go inside to obtain a few shots of the groom and his best man, crying or drinking from a hip flask or just excited. This is the time to work in manual mode if you feel confident to do so, as you need to retain full control during a process that will just happen with no opportunity to stop.

Whilst taking shots of the groom and best man with either the wide-angle lens or fish-eye, placing them in context within the venue and amongst their guests, take a few minutes to set the ambient exposure on your camera in manual mode, taking maybe a single shot to ensure everything is all right. It is possible to take in-camera meter readings; however, be aware that a camera will record reflected readings and so consider an evaluative reading as all you require is the correct exposure for the inside of the venue. If you are in doubt then just take a photograph using P and read off the settings from the camera menu. At this point you will need to ensure you have a fast enough shutter speed, at least 1/125sec or faster, to capture the bride's movement, as well as sufficient DOF to ensure everything is sharp. You may well need to lift the ISO to a level that you are happy with, without producing too much noise in the image. Modern cameras and sensors will allow ISO settings as high as 6400 or higher before noise becomes an issue. This is where either a wide-angle lens or fish-eye (not everyone's choice) will provide you with sufficient DOF as well as capturing the whole event as opposed to just a bride walking down any aisle at any venue. Take test shots with your flash to ensure your flash compensation.

Now that you have the manual settings in your camera and have completed the groom/best man shots you can exit the venue, remembering to reset your ISO back to the setting you were using outside.

You can revert to shooting in either TV or AV, as the manual settings will be retained in the camera when you access them upon returning back inside the venue, apart from the ISO which will need changing back so remember what ISO you used. By now most of the guests will have found their seats and will be waiting for the proceedings

13:00
ARRIVAL OF THE BRIDE

You are getting to the point where the bride is due to arrive, so consider working with your standard lens around 24–70mm, as you will be required to shoot both outside and inside the car, if that is what she is arriving in – after all it could be a tractor, horse or any other form of transport that reflects her personality or profession. Many strange and inventive methods have been used to add a sense of occasion and fun to the day; the most surreal I have experienced was a mock hippopotamus built around a cart that was pulled by all the guests.

The bridesmaids will be waiting at the lychgate with the officiant hovering in the church porch, the groom inside nervously and all the guests seated.

The bridal transport is imminent. You will have confirmed the type and make during the briefing session, so when a wedding car arrives, maybe in a busy street, and you jump out to catch its arrival you are sure it is the right one. There is nothing more embarrassing than snapping away at the car as it arrives, only to see it sail past and on to another wedding.

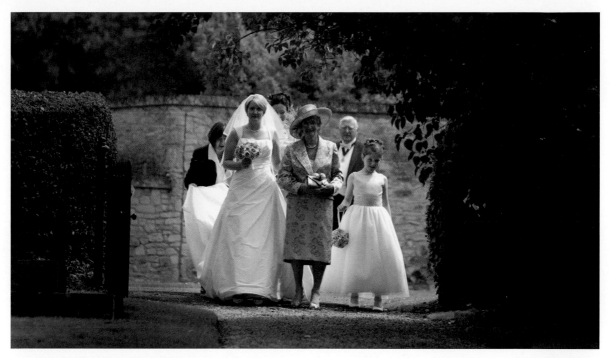

▲ Selecting a zoom lens, prepare for the bride's arrival. You will only have one opportunity to get this right. *200mm @ ƒ3.5 1/4000*

Car Interior Shot

Now that you have captured the bride's arrival, making sure you are not run over, be prepared for the shot inside the car with her father or whoever is giving her away. You may need a lens around 24mm/70mm, depending upon whether you want to bring in the inner surrounds of the car or just a tighter crop. Remember also that these focal lengths are dependent upon your sensor digital crop. A 1.6 sensor will change a 24mm lens into a 38mm due to the digital crop.

Shooting from the front seat, make sure the bride is relaxed by talking to her. It is expected that she may be feeling a little nervous, with an anxious expression you do not want in the images; you are looking for joy and happiness. Take a couple of shots before she exits the vehicle. The type and style of these images will vary depending upon the type of transport; a vintage car invariably has

plenty of space between the top of the seats and roof, whereas a modern vehicle like a Rolls Royce or Bentley will have less. This can present a problem if you are working with your flash on the camera (not the preferred position) and need to use some kind of fill flash, so having your flash on a dismountable bracket, held by your assistant or yourself, is what may be required. Available light will be entering from both behind and the sides, placing their faces in shadow, and you may need to lift this a little using flash compensation.

Half-Step Shot Leaving the Car

What happens next is what is traditionally called the half-step shot as the bride exits the car; it is a little more difficult if she has arrived in a tractor or any high vehicle. As the bride leaves the car it will be her natural instinct to look down either to see where she is placing her feet or to look after the dress. You will

▲ Prepare for the 'half-step' shot of the bride exiting the car.
Give her instructions as to where you want her to be looking.
125mm @ f22 1/125sec

need to be prepared and make sure she is looking at you, with one foot on the ground or running board of the car and the other still inside the car. Talk to her throughout, giving instructions, spending a little time shooting from different viewpoints and angles to win the innovative shots. If you have the time shoot with different lenses for another approach. It is more than likely she will be helped out of the vehicle by her father (or whoever is giving her away) or the driver. If her father is there then make sure you capture any fleeting glances between them – the quick smile, the kiss on the hand, it's all important.

From now on the process will move quite quickly with the officiants hovering, wanting to move the proceedings forward.

Group Shots Outside the Church

Try not to be intimidated and work quickly within your time frame; after all the couple have contracted you to capture their day and the bridal entrance is an emotional and important part of that day.

Place the bride, her father and bridesmaids in a pleasing group at the venue entrance and take some formal balanced images before they start their walk towards the church doorway.

Venues will have different configurations and layouts so work to the situation prevailing. There may be an opportunity for a long walk to the venue entrance so change to a long focus lens, setting the camera either to AV, ensuring shutter speed is sufficient, or to TV if you have concerns about camera shake or subject movement. There are no clear-cut settings, it is all dependent upon the feel you want

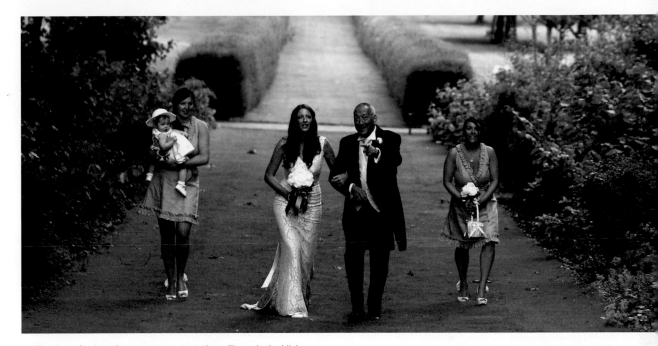

▲ Watch out for those impromptu moments that will pass in the blink of an eye. *185mm @ f5.6 1/80sec*

for the image; with the wedding party walking towards you the perspective will change, much like the *Reservoir Dogs* shot with the guys, the difference being you will only have one chance to get this right. Ask the bride to look at you at some point, as she will no doubt be concerned about her dress on the ground or indeed tripping if it reaches the ground.

As soon as you have created the formal images at the lychgate change to the long-focus lens and position yourself at the church entrance, calling for the bridal party to start their walk when you are ready. Remind them to occasionally look at you, watching out for the impromptu moments, the father kissing his daughter's hand or cheek, which will only happen once and be over in a split second. It is these moments that will ensure a very personal feel to the wedding album.

As soon as the party have arrived at the church doorway take a few minutes to shoot another formal group, pulling into the shot the doorway if it has any architectural or aesthetic value; it is advisable to include elements of the venue in these images to place the event into context. If there are steps, then take advantage of them and place the bridesmaids so that the group is balanced, with little flower girls at the front. One of the problems with churches is that they are usually constructed in an East–West orientation, positioning the entrance on the south side, and in northern latitudes that can present a problem with full sun on the doorway. If this is the case then consider placing the group at a slight angle so the sun produces a carving light on the side towards the back of their faces, and thereby you have some control with fill flash. This will avoid the harsh shadows in the eyes and prevent the groups from squinting.

13:05
PROCESSIONAL

Before the bride makes her entrance she will be given some last-minute instructions from the vicar or priest. At this point move to either the wide-angle or fish-eye to capture some silhouette images framed by the church doorway, maybe from a high viewpoint for fly-on-the-wall shots. Very often, if the bride has a veil you will capture some stunning images with the light filtering through the veil as it is placed over her head. Do not spend too long, as the officiant will move the process along with little warning.

It may be that the officiant will not allow you to shoot from the front on the chancery step as the bride enters, which is a shame as it is an important part of the day when the groom sees his bride for the first time in her wedding dress. If you are prevented from shooting from the front you will need to find a suitable position at the back or side of the venue to capture the processional. Shots of the back of the bride's dress may be possible; however, she may be followed by bridesmaids, which will mask the back of the dress. If this is the case then consider maybe a shot of the groom's face as he first views his bride. Remember the whole day is working to a plan, with contingencies and adjustments required at a moment's notice.

At this point you will need to be at the front of the church waiting for the processional and will need to change your settings to manual. Remember you have already placed them in your camera when shooting the groom, setting a shutter speed of at least 1/125sec to 1/250sec to allow for the bridal approach. Remember the way you shoot these moments is very much a personal one so use the camera settings that you feel work for you.

▶ When the bride has reached the venue door, take time to compose a formal group shot before they enter.
34mm @ ƒ3.5 1/8000sec

If working in manual mode on the camera, the ambient exposure inside the venue or church will be spot on as you have already done the groom's shots on the same setting and all you need to do now is possibly add a flash element. This is a personal approach, as you may feel the ambient and lighting works well enough for you as it is. If you require the input of flash, work with the flash on the quick release bracket, so at least it is not directly on the camera, and maybe your assistant could hold it in an appropriate position away from the camera.

With the flash on ETTL or TTL, consider setting the flash unit onto manual and maximum if you are using a wide-angle lens to shoot the processional. If the flash is on Auto zoom it will default to the focal length of the lens you are using at the time, so setting it to manual will override the default settings and allow you to set maximum zoom. Shooting with a wide-angle lens and using the central focusing point will ensure you are focusing on the bride and that is where the flash will be directed; that will also place the bride's entrance in context, as opposed to a photo of any aisle in any church if you shot with a long-focus lens. The wide-angle will also provide a greater depth of field with the flash picking out the bride. The flash will have virtually no effect when she is at the back of the church (dear old inverse square law); however, as she gets closer the flash will start to have an impact. Remember to use the flash compensation to balance with the ambient light.

▼ The bride's processional will only happen once so make sure all your camera settings are right before it happens.
15mm @ f3.5 1/160sec

The officiant may walk down before the bride, at a discreet distance so that they do not mask the bride and the bridesmaids. Every wedding is different so be prepared to adjust your plan; however, it should have all been clarified at the pre-wedding meeting or the rehearsal if you attended.

As soon as the bride is alongside her future husband you will need to move to your preferred shooting position. If it is at the front, maybe alongside the videographer, on the right as you look at the front of the venue you may find that there are obstructions like lecterns – or indeed the officiant – that block your view. If you have elected to shoot from the back then you will have ensured the chief bridesmaid will clear a way for you past the dress, especially if the aisle is narrow and it is your only way out. Another option may be to exit through the vestry if the vicar or priest allows. Also ensure that the chief bridesmaid lays the dress out properly, as a crumpled dress is virtually impossible to change during the wedding service and cannot be corrected in Photoshop either.

▲ Cameo images can be captured from the back of the church during the ceremony. *200mm @ f5.0 1/160sec*

13:05
THE CEREMONY

With the tripod set – the only time during the whole day when you should consider using one as it tends to restrict spontaneity – you can relax a little, taking a drink of water maybe, and start shooting the ceremony.

Work with your full range of lenses ensuring you still have an adequate shutter speed, as your subjects may move even if your camera does not. Look for tight-crop and wide-angle images, watching out for the little cameo shots when children look back at you out of curiosity. If there is a stained glass window behind the altar then you may need to bracket your exposures and resort to a little HDR (high dynamic range) imaging as the contrast range between the venue's ambient light and that which is coming through the window will exceed the camera's capabilities. At the time of writing the new cameras entering the market will produce HDR images in camera.

There may be an opportunity to move during elements such as the hymns or readings. This will depend considerably on the religious faith, as each has its own sequence of events. You must be aware of the critical elements during the ceremony, such as the exchange of rings and the couple's first kiss as husband and wife, or maybe the Communion rite, so you can be in a position to capture these moments. With both the ring exchange and the first kiss it is likely the couple will face each other so your position is critical to capture this important element.

At the outset there may be spontaneous acts by whoever is giving her away, such as a kiss on the cheek, as her hand is passed over, or by the groom with an expression or reaction, so watch out carefully and be prepared to shoot spontaneously, as the moment will be lost in the blink of an eye.

◀ If the venue lends itself to it, take the long shot; this is where they are being married and your images need to reflect that. *15mm @ ƒ5 1/80sec*

▼ Remember to ask the bridesmaids to make sure the dress is laid out correctly before the ceremony starts. *70mm @ ƒ3.5 1/30sec*

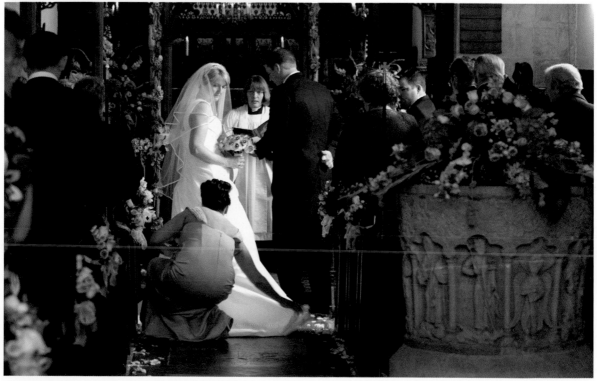

▶ The venue may provide the opportunity for the candid shots during the ceremony. Only move during hymns and speeches.
15mm @ f3.2 1/60sec

▶ You may need to bracket your exposure to capture the stained glass window as well as the couple.
75mm @ f3.2 1/100sec

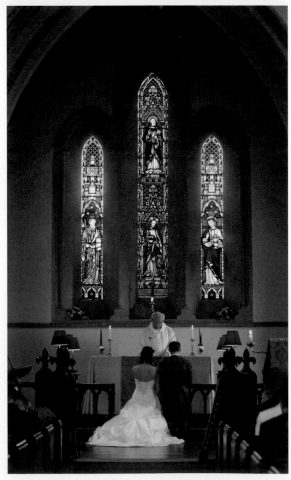

There will be cameo moments – the readings by the guests, the speech by the vicar or priest, the communion – so familiarize yourself with the procedures and timings.

There will be relatively quiet times during the ceremony, providing some time to ensure that your remote flash and other equipment is ready and functioning for the formal shots later.

It is common practice for the officiants to prohibit the use of flash during the religious elements, so you will have to crank up to the highest ISO possible without generating noise in the image, working with what you have in terms of lighting. The lighting indoors will vary considerably from venue to venue and it may be that the natural light is overpowered by the artificial light, so check your colour balance and change the setting in the white balance colour temperature settings in your camera. If you are

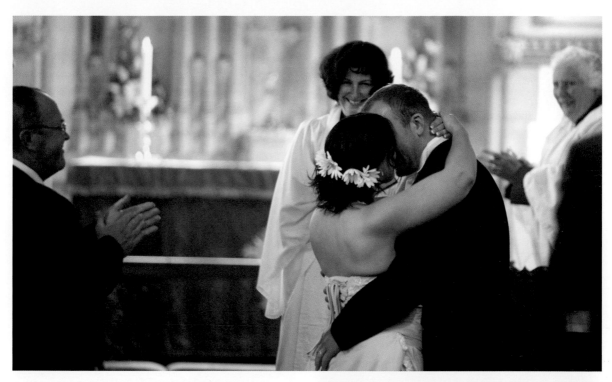

▲ Be prepared for the kiss that could happen very quickly. *200mm @ ƒ2.8 1/50sec*

unable to do so, just use the appropriate pre-sets such as tungsten. If you are shooting RAW then you will be able to make adjustments later on the computer. Many a photographer just sets AWB (Auto white balance), and hopes the camera will sort it out.

13:45 Register Signing

Traditionally there is a signing of the register, the official part of the ceremony, with the couple, now married, parents and witnesses proceeding to where the register is being signed. Your choice of lens will be determined by the signing location, as some are carried out in front of the guests, in the church or venue. Some venues have dedicated rooms and some are carried out in what is called the vestry, usually a small room at the side of the church. The one location that can present the most problems is the vestry as it is invariably small, badly lit and is full of church paraphernalia.

▲ During the signing of the register, take time to prepare a shot of the hands, maybe holding the pen. *200mm @ ƒ3.2 1/125sec*

You will normally only be allowed to photograph the signing after it has been completed. However, there may be opportunities to shoot fly-on-the-wall, photojournalistic or storybook images, remembering that it is illegal to photograph the register itself. The officiant will ask the couple to sign the register and then the witnesses, and when completed, hand the couple over to you for the formal set-up shots of the signing, with the register pages invariably turned to a blank page.

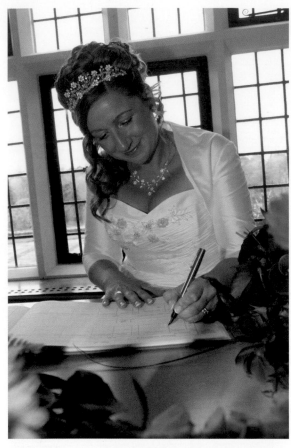

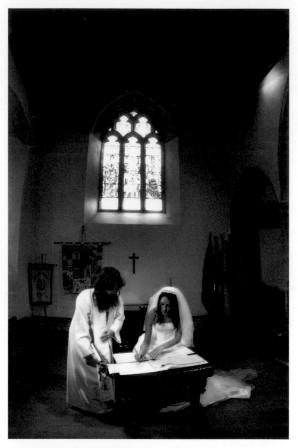

▲ The bride signing the register is a must-get shot, followed by the couple signing, then the witnesses. *34mm @ f8 1/125sec*

▲ Pull back and place the signing of the register into the context of the venue. *15mm @ f3.2 1/125sec*

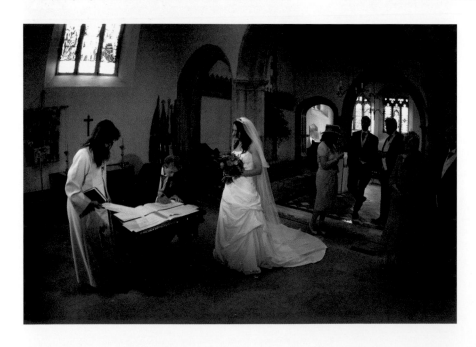

◀ If space allows, pull back for a long shot of the signing. Make sure the lighting works. *15mm @ f2.8 1/125sec*

It is usual to place the bouquet on the table with the register. Photograph the re-enactment of the signing working with the available light if sufficient or maybe with the addition of flash, working the flash compensation to balance with the available light. It is important to take time to ensure that your exposure is correct before shooting all the sequences, so that you can concentrate on the composition and creative elements. Use a standard lens for the more formal images; however, consider using a wide-angle or maybe fish-eye, focusing on the bouquet bottom right or left of the image with the couple out of focus – it's a different approach to the same subject matter. Naturally you will shoot images with the couple in focus but when you have the must-gets, expand your horizons and look for the different angles and viewpoints.

You should only require about five minutes to complete your programme before handing back to the officiant. As soon as you have finished you will need to get back to a point in the venue where you can shoot the recessional.

14:00 RECESSIONAL

It is time for your assistant to start packing up all your equipment in preparation for leaving the venue (that is, if you are not returning to shoot the signature image inside the church).

The couple will move to a position, possibly in front of the altar, in preparation for their first walk as married couple. You need to position yourself ready for the couple's departure, followed by the main wedding party. Consider your position for this emotional component. Finding yourself at the back of the aisle will allow the guests/paparazzi to creep out into the aisle in front of you to photograph the couple and spoil your opportunity; however, placing

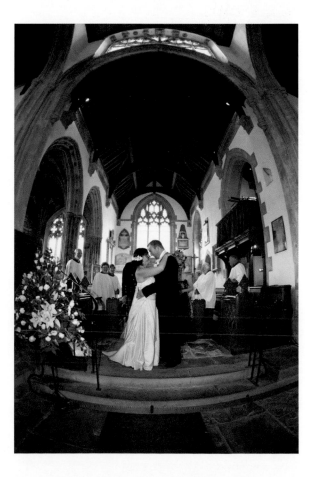

▶ When the couple are ready for the recessional, hold them at a pre-determined position for a controlled shot. *15mm @ f2.8 1/160sec*

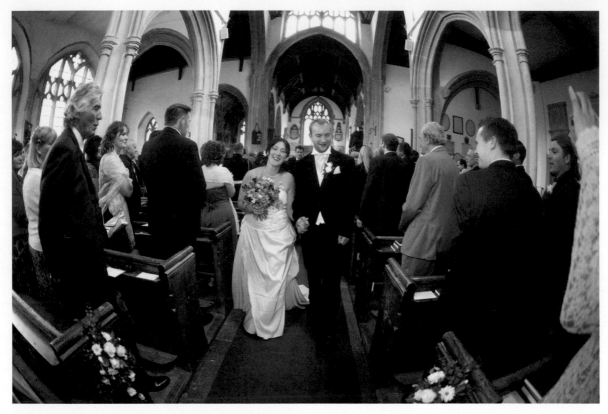

▲ Try the photojournalistic approach to the recessional, walking backwards shooting from a high viewpoint. *15mm @ ƒ2.8 1/160sec*

yourself about one-third of the way up from the front (chancery step) will enable you to maintain control of the situation as the couple approach.

Stop for the Formal

Having a pre-determined point for the couple to stop will allow you to compose a formal photograph with maybe a kiss, if they are happy to do so. You will have briefed the couple about this moment; however, given the occasion, they will not remember so make sure you give them a clear indication that you want them to stop. Take just a little time to get this right, using maybe a lens that will capture the architectural magnificence of the building as well as a tighter crop of just the couple. Remember that there is more than just one opportunity to take

a variety of images using lens choice, aperture and viewpoint. Do not feel that you are under any pressure to get this right; keep a cool head, difficult under the circumstances, and make sure you have everything you planned to take.

Once the formal has been taken, indicate to the couple that they can proceed down the aisle. You will consider changing to a wide-angle lens, providing increased depth of field and pulling all the guests into shot, as you will now be walking backwards as the couple approach, making sure there are no small children who have stepped out into the aisle to compromise and trap an unwary photographer. There is nothing more embarrassing then falling foul of an unsuspecting obstacle behind you, not to mention the possible risk of injury or equipment damage.

◀ The formal group in the
church using height
separation, shot with a
stand alone speedlight.
43mm @ ƒ5.6 1/60sec

The subsequent recessional images may well be of a photojournalistic nature, capturing the couple's joy and happiness as they proceed down the aisle between their guests, to tumultuous applause and multiple camera flashes from compacts. In the days of film these multiple flashes used to present a problem as you had no opportunity to check the image, but that is no longer the case so don't worry about flash compromise; after all there is little you can do to stop them so just go with the flow.

Consider shooting from a neutral viewpoint as well as a high viewpoint and using a fish-eye or

wide-angle lens. When using the 15mm fisheye do not shoot too close to the couple, as dramatic foreshortening will cause distortion. The wide-angle or fish-eye is used more as a tool to produce incredible depth of field, and at the same time pulling the moment into context with the venue and guests included and producing something different. When shooting from a high viewpoint you will not be able to view the image through the viewfinder so a holistic approach to shooting is required, getting a feel for the angles and shooting when the lens has stopped shunting and has locked on focus. Experience and time will help you develop this skill. If you are unhappy with the use of a fish-eye, or indeed do not have one, then use a wide-angle that will add the possible benefit of no peripheral distortion. Incidentally the degree of fish-eye distortion will depend upon your digital sensor crop; the smaller sensor (1:6 crop) will produce less fish-eye effect than a full frame sensor (1:1).

Doorway or Porch Formals

The recessional will no doubt culminate in the venue doorway or porch where you will want to produce some formal images of the couple prior to leaving. There are shots to be secured from behind the couple as they look back, where you may need to balance the ambient light streaming in through the doorway with flash compensation if using camera flash. If you are not using any supplemental lights then you will need to expose for the couple, allowing the background to overexpose. If the background is important then you may well need to invest in additional lighting. Very often the porch will present a number of problems, the least of which is the clutter and notice boards that adorn such doorways so you will need to use some form of creative crop to eliminate them.

It is now time to move on around the couple, to shoot from the front and capture the more traditional image of the married couple in the doorway. If the wedding is at midday in the northern hemisphere on a cloudless day, it is likely the sun will be streaming into the porch producing harsh shadows across the doorway. Keep the couple back in the shade and add light to them, either with a flash or reflector, although the latter may present a problem with the angles. Adding light to the couple will help to key shift the available light on the outside of the door, but there may still be an element that blows out or overexposes. If this is the case then consider a tighter crop to lose the overexposed elements.

Now you can put your fish-eye or wide-angle to creative use by pulling back and including the church fascia and clock tower. If there is a clock and it displays the right time, consider including it in the shot, setting the time into the bridal exit shot.

Moving Back Inside

If it is your intention to take the couple back into the venue to produce stunning portrait and group images, you will not want to leave them in the venue doorway as this will create a receiving line and will have a dramatic impact upon your time and workflow. With a receiving line you will have little option than to shoot candids, something the couple may want; however, if they want the formals more inside the venue, then move them away from the doorway, and take the opportunity to shoot them with their parents on the shaded side of the venue.

You will have instructed your assistant to let you know when all the guests are out of the venue, triggering the moment you will take the couple, and maybe the bridesmaids back inside. This process is of course weather-dependent and if wet you will have a different plan, leaving all the guests inside the church and shoot the creatives in front of them all. If this is the case; first check with the officiant and wardens that it is all right and at the same time ask the guests to refrain from shooting with their compacts during the process.

So the weather is fine, and you have made it clear to all the guests that you are going back inside and will only be about fifteen minutes, asking them to

▲ If the bridesmaids return back inside the church, take a few images with the bride. Children will not always look in the direction you want them to. *58mm @ ƒ4 1/80sec*

be ready for the confetti throw as soon as you come back out. If the weather is bad and you are forced to take group shots in the church, then you may well need to start them before any confetti throw commences.

As soon as the couple is ready you will need to get them back inside the venue. This may present some problems, as they will be meeting and greeting, so you will need to be a little assertive and pull them away from their guests as you will be mindful of the time constraints. Having a sixth sense about time as well as the lighting is always a great asset for any wedding photographer.

14:10
FORMALS
INSIDE THE CHURCH

Take the couple and bridesmaids, if any, to the pre-determined location inside the venue and start with the bride, positioning her, laying the dress out at its best. This is the role of your assistant, as you will be checking the ambient and setting the supplemental lighting, flash or continuous lighting to the correct balance. As you have spent time on the lighting before the ceremony it should be more or less right and require minimal adjustment, working with an appropriate light modifier, either a soft box or shoot-through umbrella, to soften the supplemental lighting and produce a pool of light over the bride.

▶ When you have photographed the bride and the bridesmaids, set up the couple shot. Watch out for the groom's feet around the back of the bride. *24mm @ f3.5 1/80sec*

Watch out for the shadows under the nose; and remember the larger the light source relative to the subject the softer the shadows. Once you have the lighting right in its balance, position and quality, you are ready to shoot, concentrating now on posing and composition.

Ensure the bride is sitting comfortably – the more comfortable, the more relaxed she will be – and check the dress is positioned as you want it. Give her instructions on posing and holding the bouquet as well as eye contact; constant communication helps to keep her attentive. Remember a smiling bride is a

happy bride. Working with a wide-angle and a good portrait lens (135mm for full frame) shoot a range of images, changing the pose, expression, hands. There are thoughtful photographs to be had, with the bride holding her bouquet in one of her hands outstretched on the dress, looking at it thoughtfully which means she does not have to look at the camera; this allows her to relax her face and not smile. If the bride is standing, have her place her weight on the back foot that will serve to throw her hip forward making for a more feminine pose. In all of these poses watch out for problems associated with her position, particularly for what is often referred to as bingo wings under the arms, produced when arms are outstretched and gravity takes over.

After you have finished the bridal images, pull in the bridesmaids, if they are there, and arrange them around the bride, with flower girls or smaller bridesmaids at the front. Having them all seated will help minimize the relative heights and allow the dresses to be set out. Make sure they are all holding the bouquets in the same way and when shooting they are all looking at you. There may be distractions, so constant instructions and conversation from you will encourage them to look at you. If you have set the lighting as a large soft light you should not need to make any changes to your exposure; just watch out for shadows cast by one bridesmaid onto another. If there are shadows consider moving your light closer to the camera but the same distance from the group, elevated to just above eye line, producing butterfly shadows under the noses. Little flower girls may present a small problem as they have a short attention span.

After you have completed the bridal group, pull in the groom and start producing the couple's images both seated or standing – it's your choice. Should they both be sitting, be careful that the groom's legs are not sticking out behind the bride, looking like a strange leggy growth from her back. It may be a little uncomfortable for the groom, but it will only be for a very short time. If the groom's jacket is buttoned

then watch out for it riding up and looking just wrong, so have the groom undo the buttons so the jacket sits properly.

Develop the poses between the couple, maybe including a kiss if they don't mind. There are people who do not like kissing shots, but if that is what the couple want then why not? Take time to consider the background, as undesirable elements may spoil the shot, such as emblems on the cloth over the altar that will look like wings growing out from the bride's back or candles growing out of their heads.

If you feel adventurous then pull in another light and separate the bride and groom, with the bride sitting and the groom standing behind her, looking at her. He will need to be lit separately but at the same exposure as the bride. The variations are not endless, but there are many possibilities when shooting the couple. Time will be your largest constraint.

14:30
CONFETTI THROW

As soon as you have completed all the formals inside the church take the couple to the church lych gate, the main gate entrance to the church grounds and start preparing for the confetti throw. It may be that the couple prefer to have the throw at the reception rather than the church; if this is their choice, and providing the reception venue has no objection, then develop that plan. There may well be restrictions on where you can throw the confetti, and it is usually prohibited inside the church grounds.

How you arrange the party for the confetti throw will depend upon how much space you have available. If you are able to use the church grounds then consider using an avenue of guests, with the couple walking towards you as the guests throw the confetti. Use a long-focus lens to produce a tight crop to the image, working on A1 servo, thus

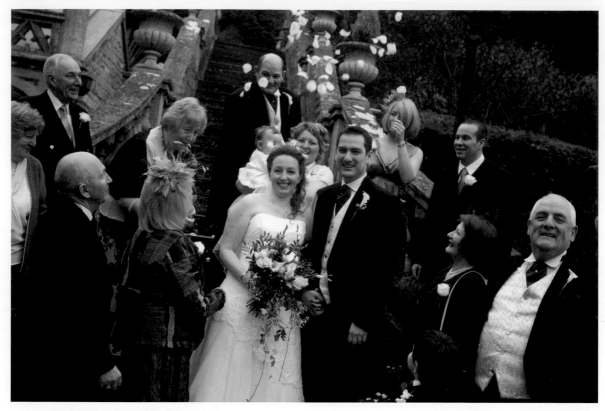

▲ The confetti throwing may well be back at the reception venue
as most churches will not allow confetti in their grounds.
34mm @ ƒ2.8 1/200sec

greatly increasing the probability of correct focus
for moving subjects. (Canon refers to A1 servo
whereas Nikon cameras refer to this as 'continuous'
shooting.) Have the shutter priority with at least
1/250sec, about ƒ8, shooting the couple as they
progress towards you. The one-shot mode is
susceptible to focus errors for fast-moving subjects,
since it cannot anticipate subject motion. Draw
in all the action that is taking place, with hands
throwing confetti. If you have a situation where only
a few people have brought confetti ask them to do
a pretend throw, as no one will know whether they
have thrown any or not once it has left their hands.

Try and make sure the couple keep their eyes
open, but it is all right if they do not as it is all part of
the process.

If you are unable to produce an avenue then
group everyone tightly around the couple, with
parents closest and children in the front. If you have
no option other than to shoot on a narrow footpath
alongside a road, as is so often the case, ask the limo
driver to move the car back a few feet so that you
can at least stand safely in the space on the road, and
this will allow the group to spread further forward.

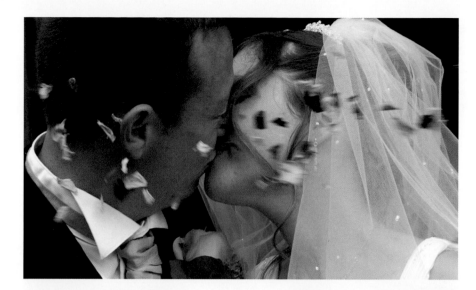

◄ On with the zoom
lens and go for the
tighter cropped image.
70mm @ ƒ10 1/200sec

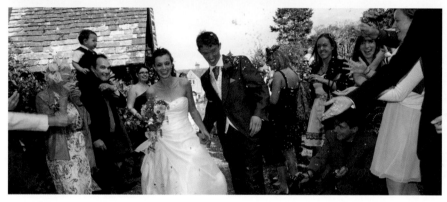

◄ If you have the space,
then create an avenue
for the confetti throwing.
28mm @ ƒ11 1/125sec

Once you have the group positioned with children and parents at the front you need to set your camera onto A1 servo or continuous focusing mode, shutter priority of at least 1/250sec and ƒ8, to ensure you have sufficient depth of field for the group. Control the group on the throw; make sure they do not throw before you are ready, and shoot a test shot just to make sure all is as you want it with the exposure before you start the action. Asking the group to throw on a count of three ensures you will be ready to capture all the action. You may consider shooting this action several times with different viewpoints, high and low with a wide-angle lens to capture as much of the group as possible. Shooting several times gives you the opportunity to change angles and develop a collage of images; then consider a tight crop of the couple with a longer focus lens, with confetti cascading around them. If they are kissing at this point it does not matter if their eyes are closed. There are times at a wedding where you may be able to experiment a little and this could be one of those times. You have shot on a relatively fast shutter speed so now consider a slower speed with the couple holding their heads steady and have guests throw more confetti over them; you should be able to capture the movement in the confetti with a shutter speed of either 1/60sec or 1/125sec.

Watch out for the cameo moments when the children pick up the confetti from the ground; get down to their level and produce some great saleable images that parents will buy.

14:40
BRIDAL DEPARTURE

As soon as the confetti shots are completed the couple will move to the car and may be presented with some glasses of champagne by the driver before they enter. These days a wide range of transport is used for the getaway, so you will need to adapt to the situation. You may well be required to shoot the couple in the back of the car, the first time they are on their own as a married couple. There are many ways to shoot this moment, either through the windows or doors, with the couple looking out, or from the front seat looking back at the couple. Make sure they are close together; however, some forms of transport may make it difficult, so just work the situation to produce a great shot.

If working inside the car you may well need to use supplemental lighting like flash to balance with the available light spewing in from the side and back windows producing unlit faces, much like the shoot with the bride and her father before the wedding. Balance the flash, if being used on camera, with flash compensation to ensure the couple are lit correctly and not over-lit or too flashy. Watch out for how the couple is positioned, where the arms and bouquet are placed. There is a tendency for grooms to position their legs in the most comfortable position which will not necessarily be the most flattering, so pay attention to how he is sitting.

As soon as you have completed all the required shots, which should only take about five minutes at most, the couple will leave.

You will have spoken to the driver to establish his route to the reception venue, and having parked strategically you will ensure that you are able to leave in front of the departing bridal car so as to arrive at the venue first. It may be that the couple want a shot of the car leaving with all the guests waving; if so then ask the driver if he can take the couple on a sightseeing tour, while you take the most direct route to ensure your early arrival at the venue.

It is at this point that you will have an opportunity to take some refreshment, before you start driving, as the day is long, and there may not be any sustenance for you at the venue. So a quick sip of water, maybe a banana or energy bar and drink to keep you going.

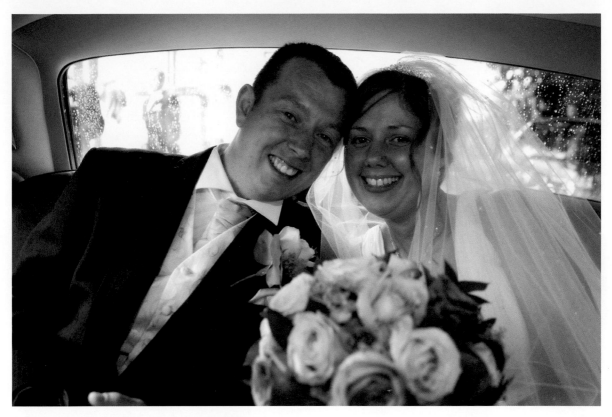

▲ You may need to use a little flash for the formal inside the car photograph. However, some cars will have a low roof and make life a little difficult. That's where an assistant is useful.
25mm @ f2.8 1/200sec

Chapter 10

Working the Day: The Reception

15:00
ARRIVAL AT THE
RECEPTION VENUE

- -

As soon as you arrive and have parked the car, position yourself to capture the couple's arrival, if the venue and location lends itself to an arrival image (after all you do not want an image of the car passing an unattractive background). Working with a long-focus lens at around ƒ4 will produce a shot of the arriving car separated from the background, giving it some prominence and importance.

PHOTOGRAPHER'S TIMETABLE

Arrival at reception venue	**15:00**
Candids	15:10
Group sets	15:20
Creatives/signature shots	15:45
Guests and bridal entrance	16:30
The wedding breakfast	**16:35**
Mock cake cutting	16:40
Speeches	16:50
Bouquet throw	18:30
Evening function	**19:00**
First Dance	20:15

▼ An oblique angle helps to add energy to the car's arrival at the venue, but also shoot it straight. *58mm @ ƒ7.1 1/200sec*

15:05 Half-step Shot Leaving the Car

Position yourself for the bride's departure from the car. It is at this point you need to ensure you are communicating with the bride, as you should be doing at all times, because as she leaves the vehicle you will again want to capture the half-step shot. It is natural for any bride to look down to ensure her dress is not going to get damaged or snagged as well as placing her feet safely; if you do not hold her in the half-step position you will miss the shot, and talking to her will ensure you do not capture a shot of the top of her head. This process should only take a few minutes, including additional shots of the bride looking at her groom or back through the car window; so just let your creative juices flow.

Whilst the car is still available take a few images around the car with the couple with the venue in the background. If there is a prominent badge on the car, come in close and play around with depth of field and viewpoint.

As soon as they are out of the vehicle they may be presented with glasses of champagne so position yourself in the most strategic point to capture the first sip. Very often this is shot in a photojournalistic style; however, if you want to compose a shot then do so. Couples these days do seem to prefer the more natural images so looking for the best viewpoints and angles will help towards producing a creative natural image.

15:10 Candids

From this point you will have around ninety minutes to shoot a wide range of situations, including the groups, the couple's creatives or signature shots, table sets, the cake and maybe the cake cutting, all combined with casual and candid shots.

You may not be able to start the group sets until all the guests have arrived and may need to change your shooting plan if the couple are happy to start with the creatives. The point at which you shoot the groups or creatives will depend upon timings, weather and the availability of people for the groups, so be prepared to adapt.

If you are not in a position to shoot either groups or creatives then concentrate on photographing candid images of guests arriving and talking. Working with a long-focus lens at around ƒ2.8 to ƒ4 will ensure a shallow depth of field, using differential focus for subject separation, producing those relaxed informal images that make people look natural. Consider tight cropped shots of the drinks and canapés as they are brought out to the guests, showing all the detail at its best.

▼ A single speedlight was used to create this image, with a little judicious help in Photoshop. *24mm @ ƒ20 1/200sec*

◄ The groom helping the bride out from the car always makes for an image that adds to the story. *38mm @ ƒ13 1/160sec*

▲ Take some time to photograph the arrival drinks; get low with an oblique angle. *50mm @ f11 1/160sec*

▲ At this time the canapés may be brought out, so capture the food before the guests have eaten them. It also works as a panoramic image. *180mm @ f18 1/500sec*

15:20
GROUP SETS

The weather may impact upon your programme, requiring you think on your feet and adjust the sequence of events to work around any potential problems. Assuming the weather is fine and you prefer to shoot the groups first, which can be one of the least creative elements of the day, start rounding up all the required participants. Do not start shooting the groups until you have everyone available however, as guests will become impatient if they are forced to stand around waiting.

You will have your shooting list with you, and your assistant will be there to ensure that the bride's dress is always laid out correctly. There are a number of ways to develop the group, either building from small groups, the bridesmaids and groomsmen for example, or starting with everyone and peeling off the guests not required for the next shot. Either way works, and it just comes down to personal preference.

Shooting with a standard lens (24/70mm for a full frame) should produce the desired results, given that every situation is different and so you will need to adapt if necessary. Shooting at around $f8$ should provide sufficient depth of field ensuring everyone is sharp; however, this will depend considerably on the depth of the group – the deeper they are arranged the greater depth of field you will require, so $f11$ may well be the order of the day.

Direct the groups with an air of authority to ensure you retain their attention, maybe pulling in a little humour – not jokes, more observational humour that is relevant. It is important to achieve a situation where all the guests are smiling, and if you stand there without appropriate direction you will more than likely get blank expressions. Do not ask guests to smile, as that will elicit a false smile, hence the use of humour.

The group shots process will vary considerably depending upon your personal preferences and the couple's requirements. In the briefing what you do not want to do is provide the couple with a list two A4 sheets long of shots you can take, as they will undoubtedly select them all, so offer them the limited set of ten group images from which they can add or subtract, and on the day you will have the shoot list close at hand.

▶ Not every photographer or guests enjoy the formal groups, so try to complete them as quickly as possible.
30mm @ f7.1 1/160sec

At all times have an eye on the time as you will need to take the couple around the venue to shoot their creatives. Shooting groups should not take any longer than thirty minutes, any longer and guests may start drifting away or becoming impatient. The level of planning you put into it will be reflected in the smoothness of the whole operation, but be mindful that every plan needs an escape route; be prepared to modify the running order or add any additional last-minute requests from the couple.

15:45
CREATIVES

The entire group shots are done, with a great sigh of relief, and the couple have had a chance for a quick drink and comfort break, and now you will need to take them around the ground to the pre-determined locations for the creatives. With a light stand, off-camera flash, light meter (or maybe not), light modifiers and so on, you will anticipate working quickly to produce the images that the couple will almost certainly have in the album, as well as pride of place on the wall, either as a stretched canvas or framed Giclée fine art prints.

▼ There may be an opportunity to take the bridal creatives in another location other than the venue, providing you have the time.
105mm @ ƒ3.2 1/4000sec

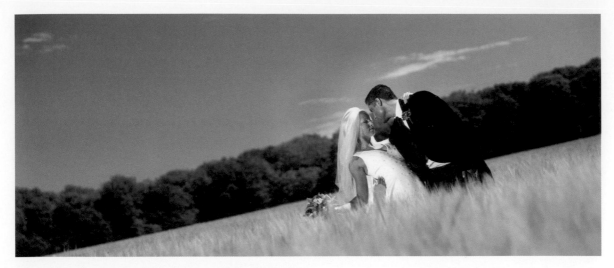

▲ If you are working 'off piste' for the couple's creatives, make sure
you are not trespassing; always get permission. A barley field made
a great location. *95mm @ f4.5 1/320sec*

You will have around thirty minutes, maybe; it
all depends upon the time the couple is required to
sit down for their wedding breakfast (and also the
possible need to shoot a mock cake-cut, if you are
not staying through the meal and speeches). If you
have planned correctly you will know exactly the
shots you want, the lighting you need to create it;
this is not the time for experimentation and winging
it. Providing your assistant is conversant with the
equipment you will be able to give precise directions
to them so you will not have to spend time changing
flash settings and so forth and can just concentrate
on the couple posing and composition as soon as
the lights are balanced and the exposure is correct.

It is important that this part of the day is just for
you and the couple. Be polite if any guests try to tag
on, and request they hold back, offering them the
opportunity to photograph the couple later. This
is your time, and your time only. The only caveat
I would make is if the bride wanted one of her
bridesmaids in attendance or the groom requested
the best man – at least they can carry some of the
equipment.

One of the biggest problems with any kind of
wedding photography, if you are new to it, is the
speed at which everything happens, and there will
be times when the red mist will descend. Having
something like a visual guide or crib book in the
camera bag will help to diffuse such a moment.
Shooting the creatives is such a time. Do not be
frightened to show the couple the image you have
in mind to shoot, as this will help put them on the
same wavelength as you, moving the process on
quickly.

Work with a range of lenses, if you have them,
shooting from different viewpoints and angles,
developing your own style. It may help the process
to show the couple a few of the great shots you have
produced, making them feel involved in the process.
Remember to capture the images they have shown
you at the briefing, naturally with your own interpre-
tation, as these are must-get shots. Once you have
the shots you have agreed upon, consider maybe a
few different images from the visual guide, adding to
your repertoire of sets. It is these creative shots that
will help to enhance your reputation with images
that have not been captured by any of the guests and
will feature in the album.

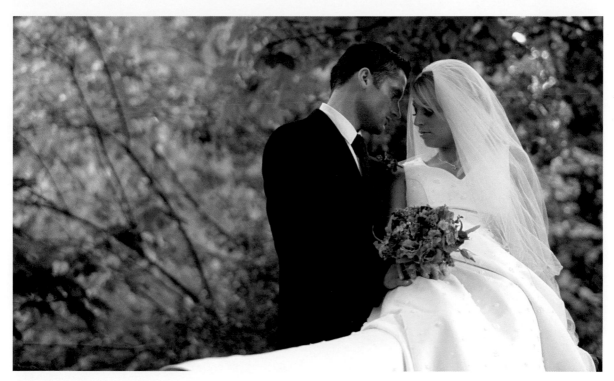

▲ Many a shot can be converted to black and white, making them timeless. *90mm @ f2.8 1/125sec*

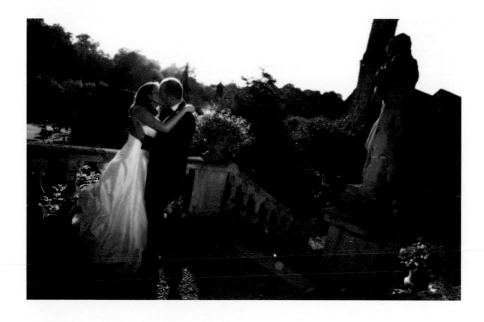

◄ Strongly back-lit subjects may need to be lit with flash if the sun is so low in the sky that it provides little reflected light. *24mm @ f22 1/125sec*

16:15
RECEPTION DETAILS

Time will now start to close in on you, as you are now required to shoot the table sets and room layout before the guests enter. It may also be necessary to photograph the mock cake cut; if not you will have a little extra time for the details.

Shooting with every lens you have in your arsenal, photograph the table layouts and table details, not forgetting the flowers and favours.

Consider using a fish-eye lens from an elevated position, hand held, to create a high viewpoint of the table as it is laid out, hopefully with the tea lights lit, if there are any. Use the zoom for shallow depth of field images, separating the subject from what may be a confused background, and take a wide-angle shot of the whole room before it is disturbed by the guests when they sit down. These are all required images, naturally taken with your creative eye. There should be time to photograph the cake and its details; these days couples tend to be a little more creative with their choice of cake.

▶ The couple will always want images of the table layouts showing all the details.
95mm @ ƒ3.2 1/200sec

▶ Some venues will provide chair covers, something the couple will have to pay for, so make sure you record the details. Shoot with a zoom lens for shallow depth of field.
200mm @ ƒ2.8 1/80sec

16:25 Couple Shown the Room

It is more than likely the couple will be shown the room before the guests enter to ensure they are happy with the layout and appearance. It is at this point you may capture a few couple shots with the room as a backdrop or if you are not staying for the speeches and meal you can photograph the mock cake cutting. If you are staying, shoot the couple with the cake before, during or after the speeches and the meal. Times will vary depending upon the couple's request, or the nature of the cake; some cakes are used for the desert so the caterers will require it sooner than later.

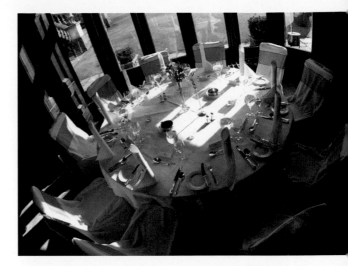

▲ Natural light through a window is all you may need to create the table layout. The one switch on the back of the speedlight that is underused is the off switch. *15mm @ ƒ13 1/100sec*

16:30
GUESTS AND BRIDAL ENTRANCE

The master of ceremonies, if there is one, will now start to direct all the guests into the room, with or without a receiving line. Should the couple or venue have requested a receiving line, then the bridal party will be positioned at the doorway ready to receive all the guests for the kissy-kisses and handshakes. From the photographer's point of view these receiving lines present somewhat of a problem in that it will be difficult to capture angles that work without backs of heads featuring regularly. Invariably you will need to bounce your flash to prevent hard unflattering images. A large white ceiling by the receiving line would help immeasurably. All that may be required is a representative shot of the line with a few candids.

As soon as the receiving line is finished everyone in the bridal party will be asked to sit down, with the exception of the couple, who will be given the opportunity for a comfort break. During this time you should determine the route they will take to enter the room, as there is no point you being on one side of the room when they process down the other. When they return they will prepare for their entrance, and then everyone will stand, so ensure you position yourself where your field of view of the entrance is not blocked.

Your choice of lens at this time is a personal one, depending upon the feel you want the image to have; a wide-angle will pull in the whole atmosphere, whereas a tight crop of the couple may elicit their expressions. As the couple is moving, ensure you have an adequate shutter speed of 1/250sec at least, working with an ISO setting that helps you achieve this, with an aperture of around ƒ4/ƒ5.6. Remember these are only provided as guidelines as every venue and lighting will be different. You may also need to do a colour balance before shooting, as it is likely there will be a strong cast from tungsten or fluorescent lighting.

16:35 The Wedding Breakfast Begins

Once the couple is seated there may be the oppor-
tunity to capture one last shot before the meal starts.
Consider using either a wide-angle or fish-eye, if
you have one, to photograph the couple together,
seated at the table. Have them pull their chairs
together and kiss, if they wish. Shoot from a low
vantage point, focusing on the table flower arrange-
ment or the bouquet, on a very shallow depth of
field, ƒ2.8 if you have it available to you, producing a
stunning shot with the flowers in focus in the corner
forming one third of the image and the couple
centred, out of focus.

As soon as you have completed the final shot
before the breakfast, you will either have some quiet
time while everyone eats or you will be process-
ing some images for a slideshow to be shown later
during the evening function. There will be no more
photography until either the cake cut or the speech-
es. There may also be the opportunity to photograph
the plates of food that are brought out, with the
permission of the caterers. This is an occasion
where you can not only capture those background
images for the wedding album but also develop your
network by supplying images of the plated food to
the caterer, with your credit included – there are
always marketing opportunities.

At some weddings the cake cut is done straight
after the couple has sat down, followed by the
speeches. If that is the case then be prepared.

16:40 Cake Cutting

The timings for either the cake cutting and speeches
will vary considerably, depending on how long the
meal takes, so be alert to the proceedings. It could
well be that the venue's wedding coordinator or
the master of ceremonies will keep you informed.
During your 'quiet time' you should consider chang-
ing your batteries for fresh ones and place the spent
ones on charge for later; you will of course have
plenty of spares.

▲ The final shot before the meal, wide angle in close to the bouquet
or table flowers with the couple deliberately out of focus, maybe
kissing. *15mm @ ƒ4 1/2000sec*

How you place the couple will no doubt be
governed by the position of the cake, and if neces-
sary, consider asking the caterers or venue to move
the cake to a more accessible position. Only do this
if there are severe problems with its original posi-
tion as moving a wedding cake can be a recipe for
disaster.

Place the bouquet on the table in a position that
works aesthetically, and place the bride forward of
the groom, relative to your shooting position, having
the bride hold the knife with both hands, one under
the knife the other over, to show the ring on her left
hand. Pull the groom in behind his bride, placing

▲ The cake details are important so take plenty; the digital medium allows us to take as many as we want to. *51mm @ f5.6 1/50sec*

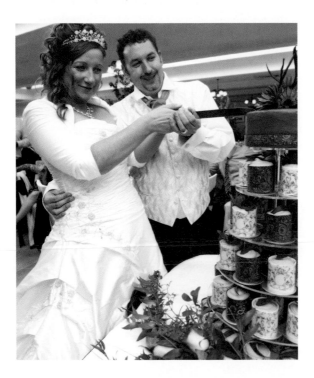

his left or right hand around her waist and his other hand holding the knife from underneath. Position the knife on the cake and shoot a number of images before the actual cut. When the couple are ready for the cut be prepared for facial expressions during the cut; for example a heavy fruit cake may take some effort to cut, eliciting strained expressions and hope-fully laughter, whereas a sponge will hardly touch the knife. These are very brief moments in time that are so much part of the day and need to be captured to convey to the viewer of the picture the joy and fun that was experienced.

◄ The cake cutting is a required element of the day. Explore the angles and maybe use a tight crop on the hands. *24mm @ f5.6 1/125sec*

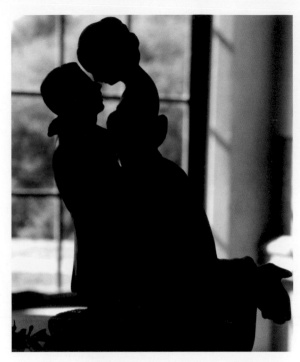

▲ Silhouettes are a different approach to the same subject so be creative. *68mm @ f22 1/100sec*

▲ During the speeches, there will be candid opportunities. However, do not stand in front of guests when photographing. *200mm @ f4 1/60sec*

You will have all the guests wanting to capture the same sequence of events, which could interfere with your ability to produce the shots the couple are paying you for, so consider suggesting to the guests that you shoot first and they can have their turn after you have finished; in fact, some master of ceremonies prepare this for you. Consider carefully the shooting position, looking at the background and consider shooting with the guests in the background, requiring the couple to have their backs to the guests, problem solved. As soon as you have taken all your photographs turn the couple around to face the guests to give the guests the opportunity to shoot the couple. Now you can start photographing the guests photographing the couple.

16:50 Speeches

The speeches may take place at the beginning or end of the meal, so liaison with either the master of ceremonies or the couple is prudent to ensure you do not miss them. Ideally you will need to select your longest focal length lens, on a monopod maybe, shooting from around the room, in positions that provide you the best viewpoint. The problem very often associated with these candid shots is the available lighting which is more than likely tungsten, i.e. yellow, and using bounced flash is problematic due to the distances involved. It may be a consideration to shoot with just the available light, something that modern cameras handle extremely well due to the high ISO settings available and adjust the colour balance either to tungsten or use the specific colour temperature for the room lights which will have to be achieved through test shots.

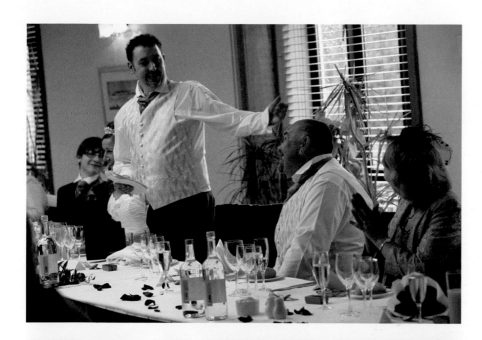

◀ Capture the animated moments during the groom's speech; it's all about when the shutter is pressed.
110mm @ f5.6 1/60sec

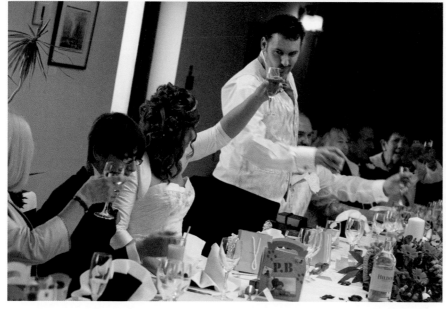

◀ Watch out for the impromptu moments and any toasts.
108mm @ f5.6 1/60sec

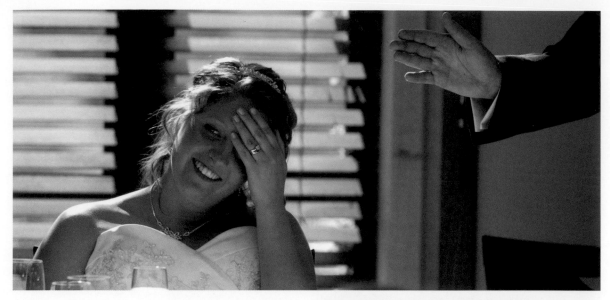

▲ There could well be many emotional moments, so a long lens on a monopod from the back of the room will catch it all without being too obtrusive. *200mm @ f3.5 1/1600sec*

Another problem will be selecting your shooting viewpoint, as you really should not obstruct any of the guests from watching the speeches. Working the perimeter places some restrictions on you due to guests, table flower arrangements and bottles of wine, etc., in the way.

Watch out for the couple's reactions to the speeches, laughter, embarrassment, love and tenderness towards each other during either the best man's or father of the bride's speeches. Go for tight cropped images and pull back to show the whole scene. Turn the camera on the guests, watching out for their reactions to the speeches, working with the long lens enabling you to be unobtrusive, capturing those genuine moments that convey the atmosphere and mood of the occasion. These images will be candid in nature and as such look unforced and un-posed in the true tradition of photojournalist photography.

▲ Look out for the unusual. There will be many people with compact cameras or video so make good use of the opportunities. *200mm @ f2.8 1/125sec*

17:30 Interval

After the speeches, or maybe before, depending upon the programme, you will have time to reflect upon the day, before the evening function starts and new guests arrive. During this time, apart from having something to eat and drink (not alcohol), you may need to select a number of JPEG images for a slideshow in the evening.

If you were unable to shoot all the signature shots earlier there may be the opportunity to take the couple out, after the wedding breakfast and when they have freshened up, to shoot some more images, where the light could also be better. If you

are committed to taking creatives after the meal, then ensure that both the bouquet and buttonhole are kept fresh; there is nothing worse than a tired flower. Also make sure the couple has not spilt any food or drink on their clothes; if they have and it cannot be removed then mask it in the photographs.

18:30 Bouquet Throw

The timing for the bouquet throw can be variable, sometimes before the meal, in which case it is likely to get damaged and be unusable for future shots, so some couples have a standby bouquet to throw, thereby protecting the original.

The process of the throw has two elements to it – the throw and the catch – so shooting it twice, if you do not have a second shooter to hand, is one way of capturing both elements. Setting your camera to a fast shutter speed, say 1/500sec, prepare for the throw, and like the confetti throw consider doing it on the count of three so you ensure capturing the moment.

When you have completed the throw, repeat the process but this time concentrate on the capture, positioning yourself so you record the expressions. Consider a position where the catchers will lunge towards the bouquet full of anticipation and excitement, setting your drive to AI servo so the lens will track the movement.

At some weddings the evening function can continue on directly after the breakfast, whereas some will have a small break in between. Take time to prepare yourself for the evening guests arriving and the inevitable first dance.

19:00
EVENING FUNCTION

During the evening function the couple will be more relaxed, presenting further chances for candid images.

One of the problems often associated with shooting at this time of day is the lighting, particularly for winter weddings, as there will be no natural light to work with; it will all be artificial and may well involve multi-coloured and flashing lights from the DJ. Adjust your colour balance to suit and shoot test shots to ensure everything is captured faithfully; however, as the lights are likely to be multi-coloured you will inevitably arrive at a compromise. Again high ISO settings are a great advantage, and beware of using a speedlight as it will kill any atmosphere or ambience that has been created and will sanitize the lighting the couple and DJ have gone to great pains to produce.

Working with all your lenses, from telephoto to wide-angle and maybe fish-eye, work to capture the mood. Watch out for the new guests and the meets-and-greets with the couple. From this moment on, your shooting is more likely to be storybook in nature, as the relaxed environment may not lend itself to formal groups or orchestrated set shots. That is not to say there may not be any opportunity because moments may arise that may need a little thought, for example a drinking contest between the groomsmen, or a ring viewing by the bridesmaids.

20:15 First Dance

You may have been given a time for the first dance to start; however, timings do not always follow the plan and delays are common. You will have had enough time to prepare yourself for the first dance, making sure you have fully charged batteries in your flash, if you are using one, and you have a fresh storage media in your camera, as there will be no time to change mid-dance. Have a word with either the venue coordinator, or the DJ if he has control of the room lighting, to ensure the background lighting is sufficient to prevent your lens from shunting (not focusing when on auto focus). They will probably be happy to lift the lighting to a level that works for you. Consider seriously whether you really need to use flash, as it will wash the available lighting that may be a mixture of party, UV, laser and multi-colour lights.

Ensure you have sufficient shutter speed to capture the movement or alternatively consider dragging the shutter, with the flash, to create the movement that is ultimately frozen at the end of the sequence when using second curtain sync. You will need to set your dedicated speedlight to fire on the rear curtain sync to ensure the movement precedes the element captured by the flash. Your choice of settings will be dictated to some degree by the nature of the first dance; after all, a slow smooch will be completely different from a barn dance, where there is a great deal of fast movement and energy, and you will want to capture the essence of the dance.

Slow dances by nature are more romantic in style and require a different approach. Working with the couple on the slow emotional dance, you may want to capture the close intimacy that will develop during the dance as the couple becomes absorbed into the moment. Give them space, whilst at the same time capturing the close bond between them, working the situation as it unfolds. Consider pulling right back to shoot a full length shot, maybe with all the lights playing on them.

Consider shots with and without the flash, as there will be the opportunity to shoot both, and in so doing you will create different emotional responses to the images. Remember to continue telling the story. By now you will no doubt be feeling exhausted and it is times like this that you need to be even more focused.

The completion of the first dance may well be the end of your commitment. However, if you have the energy and want to enjoy the party there are often fun, spontaneous and just silly images that can be captured as the party develops. Alcohol is a great liberator.

Finally the couple may be leaving in their chosen method of transport, and capturing the departure would complete the day. Whether you stay will be conditional upon your stamina, the contract you have entered into or just because you are having fun.

▼ The first dance presents a great deal of romantic moments – often in difficult lighting conditions, however. *35mm @ f2.8 1/100sec*

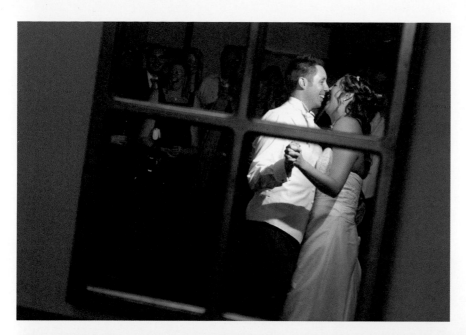

◄ Look for the angles during the first dance. Mirrors can provide a different approach, but watch out for your own reflection.
35mm @ f2.8 1/100sec

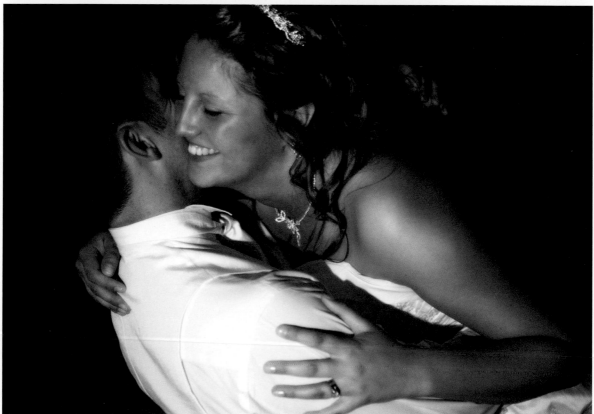

▲ The couple will be very relaxed during the first dance.
42mm @ f2.8 1/100sec

Chapter 11
Digital Workflow

When you get back in the studio what you are trying to achieve is a fast workflow that enables you to have some free time, especially if you are a busy wedding photographer, shooting multiple weddings in a week (hopefully only one a day). If you take several days to process hundreds of images you will find that you have no recreational time and that will ultimately have an impact upon your work.

The software you use will be a personal choice, depending upon whether you use a PC or a Mac; it will also depend upon your budget, that is, do you buy the latest software or work with what you have? There are many ways to achieve the same result, and what follows is offered as one scenario.

BEFORE YOU LEAVE HOME

Before every wedding there are certain checks and processes that you will need to carry out to ensure you have a successful day without any technical incidents. Checking the function of your camera is an obvious one. So when checking make sure that your numbering system is not going to conflict with any other camera you may be using, either yourself or a second shooter, because at some point you may want to combine the images into a single folder. It may be that one camera is shooting RAW and the other is shooting in JPEG – that will be sufficient to prevent any overwrite when you get back to the studio and upload the images. If you have a sequence that will overlap during the day and your

prefix (imp_) and suffix (.jpg) are the same on both cameras, then you will need to rectify the situation by either changing the prefix or suffix or just setting one camera to zero. Whichever way you do it does not matter, as long as you eliminate the risk of duplicate image numbers on both cameras.

While setting the image number sequence also make sure that both cameras (assuming you are using two cameras) have the same time set so when you combine the images from the two cameras you can sort them into the correct time frame.

Format all your storage media in the camera in which you are going to use them, checking first that you have uploaded and stored all the images that are on there from previous shoots. Ideally do not commit to shooting a complete wedding on one card; you only have one chance to get it right and should anything happen to the single card then you have a problem. Consider shooting each sequence of the wedding on a single card so the complete day is spread between multiple media. It would be disastrous if you had a single card either fail or get damaged, whereas losing just a small portion of the day, whilst bad enough, is not a total failure. These days it is possible to use cameras that capture onto multiple media, which is a more secure and safer route to market; however, they are quite expensive pieces of equipment.

Set the camera to the shooting format you wish to use, preferably RAW, as this will enable you to change some of the shooting parameters in the RAW conversion software. Try to use the same manufacturer's software as your camera, as this will ensure conformity throughout the process.

UPON RETURNING TO THE STUDIO

Backing Up!

As soon as you return from the wedding you should start the back-up process, taking all the storage media (CF or SD cards) and uploading to the computer. Your aim is to achieve storage of the wedding images in at least three locations, one of those preferably offsite at a different location altogether. As soon as all the images are loaded onto your computer, hopefully with a back-up system in play, you can start to relax a little.

Unfortunately there is no such thing as 100 per cent safe storage, whether it be DVDs, stand alone hard drives or off-site storage, none of them are fail-safe systems. Therefore multiple storage formats should be a serious consideration if you are committed and/or contracted to retain the images. You could alleviate the situation by supplying the couple with all the high-resolution images, and then the responsibility becomes theirs. There are of course problems associated with relinquishing the HR images, allowing the couple to do what they want with them, the least of which is the possibility of the couple printing out the images on inferior media, placed into a far from satisfactory album and presenting it as your work. You make the commercial choice.

Now that you have all the images safely backed up, copying the original RAW files from the camera to archive storage as the ultimate backup, you can start to process the images.

Culling

No doubt you will have shot hundreds of images, even thousands, because you can – not like in the days of film where you needed to be selective. The digital age has not only changed the way we shoot images it has also changed the nature of wedding photography, making it a more photojournalistic process as opposed to a formal one.

Your first port of call will be to scan all the images in your choice of editing software, deleting all the images you do not want the couple, or anyone for that matter, to see. Remember you should have them all as RAW files direct from the camera.

Viewing thumbnails is a very quick process; however, you will not be able to judge adequately whether the image is of a suitable quality or sharp. Yes you can make a creative assessment, but you must only show clients images that are correctly exposed and sharp. So select the film strip option available in most quality image processing software and scan through the images, tagging those that you wish to delete. Once you have selected all the poor quality images, select all those you have tagged and delete them. You are now left with every image you are happy to show the couple.

Which Images to Show the Client?

Some photographers will only show the couple a very small selection of images in preparation for the album design, asking them to select only the images they like, and from this you can start preparing the album. There are other photographers who will prepare a finished album from their own choice of images, not allowing the couple to view all the im-ages taken. This is your commercial choice and the one you choose will suit your workflow.

If you intend to show the client all the images (minus those previously deleted) and now have a definitive selection, process a few with any effects you wish to show the couple. You will not need to work all the images at this point, only a selection, showing the couple what you can produce in the way of either black and white, selective colour (colour popping) or any other process that you feel works with the selected images. In practice working about three per cent of the images should be all that is required to illustrate your creative style.

POST-PRODUCTION

Many photographers will consider that any subsequent work to the image should be kept to an absolute minimum to help reduce post-production time. Whilst this has some validity it is vital to provide the couple with the best images you can offer, and judicious processing should be considered.

There are a number of software providers that offer similar post-production opportunities including Adobe Lightroom and Apple's Aperture; however the industry standard is Adobe Photoshop, either Elements or the full version.

As a starting point you must make sure that exposure levels are correct, using either the curves adjustment or levels in Photoshop to help control the contrast range and overall tonal quality of the image.

The problem with post-production is that some processes can become dated, moving in and out of fashion. The degree of post-production will depend greatly upon how many weddings you are shooting, as just shooting a couple may well allow you the opportunity to devote more time to the process whereas shooting several weddings a week will require a streamlined approach. However, there are a number that should always be considered.

▲ The use of curves adjustments can be intimidating. However, understanding how they work will add another dimension to your images.

▲ The outer sliders adjust the black and white points in an image. When the shadows (left slider) are clipped, the pixels will be black and highlights (right slider) will be white, with no detail, a situation definitely not wanted in a bridal image.

▲ Black and white is timeless and Photoshop provides considerable control when converting to B&W. The simplest being image > adjustments > Black & White.

▲ To create duotones, tritones and quadtones, you will need to discard the colour information select image > mode > grayscale, then you will have access to Duotone that previously was greyed out.

▲ Once you have image > duotone you will have the option of Duo, Tri or Quad tones. Selecting Custom you can pull down a large number of presets. This example is Bl 409 WmGray 407 WmGray.

▲ Similar adjustments can be made in Adobe Lightroom including histogram and curves adjustments.

Being Creative

Once the exposure has been corrected you can now consider more creative post-production. Try converting to black and white, for example. The process of black and white conversion can be achieved a number of ways in Photoshop, the simplest being image > adjustments > Black & White that will pull in an adjustment tool enabling control and allowing colour channel input.

In the days of film when processing was completed in the darkroom, various techniques for toning images were used, and these can be replicated in Photoshop using duotone/tritone and quadtone to capture these classic effects.

Some of the other creative options run the risk of being overused, such as the colour popping and zoom effects, processes that should be used with caution. Creating a black and white layer on top of the colour layer in Photoshop and then erasing the black layer where you want the colour to pop through produces the colour popping or selective colour process.

The use of a zoom or spiral effect that can be found in Photoshop > filter > blur should be used with a great deal of care, as it will not work with every type or style of image and is somewhat dated.

There may be occasions where you will need to add either skies or alternative backgrounds, something that is achievable in Photoshop but does require some considerable knowledge using layers and masks.

▲ Lightroom has a number of presets under Develop that will allow you to add further creative options from B&W Creative – Antique Grey to Cyanotype and Selenium Toning.

▲ Aperture offers some post-production. However, it does not provide the levels that Photoshop can offer.

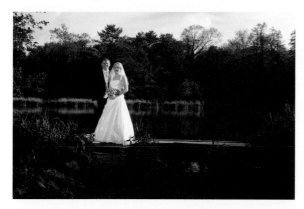

▲ The colour popping process may well have had its day. However, if couples want it, who are we to argue?

▲ The radial zoom effect has been used in the past and only lends itself to certain images and becomes a matter of personal taste.

▲ The addition of skies may be required if the shot requires it. A white or grey sky would be unacceptable.

▶ Cross Processing is a treatment that was given to either a colour negative or transparency when processed in the wrong chemical solutions. It was generally mistaking the C-22 and E-4 processing.

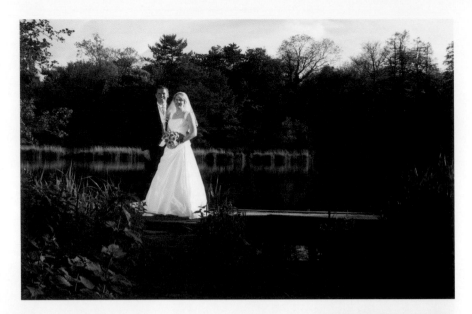

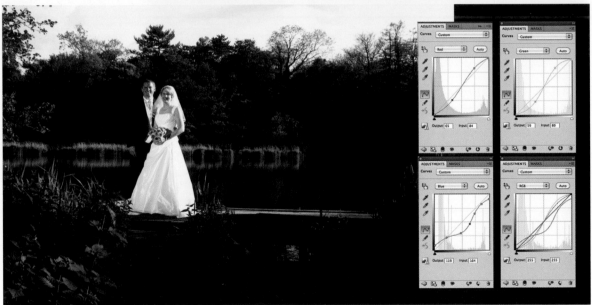

▲ The curves process when producing a cross processed image. The red channel is set to Output 65 / Input 84 - Green Output 59 / Input 89 and Blue Output 119 / Input 164 for this image. You can create your own for a different result.

Another process you might try is the art of cross processing, which was used during the heyday of film, where a colour negative film was processed in a colour transparency developing solution, producing a colour shift.

Cross processing occurred where a colour negative (print) film was processed with the E-6 chemicals (normally used for reversal film transparencies), resulting in a positive image with an orange base of a normally processed colour negative. Processing a reversal film in C-41 chemicals (normally used for negative colour film) will result in a negative image on a colourless base.

This technique can be replicated in Photoshop by creating a new Adjustment Layer > Curves. Select the red, green and blue channels and adjust the curves to produce the balance you want. Finally select another New Adjustment Layer > levels and fine-tune the image. This is an oversimplification of the process; however, a full explanation can be found on the internet if you search 'cross processing in Photoshop'.

There are far too many processes to cover in this book but there are ample resources on the web for discovering all the choices that are available.

At the end of the day any processing you do to an image has to be in context with the image. It may be chimeric, but very often an image will talk to you and tell you what it wants to be, screaming 'make me black and white'. Used with caution post production can add another dimension to your images.

SHOWING THE CLIENT

If you have not shown the couple the images at this stage, produce a disk for them to view, or produce an on-line album for them to examine your selection. They will now need to make a decision as to which images they want in their album, limited to the maximum amount the album will comfortably contain. As a general rule there are about four images per page, depending greatly upon the page size of album chosen; some of the pages will have more and some less. The total number chosen by the client will depend upon the number of pages it contains. It is important not to try and cram the album with images; its content will need to flow in a chronological order with busy and quiet pages.

As soon as you have the couple's choices, you can start designing the album.

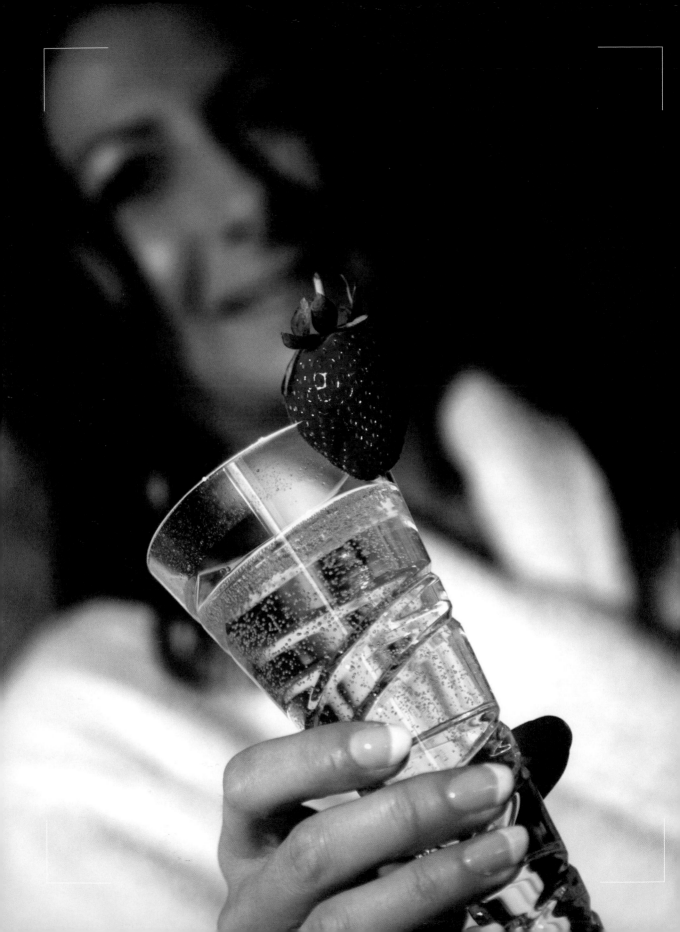

Chapter 12

Albums and End Products

The beauty of hard copy presentation such as albums and prints is their longevity and visual attraction. A hard copy wedding album or photographic prints (not inkjet from a dye ink printer) providing it is stored safely will stand the test of time and be available to view hundreds of years from now. The format in which digital images are supplied, on the other hand, is not likely to be available in fifty years.

The development in the current wedding market for couples to request high-resolution images on a disc for their own use presents issues that may have a detrimental effect on your business as you will be allowing the couple to produce inferior quality products. Many a professional wedding photographer will not allow the release of the high-resolution images as they wish to maintain the high standards that it has taken them many years to develop.

The difficulty is satisfying the couple's wishes, and if wedding photography is to be your living then it is difficult to turn business away, so if you are faced with this situation why not offer both, an album followed with the high-resolution images.

As well as albums you could supply Giclée (high quality ink jet printing) fine art prints using pigment inks onto Fine Art Museum paper, framed prints and canvas wraps, available from many suppliers.

ALBUM STYLE OPTIONS

There are a considerable number of album types available, ranging from the low cost photobooks that are printed onto variable quality art paper, to the top-end handmade product, with a considerable difference in price. The traditional overlay album is still a popular option, with many suppliers offering standard templates to help in the design process. Coffee table (flush mount) books and lay-flat albums are popular options with a wide variety of designs, sizes and finish available enabling flexibility in design with image overlays.

Making a choice is difficult, and a visit to an appropriate exhibition that has album suppliers on show is a good way to help make a decision on your album portfolio. Viewing and handling the samples on show will enable you to assess both quality and manufacture.

▼ Wedding albums come in many formats, prices and quality; make sure you select an album that does your images justice.

Whether you offer the couple a choice of albums or just a single supplier is a commercial decision only you can make. However, make sure that what you are offering provides high quality printing, as poor colour balance and printing will be counter productive. Remember that the albums will be passed around as a presentation of your work, hopefully pulling in more clients.

It will be the couple who should make the album choice from your portfolio, so do not offer them a wide choice of albums; just present a well-balanced portfolio that reflects your style. Remember couples will have differing perceptions of what their album and wedding images will look like, so make sure you cater for as many styles as possible without overloading them with a bewildering array of products. (If you restrict your options it will reduce the potential market you are trying to attract.)

Above all the finished album must represent the best you have to offer and must be unique. Try not to use standard templates that will produce a sameness to all your albums. Work intuitively, allowing the couple's personality to shine through in the album. Remember you are telling their story and every wedding is different, therefore every album should be individual.

THE DESIGN PROCESS

Software

The software you choose to design the album will be a personal preference, with many album suppliers offering their own, some of which offer a very basic design platform and others providing more expansive options. At the time of writing Photojunction is a first class software option available as a free download from http://photojunction.com. It does take a little time to work around the interface; however, perseverance will pay dividends. Ideally you need to choose a programme that offers double page spread design. The important thing to remember is to work with software you are comfortable with and which can produce an end product the album manufacturer can work with.

Decide on the Style

The design should reflect the couple's wedding: a more formal wedding would produce a formally designed album and a more creative wedding should be reflected in the album presentation. Before you even open the album-creation software, consider preparing a storyboard of the chosen images, providing a visual representation of the album on paper. Consider a mix of styles in the same album – there are albums out there that combine a coffee/ magazine book style with a conventional overlay or matted format.

► The album cover should have a creative image.

Image Selection and Placement

Images need to be displayed in chronological order so you preserve the timeline of the wedding, with a set number of pages designated to the various elements of the day, bridal preparation, groom's preparation, guests' arrival, bride's arrival, the ceremony, the creatives at the church, the reception groups, the creatives at the reception, the speeches and cake cutting and finally the first dance.

Select the image in each element that stands out, having greater emotional importance than the others and build around that image. Remember the fewer the images the stronger and greater the impact will be. Be careful you do not cram the page with images, as your desired effect will be lost.

With images that spread over two pages consider setting an image as the background, reducing its opacity so it does not conflict with the relevant images that help to reinforce that story. Make full use of black and white, which has a timeless quality to it.

Try to visualize the pages before you start creating the album; for example a few shots of the bridal preparation may not support a double page spread whereas the groom, best man and ushers shots will, so a little pre-planning will help.

Take time to scan the images chosen for the album, giving consideration to the numbers chosen for each element of the day.

The album's first page can start with a signature image or the bridal preparation and flowers if there are enough images.

The use of colour can help draw you into the picture.

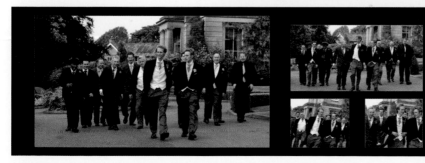

Black and white is always a favourite with couples.

▶ The groom preparing for the ceremony will provide plenty of opportunities for creative shots.

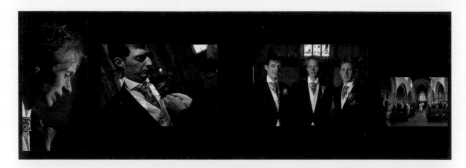

▶ The bridal processional and ceremony is an important element of the day and should justify a double page spread.

▶ The signing of the register is a standard requirement, not forgetting the recessional and creatives after.

You may want to start the album with a signature or creative image instead of the bridal preparation, depending upon the images available to you. When shooting the wedding remember that you are also shooting for the album, producing images that will provide background images or telling the story with detail images.

Elements of Design

The design process will encapsulate a range of disciplines.

Colour is important to the overall design as the colour will convey a mood or theme.

The lines you adopt will convey either energy or a rhythmic theme, given that horizontal lines suggest stability and strength whereas diagonals will stimulate the eye and add energy to the page.

Space on the page will allow the images to speak for themselves, inviting the viewer into the picture without the confusion of unrelated images competing for their attention. As in the images, use negative and positive space to allow the eye to drift around the page in the direction you want it to, using image size and position to help develop the story.

Balance on the page is the overall visual weight of a composition. Images of the same size on both sides imparts a balance to the page, whereas unequal distribution of images on each side while still providing total weight that is balanced, is said to be asymmetrical; a simple analogy is a plant that looks

At the reception, as well as groups and creative or signature shots, do not forget the table sets.

The cake cutting and food will help close the album, following the timeline. Do not forget the candid images during the speeches.

balanced but has leaves of different proportions on each side.

The page or pages will need a focal point from where the viewer's eye starts or finishes. The images on the page will be designed so that you use emphasis to direct and focus the viewer's attention to the important elements of the composition, at the same time producing harmony.

The completed album should have a rhythm not only to the individual pages but the album as a whole. You will need to develop calming elements where required, for example during the ceremony elements, and energy during those parts of the day that are active, at the same time ensuring the whole has unity.

When designing an album try not to complete it in one session. Allow time to sit back and digest it, returning to it later. At some point you will have a spread that will just not work for you. Give it time; the answer will form in your mind as you take time to relax.

10 TIPS FOR ALBUM DESIGN

1. Communicate with the couple on their choice of images.
2. Only select the best images to show the couple.
3. Less is more.
4. Divide the album into the relevant elements of the day.
5. Create a rhythm to the album, busy and quiet pages.
6. Include black and white – if that's what the couple like.
7. Page one image needs to be a stunner.
8. Details can be transferred to the back page as a closure.
9. Once the album has been designed, leave it a few days and come back to it.
10. Remember to look for background images for the album as you shoot.

Close the album with some creative shots of the couple.

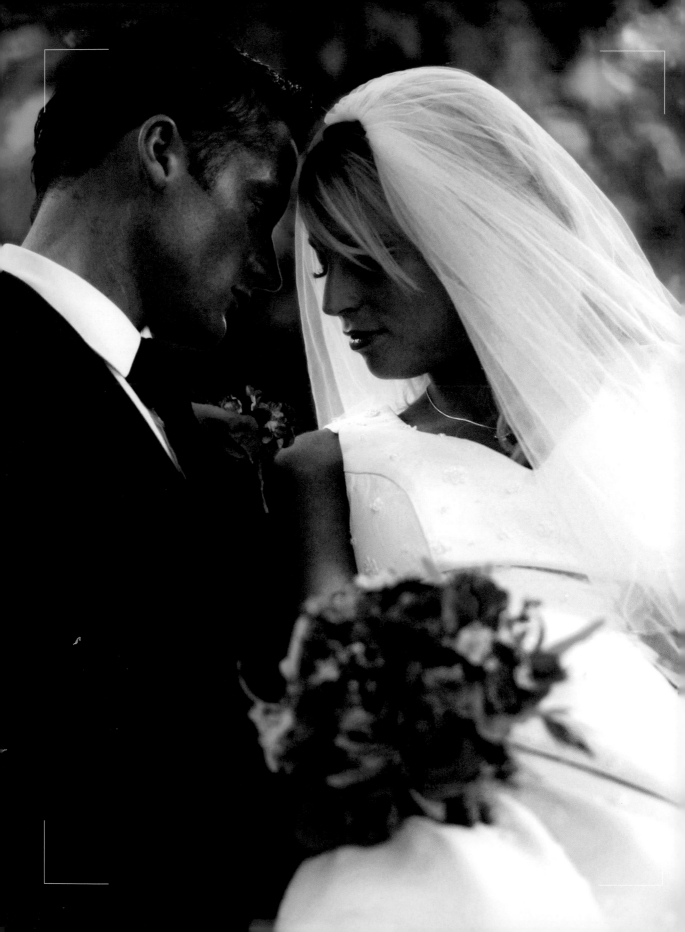

Conclusion

Wedding photography is a genre of photography that offers you an exceptional opportunity to shoot in multiple disciplines in an environment that is a challenge, and particularly encouraging you to continue your development as photographers.

The current climate for wedding photographers is difficult, in that the digital age has produced a large number of so-called photographers who think it is easy money to shoot a wedding; they will invariably have full-time professions and supplement an income at the weekend. If your ultimate goal is to be a professional wedding photographer you will need to think seriously about how much you charge, as all your income will derive from your fees and the success of your venture will depend on adequate income.

So why should you decide to shoot weddings? In the first place it is such a fantastic rewarding experience, capturing a story between two people with all the fun, beauty and emotion that goes with it. It is history in the making, with two families coming together, and it's an immense pleasure to be able to capture that point in time that will ultimately become the couple's memories.

It is a high stakes game, as you only have one chance to get it right. Therefore a thorough understanding of your equipment and craft is essential. Reading a book is not enough, you will also need to develop your skills with training sessions and workshops to find out how others do it. There is no real substitute for practice and getting out there and putting into practice that which you have learnt. Wedding photography will help you develop your talent as a photographer, and working under pressure like a final exam makes you a better photographer.

The skill set required to shoot a wedding includes the skills of a portrait artist capturing the romantic and affectionate elements with a couple who may not feel comfortable in front of the camera, so you will also need great social skills. Another style of wedding photography finding favour is the fashion-influenced images, so you will need the skills top end fashion photographers have developed, combined with great lighting in what may be difficult lighting situations. Then you will need the skills of still life photography for the food shots, flower details and so on. You will need an understanding of architectural photography and its lighting complexities. There is also the ability to think on your feet, react to changes in circumstances and capture the candids in a photojournalistic style, employing composition and viewpoint to get the message and story over to the viewer. You will need to develop your skills as a negotiator, planner, and organizer and acquire exceptional people skills.

The next challenge is to take your wedding photography to the next level through creative development, generating new ideas and images through a process of creative visualization. Develop a technique of visualizing on the go, keeping an open mind through constant observation and sometimes letting things run and react to the opportunities that present themselves. Explore the creative work of others, deconstruct their images and work out why a particular one was shot, how it was shot and the lighting that was used.

This job will push you to the limit, both physically and mentally, culminating in a feeling of achievement and satisfaction when you show the final images to the couple and the tears of joy appear. It does happen.

WHY SHOOT WEDDINGS?

A few years ago I was asked to photograph a couple's wedding where the bride was extremely concerned about how she was going to look in her wedding photographs. The problem was that she had undergone some facial reconstruction following a particularly nasty flesh-eating condition and she had the strong belief that she was not attractive or beautiful, despite being told on many occasions by her partner and indeed myself that she was, and there was nothing to worry about. Her choice of photographer was important to her in that the photographer needed to be skilful enough to capture her beauty but also sympathetic to her feelings.

The day went well, with many affirmations of her beauty and how gorgeous she looked, taking particular attention to her good and bad side, not that she had a bad side; unless you were told about her condition you would not have recognized any problem.

The time had arrived for me to present the images to the couple as a DVD that was played on their television in their own surroundings. After about five minutes I noticed she was crying, and my heart sank, thinking that I had it all wrong, so I ask her what was the problem. She turned around to me and said, 'I now believe it.'

What a photographer can do is show people themselves, how they look to others, and a wedding photographer can show them at their best, at a time when they are happiest. It's a very satisfying kind of business to be in.

Appendix: The 'Must-get' Shots

Most brides will have an idea of what they want their wedding album to look like, from the overall style to specific shots they have seen in a magazine or in someone else's album, so it is a good idea to have a list of 'must-get' shots.

It is not a good idea to show the list to the couple, as they will more than likely accept all of them, putting you under greater pressure; rather select a few key shots to which they can add or subtract.

Here is a list of images that should be included.

BEFORE THE CEREMONY
The bride in her dress
Bride with mother and father together and separately
Bride with entire family
Bride with chief bridesmaid
Bride with bridesmaids
Last minute touches to hair and make-up
Bride and father in car – probably at the church when they arrive

AT THE CEREMONY
Guests arriving
Ushers and best man
Musicians
Groom and best man at the altar
Bride and father getting out of the car
Bride, father and bridesmaids going into venue
Bridal processional
Exchanging vows
Signing the register
Bridal recessional
Bride and groom outside venue
Bride and groom in car
Signature shots back inside the venue

BEFORE THE RECEPTION
Bride
Bride and bridesmaids
Groom
Groom and best man
Groom, best man and ushers
Bride and groom with all attendants
Bride with her parents
Bride with groom's parents
Bride with both mothers
Bride with both fathers
Bride with both mothers and fathers
Groom with his parents
Groom with bride's parents
Groom with both mothers
Groom with both fathers
Groom with both mothers and fathers
Bride and groom with bride's parents
Bride and groom with groom's parents
Bride and groom with both fathers
Bride and groom with both mothers
Bride and groom with both mothers and fathers
Bride and groom with entire wedding party and guests

AT THE RECEPTION
Receiving line
Table shots and favours
The cake
Bride and groom cutting the cake
Speeches
Musicians
The first dance
The bouquet throw

Further Information

The following websites all provide invaluable support for photographers wanting to explore the techniques of wedding photography further.

Training for wedding photography
www.photographyworkshops.co.uk

Wedding visual guides
www.photographyworkshops.co.uk

Album design
http://photojunction.com

Flash equipment
www.theflashcentre.com

Speedlight equipment/Flash brackets, etc
www.interfitphotographic.com

Elinchrom skyport radio triggers
www.theflashcentre.com

Elinchrom Quadra portable studio flash
www.theflashcentre.com

Wedding albums
www.queensberry.com
www.colorworldimaging.co.uk
www.graphistudio.com
www.jorgensenalbums.com
www.albumsaustralia.com.au
www.italianweddingalbums.com
www.bookedimages.com

Slideshow software
http://animoto.com

Photoshop
www.adobe.com/products/photoshop.html

Music copyright
www.prsformusic.com

Website development
www.clikpic.com
http://wordpress.org

Further reading
http://strobist.blogspot.com
www.wpja.com
www.wedpix.com

Index

A

Adams, Ansel 53
advertising 28
AI servo (Canon) 132
album design 164–165
albums 161, 163
ambient 38–39, 47, 52, 55, 56–58
aperture 49, 52, 56, 145
aperture priority 44, 47, 64, 101
assistant 84
auto white balance 123
avant-garde 14

B

backing up 156
best man 110
black and white 19–20, 158
boudoir photography 18
bouquet 102, 104
bouquet throw 151
bridal arrival 114
bridal departure 134, 138
bridal groups 116–117
bridal preparation 100
bridesmaids 101
bridesmaids arrival 113
briefing 81, 83–84
brightness 43, 45
brochures 29
business 25
buttonholes 106

C

cake cutting 144–148
cameo shots 120, 122. 133
camera metering 53
camera numbering 155
camera time function 155
cancellation policy 31
candid shots 37, 138
Catholic ceremony 88
centre weighted 53
ceremony 120
chancery step 92, 113
church 84, 92, 107

Church of England 87
church wedding 87
civil wedding 88
clipping 55
cloud storage 31
coffee table albums 163
colour 43, 64
colour balance 145, 148, 151
colour matching 32
colour temperature 45
colour temperature orange 43
competition 28
composition 93
confetti throw 92, 129, 131–133
continuous focusing (Nikon) 132
contract 31
contrast 46
copyright 32
cravats 106, 109
creative shots 15, 16, 91, 92, 141–142, 151
cross processing 160–161

D

dedicated flash 91
depth of field 56
diffusers 60
digital crop 36
digital negatives 26
digital workflow 155–161
domain name 31
dominance 64
doorway formals 128
dragging the shutter 47, 152
dress, the 103–105
drive 44
duotone 158

E

elements of design 166–167
equipment 35, 107
eternal triangle 110
ETTL 50, 54, 119
evening function 151

F

first dance 152
first kiss 120
fish-eye lens 128, 144, 146, 151
flash 38, 87, 91
flash bracket 38
flash compensation 38, 49–51
flash gun 38, 48, 55
flash meter 52–53, 92
flash synchronization 46–47
flash zoom 119
flowers 102
focal length 36
focal plane 47
focal point 64, 167
form 64
formal 13
formals inside the church 128–130
formatting cards 155

G

giclée prints 163
google ranking 30
grain 20
grids 58, 61
groom 106, 109–112, 114
group sets 85, 91, 96, 97
groups 95–97, 140–141
guests 108

H

half step shot 115, 138
HDR 16, 120
high resolution images 156, 163
high speed sync 47
highlight alert 54
Hindu wedding 88
honeycombs 39–41, 61
humour 140

I

illustrative photography 17
image choices 86
images 27
incident light reading 50, 53
infrared triggers 54
insurance 32
inverse square law 48, 58, 119
ISO 20, 36, 38, 44, 50, 52, 53–55, 64, 122, 145, 148

J

Jewish ceremony 88

K

kiss, the 89

L

lenses 36–37
light 43
light meter 52–53, 93
light modifiers 39, 48, 55, 58, 91, 93, 129, 141
lighting 64, 93
lilies 104
location 95
logistics 85
lych gate 113

M

make-up artist 101
manual mode 44, 101, 114, 119
market research 27
marketing mix 27

N

networking 146
noise 20

O

officiant 112
overlay album 163

P

panoramic 16
paparazzi 92, 125
parking 84, 107
partial metering 53, 54
participants 84
pattern 64
perception 63
peripheral distortion 37
personality 25
photobook 26, 163
photojournalistic 11, 16, 37
planning 83, 97
portfolio 30
posing 93
post production 156–157
preparation 100
pre-wedding chat 83, 93
pre-wedding shoot 86
pricing 25
pricing strategy 28
priest 112
processional 118
professional indemnity 32
programme 44
proportion 64
public liability 32

Q

quadtone 158

R

radio 39
RAW 20, 43, 45, 123, 155
rear curtain sync 47, 152
receiving line 145
reception 93, 144
recessional 125–127
reconnoitre 83
red eye 48
reflected light reading 53
reflectors 39–40, 56, 58
register office 87, 88, 89
registered venue 87, 89
reportage 12
Reservoir Dogs shot 110
restrictions 85
rings, the 106, 112
romantic 15

S

scrims 38–41, 46, 56, 60, 61
seeing the picture 63
selective colour 21
sensor 36
services 31
shadows 58, 64
shape 64
shutter 46–47, 51
shutter priority 44, 101
shutter speed 56, 64, 108, 145, 152
signature shots 13, 15, 56, 57, 86, 91–93, 138, 150
signing the register 87, 89, 123
snoots 58, 61
social networking 28
soft boxes 39–40, 46, 58
speeches 148–150
speedlights 106, 151, 152
spot metering 53
storybook 12
strobes 60

T

table details 144
timings 83
travel expenses 32
trigger 38–39, 54, 89
tritone 158
tungsten lighting 148

U

umbrellas 39, 46, 59–61
unlimited licence 32
ushers 108

V

venues 83
vicar 112
visual guide 85, 142
visualization 63

W

weather 32, 83
website 30, 31
wedding breakfast 146
wedding fairs 29
wedding insurance 85
weight bag 40
white balance 44
wide angle lens 119, 146
wireless triggers 39

Z

zone system 53